Contours of Change

Contours of Change

MUSLIM COURTS, WOMEN, AND ISLAMIC SOCIETY
IN COLONIAL BATHURST, THE GAMBIA, 1905–1965

Bala Saho

Michigan State University Press | *East Lansing*

♾ The paper used in this publication meets the minimum requirements
of ANSI/NISO Z39.48-1992 (R 1997) (Permanence of Paper).

Michigan State University Press
East Lansing, Michigan 48823-5245

Printed and bound in the United States of America.

26 25 24 23 22 21 20 19 18 1 2 3 4 5 6 7 8 9 10

LIBRARY OF CONGRESS CATALOGING-IN-PUBLICATION DATA IS AVAILABLE
Names: Saho, Bala SK., author.
Title: Contours of change : Muslim courts, women, and Islamic society
in colonial Bathurst, the Gambia, 1905–1965 / Bala Saho.
Other titles: African history and culture.
Description: East Lansing : Michigan State University Press, 2018. | Series: African history and culture
| Includes bibliographical references and index.
Identifiers: LCCN 2017011158| ISBN 9781611862669 (pbk : alk. paper) | ISBN 9781609175498 (pdf)
| ISBN 9781628953176 (epub) | ISBN 9781628963175 (kindle)
Subjects: LCSH: Muslim women—Gambia—Social conditions—20th century.
| Marriage (Islamic law)—Gambia—History—20th century.
| Marriage law—Gambia—History—20th century. | Muslims—Gambia—Social conditions—20th century.
Classification: LCC HQ1817 .S25 2018 | DDC 305.486970966510904—dc23
LC record available at https://lccn.loc.gov/2017011158

Book design by Charlie Sharp, Sharp Des!gns, East Lansing, Michigan
Cover design by Shaun Allshouse, www.shaunallshouse.com
Cover image of Njau women is used courtesy of Michael Ford/Yellow Cats Production,
www.yellowcat.com. All rights reserved.

Michigan State University Press is a member of the Green Press Initiative and is committed to developing
and encouraging ecologically responsible publishing practices. For more information about the Green
Press Initiative and the use of recycled paper in book publishing, please visit www.greenpressinitiative.org.

Visit Michigan State University Press at www.msupress.org

Contents

Acknowledgments

The writing of this book has been a long and arduous journey. The one thing that guided me throughout the search is my mother's famous dictum, *kuu koleyaata* ñaa-*wo*-ñaa*, a ka baŋ ne* (however hard a task, it will come to an end). She had been caring and supportive. She worked so hard to see me go to school every day with a smile on my face despite all adversities. I owe a debt of gratitude to her, the rest of my family members, and so many other people who have played significant roles in helping me academically, morally, and financially to finish this book.

First and foremost, I must thank my chief academic advisor Professor Walter Hawthorne, chair of the History Department at Michigan State University. Prof. Hawthorne has been with me throughout this journey. He provided guidance and moral and financial support. He and his family also made it possible for my family and I to live comfortably in East Lansing during my graduate studies. I must also thank the rest of my advisory committee members for their insight and thoughtfulness. Professors Peter Alegi, Gordon Stewart, Thomas Summerhill, and Mara Leichtman have been resourceful and helpful. I am grateful for their support and careful advice. These people advised me on how to succeed in life and in the academic world.

I am also indebted to Professors Donald Wright, Toby Green, Ben Keppel, and Dan Snell. They have read versions of the entire manuscript and their comments were invaluable. Professors David Wrobel, David Chappell, Dan Mains, Mariam Gross, and Paul Gilje offered priceless comments and support. I would also like to especially thank Professors Bill Roberts, Assan Sarr, Leslie Hardfield, Lumumbaka Shabaka, Jill Kelly, Peter Limb, and Joe Lauer for their treasured support through this journey.

Along the way, my friends and family have been supportive morally and otherwise: Bakary Touray, Bai Ousman Jobe, Buba Saho, and E. M. Jobe. A special thank-you to all my interviewees for taking time off their busy schedules to inform me—especially Qadi Alieu Saho, Qadi Muhammad Lamin Kah, Alhagie Muhammad Lamin Bah, Seringe A. M. Secka, Qadi Alhagie Masamba Jagne, Qadi A. L. H. Muhammad Abdoulie Jaiteh. A special gratitude to Sheikh Adi Jobe for translations from Arabic.

Also, I want to thank my friends and research assistants at the National Centre for Arts and Culture (Banjul), Baba Ceesay, Hassoum Ceesay, Alieu Jawara, Lamin Yarbo, Lamin Nyangado, and Bakary Sanyang, for their support. Dr. Issa Lele and Dr. Soulemane Soumahoro were excellent cartographers.

Finally, I highly appreciated initial funding from West African Research Center in Dakar, Senegal, as well as Michigan State University's Department of History and College of Social Sciences. The University of Oklahoma (OU) has provided two consecutive Junior Faculty Fellowships to complete research for the book. The OU Office of the Vice President for Research also generously supported the publication of the book. I greatly appreciate their support.

Introduction

On June 6, 1927, a man by the name of Muhammad Bojang appeared before the qadi (Muslim judge) of Bathurst (now Banjul) to enter a claim against his wife, Isatou Fye. Muhammad took the oath and stated that Isatou was "mischievous" and "uncooperative." In his testimony, he declared:

One Sunday, when we were living at the village of Sutukung, Lower River Region, I quarreled with my wife and she went to tell her parents and the Imam. They asked her to be patient but she refused to be cooperative. One evening she went out. I came home and found a cloth with sperm on it. I asked her if that was not her cloth but she told me not to ask her. The following morning, I greeted her but she did not respond. Then she went away. After some time, I went to one Abdou Manneh and gave him fish money to give to my wife's grandmother.[1] On my way back, I met up with her. We exchanged insults; I pulled her hair and beat her. Then people came to separate us.

When asked to testify, Isatou in her defense took the oath and stated:

I did not refuse to sleep with him. When we were at Sutukung, we used to quarrel. Once we quarreled and he beat me, took a knife and hurt me on my left eye. I was admitted at the hospital. When the Commissioner of the region heard the news of the incident, he gave £3 to me but said he could not adjudicate our problem because of our previous fight in 1926. After that I went to stay with one Bakary Sey but my mother asked me to go back to my husband. When I returned, that night he beat me again and bruised my face. In the morning, I went back to the Commissioner and he asked us to come to Banjul to the qadi. We took a boat from Bambali [village], with one Muhammad Mboge, came to Tankular [village], and to Banjul. In Banjul, we had a fight and I went to see Mamadi Njie and Samba Joof so they could resolve our difference. My husband brought along the sperm-stained cloth. Mamadi and Samba asked me whether the cloth belonged to me or not. I explained everything to them. They asked us to reconcile but I told them that I am afraid to live with him. In the morning, other people asked me to return but I maintained that I am afraid to return.[2]

When the qadi had heard the disputants, he asked the wife to forgive her husband for the beatings and accusations, but ordered divorce.

In this book, I draw on stories such as these to draw attention to the ways in which women used the qadi court to free themselves from abusive husbands, untenable marriages, and other forms of patriarchal dynamics in colonial Bathurst—issues that, prior to this period, they were likely bound to suffer and endure in marriage. Much detail can be gleaned from such cases with regard to how marriages were complicated by domestic violence, physical and emotional abuse, social insecurity and jealousy, as well as by the role of the qadis, colonial administrators, and the community in general in the multiethnic and multicultural Bathurst of the early twentieth century. Essentially, the case demonstrates that some women were aware of their marital rights and knew how to negotiate these rights and claims in court.

An interesting perspective of this case is the way in which the wife established autonomy in the drive to end the marriage. The wife's meticulous explanation of the abuses she endured positioned her to negotiate her terms and conditions by making sure that her husband's abusive character was brought to the fore during the court proceeding—a factor that won for her the empathy of the qadi. Though the husband in his testimony did not elaborate much on the specifics of his wife's misdeeds, the wife, however, not only detailed the beatings but also exhibited her

awareness of the legal and traditional mechanisms available to her by involving the commissioner of the region and other relatives and friends.[3]

To an extent, this case and many of the cases sampled in this book uniquely inform us about the shaping of Gambian women's petitioning for greater rights, and also the molding of their sense of shame in the colonial era. In other words, the cases show that a cross-section of women used the court to bring to the fore issues of domestic abuse and other forms of injustice. In the face of patriarchy, kinship relations, and family names, it was difficult for women to publicize their household problems or bring cases against their husbands because it made the remarriage of such women challenging and problematic.

Though these opportunities can be viewed as unintended consequences of colonial rule, it was a profound change, for example, that women, through the court, now had a means to settle disputes between and within families over marriage rights, and to protect themselves from abusive husbands. Although it had been the husband who had brought forward this particular case, the wife passionately debated her position and ultimately was able to take herself out of an untenable relationship.

This case further demonstrates the linkage between Bathurst colony and the protectorate, especially in legal matters. It highlights the role of the Muslim court as a location where aggrieved persons could seek redress in the name of Islam. Moreover, this case provides a window into the social, economic, and political changes taking place in Gambian society during the first half of the twentieth century, and how the people of Bathurst responded to these transformations.

In 1816, largely as an effort to halt illegal slaving in West Africa's Gambia River, Great Britain established a settlement on a flat, scrubby island off the river's south bank, near its mouth, naming it Bathurst after then British colonial secretary Henry Bathurst. Over the course of the nineteenth century, Bathurst's population grew from Africans trickling in from surrounding rural areas, Africans "recaptured" from illegal slavers by the Royal Navy and settled there, and traders and retired soldiers from around the Atlantic world. From this hub, British commercial interests grew as African farmers began growing groundnuts (peanuts) to export, and in turn bought imported goods such as cloth, cutlery, and food products. When Europeans "scrambled" for African colonies after 1885, Britain laid claim to two hundred miles of the Gambia River, and in 1889 formally established "the Gambia Colony and Protectorate." Bathurst and nearby populated areas near the river's mouth were known as "the Colony" and were under strict British control and influence; rural

areas, which included over 90 percent of Britain's claim, were "the Protectorate," a land of villages and rolling savannas where life went on much as before, especially prior to the introduction of colonial rule in the early twentieth century.

By the early decades of the twentieth century, persons representing one or another of the Gambia's half-dozen ethnic groups and migrants from several African countries in the subregion populated Bathurst. Descendants of the liberated Africans called Aku, enslaved Africans captured at sea by the Royal Navy's West Africa squadron (instigated by the actions of the British Anti-Slavery Movement), also lived in the city. The Aku were Christian; the rest of the residents, with the exception of a handful of British citizens, were Muslim. This largely Muslim population was interested in being part of the colonial system in order to take advantage of the new economic, political, and educational opportunities the system offered. They were also interested in the legal developments of the colonial setting and made efforts to interrogate its parameters.

Integrity of the Subject: Themes of the Study

An essential contribution of this book relates to the place of women in the formation of colonial Bathurst, the evolution of women's understanding of the importance of law in securing their rights, as well as the ways in which women utilized the new qadi court system to fight for growing rights within the domestic sphere. Gambian women's increased awareness is significant because it signals changes that were already underway in the Gambia Colony and Protectorate during the early colonial period. I also attempt in this book to complement important works by scholars of other African societies with similar colonial experiences.[4] Clearly, records from the qadi court in the Gambia are in agreement with these works that often qadis were sympathetic to women's claims. It is also evident that the court opened up ways in which women negotiated conjugal and other forms of relationships and constructed a sense of self in African colonial societies.

By exploiting the unused body of records from the Muslim court, the Gambia National Archives, and oral sources, I explain how the creation of the Muslim court by the British colonial administrators brought changes to Bathurst over the first half of the twentieth century. I show how the laws shaped the lives of both men and women and created legal debates and new discourses, as the people of the city experienced colonial rule. As evidenced by records brought before the

Muslim court, men and women in Bathurst contested, challenged, and negotiated divorce, child custody, inheritance, and other social relationships—matters that transformed dynamics within marriage and brought changes in this largely Muslim society. The Muslim court in the Gambia provided a cross-section of women with both a forum for the articulation of their rights and a process that worked at least at certain levels to protect them. Some of these changes are more noticeable in the way the court provided women with a means to settle disputes between and within families over marriage rights and particularly in the areas of divorce, maintenance of divorced wives with children, property rights, and women in abusive marriages. In this way, affected women in colonial Bathurst were able to free themselves from abusive husbands, untenable marriages, polygamy, and other forms of patriarchy.

I carefully document the ways through which a cross-section of women were able to use the courts for the articulation of their rights. I also establish that women were not shy about bringing marital issues before the public.[5] What was private— that which was located within the household—now became public because there was no confidentiality in the courts. As such, family discussions that were previously debated and resolved privately by other family members and close kin now moved to the public sphere, because the courtrooms became an attraction for bystanders and spectators.[6] By and large, whatever happened in the court eventually found its way into the streets of the colonial city and at the market as news topics—information that was shared by market women and men and their clients. In that way, women built networks along kinship lines, at social gatherings, and through the market. Hence, the success of one woman in court became an inspiration for others with similar matrimonial problems.

Furthermore, *Contours of Change* demonstrates the centrality of the qadi court and other Islamic institutions in the formation of subjectivities in colonial Gambia. Some of the literature focuses on the formation of colonial identities and how this was also connected to the emergence of new legal frameworks in colonial worlds. Toby Green, for instance, recently turned to this question by focusing on the Atlantic world, underscoring how this plural, pan-Atlantic legal framework shaped new subaltern subjectivities.[7] Part of the literature on African colonial encounters focuses on how colonial subjects were constructed as people with inferior political and social status.[8] In other words, the relations that existed between the colonial masters and their subjects reinforced racial categories and created categories of citizens in the colonies. As such, social groups tended to be constructed as irreconcilable differences, with each constituent distanced from the group. This focus on

law and subjectivity is also a recurrent theme in George Karekwaivanane's work on colonial Zimbabwe.[9] While the emphasis on the status of Islam is important, I also focus on the place of legal pluralism in the configuration of Africans by Europeans, a subject that remains critical in understanding colonial rule, and that has also played a key role in shaping recent literatures on colonial African identities. This study therefore offers a variety of new approaches to colonial subjectivities, legal jurisdictions, and changes in the institutionalization and formalization of existing legal practices.

Indeed, the court played a central role in the development of Bathurst society and has continued to speak to the personal and group differentiation among the city's Muslim population. An examination of the history of the Muslim court of Bathurst reveals that the Muslim population of this colonial town was a fractured community—one where debates often arose over such issues as qadiship, management of the Muhammadan School, imamship of the Bathurst Mosque, and political representation in the legislative council. It was also a community in which intra-Muslim cleavages and gender conflicts tended to sever relationships between husbands and wives, and children and their parents. At the beginning of colonial rule, European powers, which were thin on the ground and eager to find ways to administer with minimal cost, took it upon themselves to maintain what they considered to be existing law and order with minimal supervision. To this end, Europeans approved the establishment of Muslim courts in many African colonies where Islam was a dominant cultural force. For example, in 1903 a court was already established in Nigeria; in Saint Louis, Senegal; and in the French Soudan.[10]

In 1905 a group of Muslim elders in Bathurst demanded that their cases be heard by a qadi rather than the European court, which they saw as Christian. In response, the British authorities appointed a qadi and also included a Muslim as an official member of the Legislative Council. The Muslim court, headed by a qadi appointed by the governor, had the power to levy fines against convicts but had no power of imposing other forms of punishment such as imprisonment and flogging. The legislation provided that whenever in the opinion of a governor the qadi was a man of great ability, the court should be constituted of the qadi and two assessors, who had to be persons of the Muslim faith and justices of the peace, selected by the judge of the Supreme Court. In addition, whenever the offices of the qadi were vacant, or the qadi was unable, by reason of absence from the colony, illness, or incapacity, to perform the duties of his office, the court was to be constituted by two or more assessors, and the senior assessor should give the judgment of the

court. All proceedings of the court were compiled in Arabic, and therefore a person learned in Arabic was appointed as clerk.[11]

Although the territorial jurisdiction of the Bathurst court principally served the residents of the city, there was no such law that restricted the court's jurisdiction to Bathurst. By virtue of its subject-matter jurisdiction, the court heard matters from different areas of the protectorate because denying access to jurisdiction to that court would presumably amount to denying access to justice that was guaranteed by the English Common Law applicable in the Gambia at the time. Also, the protectorate had no access to such a court, and the law in the view of the British administration should create a way for British subjects to access the law. The linkage between the colony of Bathurst and the protectorate became discernible in rural-urban migration for economic activities and also pursuit of justice. The search for justice can be seen in the amount of complaints originating from the protectorate that were heard in the Bathurst qadi court.

Essentially, the court was created to deal with matters of family law, because control of families was important to both the British and the Muslim elders. The British were interested in regulating domestic relations among the populace to maintain peace and order and to promote a stable work force to enable the cultivation of peanuts, the main cash crop of the region for half a century. The Muslim elders were also interested in preserving the institution of marriage as sanctioned in the Quran.

In addition, the establishment of the Muslim court transformed relations in Bathurst, because its control continued to be a vital issue among the city's Muslim elders. In other words, control over the management of the Muslim court and similar Islamic institutions—like the Bathurst Mosque, founded in 1854, and the Muhammadan School, founded in 1903—remained at the center of conflict among the city's Muslim population. Analysis of the court records not only reveals the disputes between Bathurst Muslims but also gives insight into the voices of women in these courts. Women went to the courts for various issues ranging from domestic violence to matters of beautification—that is, women who sought divorce because their husbands would not buy them jewelry.

The establishment of the Muslim court also marked a shift from customary court procedures (the way local populations continued to arbitrate since precolonial times) to more formalized institutions (written and codified laws with bureaucratic structures during colonial rule). However, it should be noted that customary law was never fully supplanted, but the court gave an alternative venue for claims to

be heard. The institutionalization of the court set it apart from the traditional and customary ones in that the new court provided not only some level of assurance for redress but also means and opportunities for appeal. Records indicate that during the colonial period, the Supreme Court at times overturned qadis' decisions upon appeal by one of the litigants. In addition to being the venue for the redress of wrongs and conflict resolution, courts, whether Muslim or secular, are also characterized as sites of contention and mediation.

To appreciate the kinds of legal, political, economic, and social changes that came to Muslim society in Bathurst as Muslims interacted with British officials, I focus on issues of colonial rule, Islam, the Muslim court, and the role of women. An examination of the context, nature, and consequences of the Muslim court widens the lens through which the history of African interactions with Islam and European colonialism can be studied. Also, a focused study such as this can broaden the scope of investigation to examine the history of a neglected institution such as the court, and ways in which postcolonial scholarship has marginalized some unintended positive effects of colonialism at the local level.

Furthermore, my study meets a crucial need in the study of Muslim courts in Africa, especially in the Gambia. There are no previous studies on the relationship between women and the courts. This is one of few works to elucidate the spillover effects of the courts to women in particular and the larger Gambian society in general, with the exception of works by Donald Wright and Charlotte Quinn.[12] And although Gambia is now one of the smallest countries in Africa, this book offers a significant contribution to scholarship, given that the British settlement at Bathurst is one of the oldest colonial spaces in West Africa, and the society that went on to form there is one of the most complex in ethnic, religious, and political terms.

Creating the Historical Space: Harmonizing the Historiography

To understand the true nature of colonial rule in Africa, one must appreciate the multiple meanings and implications of the new legal structures established by the Europeans in the late nineteenth and early twentieth centuries. These legal structures came with significant social and political repercussions, which on the one hand created legal plurality, and on the other curtailed social and political movements and established strict rules and patterns of behavior.[13] Terence Ranger argued that since so few connections could be made between British and African

political, social, and legal systems, British administrators set about inventing African traditions for the people living in their colonies. In the process, according to Ranger, Europeans aimed to codify and promulgate these traditions, thereby transforming flexible custom into hard prescription.[14] In other words, since customary law was seen to regulate land use and ownership, family, and other relationships, colonial administrators hoped that customary law could become statutory law to regulate the affairs of their subjects.

To achieve their objectives, European powers introduced systems of administration for each colony. In some colonial territories, the Europeans—the French most notably—employed a more direct form of rule in which Europeans were fully in charge of administration. Wiser about the costs of colonial administration from their long experience in India and elsewhere, the British practiced what they called indirect rule—the principle of ruling through existing traditional administrative structures, with a small number of colonial authorities serving as overseers.[15] The British thus moved quickly to work with Muslim structures they found in place to begin creating the "colonial state." Murray Last, writing on northern Nigeria, suggests that since Islamic political culture puts special focus on community leaders for setting moral standards and the rule of law, it was not difficult for the British to co-opt them into the new structures.[16] Hence, British administrators worked with Africans who they assumed were knowledgeable about customary and Islamic law and then called on judges they appointed to apply that law.[17] In Muslim areas, that law was sharia, and it was applied in Muslim or qadi courts that to this day oversee civil disputes. The principle of ruling in the court is according to the Maliki Law School (c. AD 712–795), one of the four Islamic schools of thought in the Muslim world. Maliki law is widely practiced in West Africa.[18]

Soon after its creation in the Gambia, the Muslim court became an important feature of British colonialism as an instrument of conflict resolution. As part of efforts to maintain peace, the court was created to assist in the administration of justice in the British colony. But in spite of this court's roles in the day-to-day running of the Gambia colony, no single monograph exists on it. Instead, studies of Islam and Muslim communities in what became the Gambia Colony and Protectorate have tended to focus on the role of clerics in the spread of Islam and colonialism.[19]

Some examples of these reputable scholarly works include J. M. Gray's *A History of the Gambia.* As a colonial magistrate himself, Gray provides a rich overview of the colonial history of the Gambia and the militant Muslim revolutions known as

the Soninke-Marabout Wars, from 1850 to 1901.[20] Charlotte A. Quinn's work on the nineteenth-century Muslim revolutions in the Mandinka kingdoms of the Gambia River region remains a must-read for the Islamic uprisings and how the larger Senegambia society was shaped by these religious wars.[21] Also important is Donald Wright's work on Niumi, a region in the Gambia that became integrated into large economic complexes brought about by the arrival of Europeans. Wright also looks at Niumi's contact with Islam, and the revolutionary changes that followed this interaction in the Gambia during colonialism.[22] A few of the works also deal with the issue of women. Judith Carney and Michael Watts's work focuses mostly on issues of contestation over resources in the Gambia, particularly land and labor.[23] This book differs from earlier works by focusing on the underutilized court records, and shows how Muslim men and women reacted to British legal systems through Islamic and customary laws, as well as how the qadis applied customary laws and the sharia in the Muslim court of Bathurst.

This study contributes to scholars' interest in using judicial records to better understand African social history, a historiographical movement that has been growing steadily since the 1950s.[24] Of particular significance is the work of Susan Hirsch, whose study makes a special contribution to the understanding of the qadi courts, positioned within "multiple webs of power" in Kenya, as a forum that became sympathetic to women's claims; Muslim women actively used legal processes to transform the religious and local cultural norms that underlined their disadvantaged position in the Muslim community of postcolonial Kenya.[25] Carol Dickerman also sees courts as centers of mediation in Usumbura, Ruanda-Urundi, where sometimes conflicting and sometimes coinciding interests of colonial administration, court, and community were expressed in three common causes of litigation: bridewealth, divorce, and consensual unions. For Dickerman, these particular kinds of disputes illustrate how the court affected marriage formation and norms of domestic conduct.[26]

In line with these works, this book is also an attempt to grasp how Senegambian women used the courts to seek redress for real and perceived injuries in Bathurst. This exercise will require understanding that the courts existed in a colonial system. Scholars have maintained that the position of most women declined under the aegis of colonialism both because of its gender bias and because women were living in politically dominated and economically exploited territories. European colonizers hailed from societies that had rejected prominent and public political roles for women and that empowered men to represent women's interests. These scholars

see colonialism and colonial rule as systems that controlled and exploited African women and men, with adverse consequences for women and children.[27] Recently, Emily Osborn has shown how colonial occupation in Guinea rewarded men with authority and furthered the domestication of women as dependent accessories of their male relations.[28]

There is no question that colonial officials and African elders, including local authorities, sought to establish control over women and young people in order to control their labor, but it is essential to recognize that women also used the courts and law to their advantage to claim and negotiate their rights, as demonstrated by Richard Roberts and others.[29] Osborn sees these initiatives as limited because, in Guinea, the French did not see divorce as a way to emancipate women or empower them to become autonomous, self-determining agents who could make their way independently in the world as equal to men.[30] However, Thomas McClendon's work on colonial Natal notes that "while the patriarchal alliance of African men and the state used customary law as a vehicle to refashion rural traditions and bring African women under control, women and other subalterns found, ironically, that white-staffed customary law courts sometimes provided an opportunity to escape rigid control, for instance, by divorcing abusive or neglectful husbands."[31]

In examining African women's experiences in, and interaction with, colonialism, Jean Allman, Nakanyike Musisi, and Susan Geiger caution that reducing African women's experiences under colonialism to a universal understanding does not do justice to their multifaceted, complex, and personal experiences. This study reveals that women's experiences under colonialism were not homogeneous but were instead shaped by multiple forces and agendas.[32] This also reveals that women in colonial Bathurst, particularly those who interacted with the Muslim court, not only were active in challenging aspects of patriarchy within households but also created new urban networks and generated positive results in their social lives. They also used the experiences from the court to form friendships and social exchanges with fellow women because of the close-knit character of Gambian society and the cramped living conditions in the colonial city. Bathurst was known for its small-sized bamboo houses, its overcrowding, and its practice whereby different families and strangers lived in the same compound.

These women's experiences are in line with studies that, since the 1970s, have increasingly focused on women's roles, including those of women in Islamic societies in the region. Some of these studies on women and gender reveal women as active participants in their various societies, as they not only negotiated their

social, political, and economic statuses in society but also used outright protest to achieve their goals. As Dorothy Hodgson and Sheryl McCurdy note, women challenged the boundaries of discourse and authority, which they either entirely transformed or molded into space for negotiating cultural power. They show that the difficult situations women found themselves in sometimes helped them to develop multiple strategies to cope with the disparity imposed on them by religion, patriarchy, or economic conditions.[33]

By building on existing historiography, I combine court transcripts with oral histories to provide a route of inquiry into women's and men's rights in twentieth-century Gambia. In doing so, I discuss the interactions between European and Muslim laws on one hand and tradition and custom on the other, and how these interactions influenced the outcomes of family disputes in the Gambia. Because these types of conflicts are often gendered, understanding the way they are resolved in Muslim courts lends insight into the interpretation of men's and women's rights and how these changed under colonial rule.

For instance, the court transcripts that I have studied bring into sharp focus the interaction of customary, Islamic, and European law, or "legal pluralism," where litigants tried to find their way from one court to another. The question of legal pluralism has been a subject of much discussion by scholars. The debates revolve around the issue of the imposition and juxtaposition of European laws on African customary laws and practices. Much of the discussion also centers on the efficacy of African customary laws under colonial domination.[34] Essentially, while the European law was meant to subjugate Africans and to construct colonial power, some Africans, in particular the women, appropriated the new laws to their advantage and used the courts as platforms to air their grievances and assert their rights. The way in which they did this is a testament to the complexities and multiple valences of power at this time.

In order to gain a richer understanding of the cases presented in this book it is important to value microhistory that sheds light on broader historical phenomena through individual lives and events. Like some of these scholars, I present cases in this book that tell of particular individuals and their marital experiences in colonial Gambia. The sources lend themselves to a close study of social relations through the lens of personal lives that highlights the interplay of customary and Islamic marriages and the wider social context of the British colony and protectorate of the Gambia.[35]

Pathways and Conduits: Methods and Sources

I have been fortunate to access numerous records created by colonial officials. In reading through these documents, I could not stop thinking about the individuals who produced them. What was their state of mind or physical state? How many miles did they trek on that particular day, and by what mode of transportation: horseback, donkey, or foot? Who was the interpreter and how much English did he or she speak? Were the Europeans who wrote down the testimonies, and the Africans or Europeans who interpreted, well versed and immersed in the languages and cultures of the people and societies in question? Thomas Spear writes about documentary sources as the biased history of European accounts and therefore warns us to "critically examine these sources, requiring us to question [their] provenance, who produced [them], when and why."[36]

Like many other documentary sources, court records come with some noteworthy limitations. For example, in reading these records, one must consider how close the qadi and his assessors were to the case being judged, or to the litigants. Relationships in a community could influence decisions in court and impact the records positively or negatively. These relations could also lead to a lack of transparency or account for loss of detail in some cases. Also, interpreters may not have been knowledgeable in languages of the court (in this case, Arabic and English) or about the social and cultural contexts of the communities from which litigants came. In other words, it is difficult to know how much information is lost in interpretation and translation. Also, the court records tell us little about how these marriages were arranged before they could take place between a man and a woman. Therefore, understanding the context and manner in which marriages were arranged is also important to understanding the complexities of divorce as evidenced in chapter 2. Thomas McClendon also cautions that court records in particular could provide a sort of tunnel vision of a social conflict because they tend to omit the context and history of the dispute.[37]

Those limitations notwithstanding, I utilize the unique and untapped body of Muslim court records, including archival data on court cases, historical data on the establishment of the Muslim court, and information on past and current court cases. Because courts are places where disputes are presented, discussed, and resolved, an analysis of court records provides insight into men's and women's negotiation of rights and power within the household and greater Gambian society.

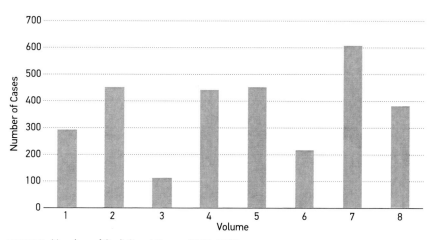

FIGURE 1. Number of Qadi Court Cases, 1906–1960

The Muslim court transcripts that I studied are not cataloged, and this likely made their accessibility to previous researchers difficult. They are placed in different rooms at the qadis' court in Banjul, on Ecowas Avenue. The transcripts are bound together in hardcover, although some of the volumes must be handled with exquisite care due to their extreme fragility. The transcriptions are in Arabic and English, especially from 1906 to 1916. All of the transcripts after 1916 exist only in Arabic. The interruption in English-language coverage was due perhaps to the outbreak of the First World War and the resultant diversion of manpower. I became aware of the existence of these records during the time I served as director of research and documentation at the National Centre for Arts and Culture (NCAC), Gambia Government's sole cultural institution. The NCAC holds a depository of Gambia's oral history and is in charge of museums and monuments, performing arts, and copyrights. In general, I have based my analyses on qadi court transcripts generated from 1905 to 1965, annual reports, and colonial correspondence between 1900 and 1965. The records from 1958 to 1960 are bound together without hard covers. Figure 1 shows the distribution of cases in the bound volumes.

During the period under study, the qadi court dealt with 2,952 cases (including a few repeated cases). In total, I reviewed 1,904 cases and sought help from an Islamic scholar in the transcription or translation from Arabic of those records created after 1916.[38] The cases and records examined during these periods are fairly representative of cases brought before the courts and more broadly of social change in the Gambia. The native court transcripts, including district and village courts

as well as courts held by traveling commissioners, are all in English, cataloged and deposited at the National Records Service in Banjul. Unlike court records studied by Stockreiter in Zanzibar, one significant advantage of Banjul qadi-court records is that the cases are fairly well recorded and often complete. The Year Books contain full transcripts of the cases. The transcripts are carefully recorded in such a way that if a case is postponed, it appears in subsequent pages with a reference number, names of litigants, and the original date of the hearing. As such, the Bathurst records help to broaden our understanding not only of the colonial period but also of household dynamics because of the complete nature of the documentary evidence. As examined in chapter 5, women elaborated on details of the relationship with their husbands, often including the history and nature of the marriage. In this way, the records lend themselves to seeing both sides of marital disputes and to a broader interpretation.[39]

In addition to archival research, I relied on oral histories. Beginning in the 1950s, historians of Africa came to realize that in order to turn away from exclusionary history and produce a responsive history that includes African voices, scholars needed research strategies that start in Africa, historicize Africa's past, draw on African sources, and arrange the new information around historical hypotheses focused on concerns of Africans.[40] Jan Vansina's *Oral Tradition as History* was a landmark work in developing this methodology.[41] The use of oral history to investigate the social history of communities has been successful in multiple research contexts, as oral histories reveal historical processes that often do not appear in the written historical record.[42] Recently, Green persuasively showed how oral history can shape accurate and meaningful knowledge about the West African past.[43]

I conducted a total of 203 interviews, 145 of which were with men. The interviews included a life history component that explored qadis' personal histories as well as their own accounts of the history of qadi courts, their educational backgrounds, and information on some of the cases they handled. Such histories are important for understanding a qadi's familiarity with Islamic law, which can influence judgments and the resolution of conflicts. Research has demonstrated that cultural, social, and personal experiences—the life history of individuals—can reveal details about an individual's life and her or his environment.[44] As Louise Tilly notes, they can also "identify dominant social patterns."[45] By including women in my sample, I seek to understand a previously overlooked perspective on the factors that create discontent in marriages, child custody issues, and disputes over inheritance and property rights.

Focus-group interviews were held in four clerical villages (villages established by clerics and their students): Medina Seedia, Fass Sakho, Medina Seringe Mass, and Pakalinding. These villages were selected as interview sites for various reasons. Most of the qadis, past and present living in the urban areas, descended from or studied in Medina Seedia, Fass Sakho, or Medina Seringe Mass. Therefore, in order to understand the qadis, it is important to know where they come from—in terms both of family and training. I believe that it is important to look at the link between the Muslim courts and the production of qadis. Michael Peletz notes that the Muslim courts offer a unique and interesting dimension to the investigation of the relationship between different social groups as important institutions for the production and molding of families and citizens. Although Peletz's work is on Malaysia, I argue that the same can be said of the clerical centers in many parts of Gambia, where students were and are molded in the image of the cleric to maintain and continue the tradition of authority and power.[46]

The focus-group interviews included group discussions on a particular topic to stimulate discussion and to elicit descriptive data. The approach to focus groups was to utilize the Gambian institution of the *vous*, whereby age mates or peers meet to discuss all manner of social topics, and I selected the interview sites because of their reputation as clerical villages. At focus groups, conversations were broad but well defined.[47] This strategy allowed for in-depth discussions among community members about the significance and meaning of particular norms and values of Gambian society. For example, how do Gambians reconcile "customary practices" with sharia in a changing world? Focus-group interviews also generated valuable information from qadis' assessors and other religious leaders of the community.

Participant observation included attending court cases at the Muslim court of Banjul. During these court sessions, I observed and noted the court proceedings and resolutions. I asked questions of litigants and witnesses.[48] In fact, all the court sessions I attended were cases in which women were seeking divorce or seeking maintenance from their husbands.[49]

I conducted the research in English, Wolof, and Mandinka, languages in which I am fluent. I initially planned to hire a female research assistant in order to facilitate interviews with women, since feminist research methodologies have shown how the positionality of researchers affects the outcome of the research.[50] However, a few weeks into the research I realized that there was no need, since most of the Gambian Muslim women I interviewed were readily accessible and willing to talk to male researchers. This is perhaps due to the fact that, unlike in other Muslim

societies, where the boundary between men and women is strictly delimited, in Gambia, among the majority of those who consider themselves Muslims, men and women interact and work together in the same environment.

Despite my ability to speak Mandinka and Wolof fluently and my nearly twenty years of experience collecting oral histories, I found my search for relevant information from descendants and acquaintances about the first generation of qadis frustrating and at times fruitless, especially within Banjul and the surrounding areas. My attempt to gain insight about the life histories of past qadis came to naught because the descendants or acquaintances focused on genealogical ties and could not provide any knowledge about their educational background, institutions, academic curriculum, teachers, and how cases were handled and resolved. In the countryside, especially in clerical villages, my experience was completely different. There, people tended to remember their past more vividly and often kept a record or two about particular issues such as family histories, settlement patterns, and social and labor relationships.[51] Finally, I found my interviews with present qadis about their lives—their educational background and the kind of cases they handle—enriching and fruitful.

Context: Scope of the Study

The period between 1905 and 1965 marked a profoundly important period in the development of Bathurst and the rest of the protectorate. In little over half a century, the communities in Bathurst were able to position themselves in the new colonial setting in meaningful ways despite the challenges faced by colonial rule. One of the problems for the residents of the city is the question of integrating traditional judicial culture into the new European legal systems or, in the words of Sally Engle Merry, how the "legal pluralism" operated through the new colonial setting. Also, the city's residents particularly the Muslims had to cope with the economic and political, social and cultural opportunities brought about by colonial rule and the resultant rural-urban migration. Colonial rule reconfigured the legal terrain and forged new forms of relationships between the city's growing Muslim population and altered the traditional judicial culture of the country. It is clear that in the realm of law, the history of Bathurst cannot be disengaged from the history of the protectorate, because Bathurst was not only the seat of government but also the legal headquarters of colonial Gambia. Major crimes such as murder committed

MAP 1. Map of the Gambia Showing Key Research Sites

in the protectorate or crimes considered "repugnant" by the British were usually tried in Bathurst. Also, Bathurst was a place where appeals were heard.[52]

Indeed, some of the challenges in the transformations and developments in the early formation of Bathurst also call attention to how British colonial officials made attempts to regulate marriage by promulgating several ordinances that aimed to curtail abuse against women and minors. Some of these regulations came into effect as early as the 1860s. My contention is that while these traditional, Muslim, and colonial practices militated against women's position in society, the new laws and institutions introduced by the British aided women to challenge general male patriarchy and also gave women an opportunity in their matrimonial homes, especially in issues pertaining to domestic abuse.

Another of the challenges is to appreciate the establishment of the Muslim court and its connection to other similar institutions as well as the changes that followed their establishment and the dynamic relations between the city's populations. Control over these institutions instigated divergences and frictions among the city's Muslim populations. In other words, control over the management of these institutions remained at the center of conflicts within Muslim communities.

An important feature of colonial rule is the rapprochement between customary,

Islamic, and European laws and consequently the effect of the resulting laws, policies, and practices on a cross-section of men and women in the Gambia. As scholars seek a more sophisticated understanding of how the history of colonialism in Africa shaped the many cultures and political orders there, there is need to pay special attention to a neglected part of the story: the evolving status of women, and how that position was molded by the complicated interplay between traditional practices and customs and those that European administrators sought—often uneasily—to impose from the top. By foregrounding particular examples of how women used the courts, it is clear that actions by the court in supporting women's claims gave legitimacy to changes that were happening between men and women in the larger Gambian society during the early twentieth century. A cross-section of women took advantage of opportunities provided by the colonial administration to take their cases to the Muslim court, where they challenged patriarchy and issues of property rights, marriage, and divorce.

Advent of Colonial Rule: Shaping the Legal Landscape

There are a vast array of primary sources that show how the new European legal systems reconfigured the legal terrain and forged new forms of relationships among Bathurst's growing Muslim populations and in the rest of the protectorate. In the new colonial setting, dual legal systems were in operation. These new legal structures included native court systems that dealt with native matters. Hence, a look at how the new statutes provided political mechanisms for control and movement of the population of Bathurst and the rest of the protectorate can reveal detailed information on these courts, institutions that ran parallel to the Muslim court. The issue of Islam is considered here, because for several centuries Islam became not only a religion but also an identity for Senegambians. Also, for almost half a century (1850–1901), the region witnessed numerous wars between clerics and nonbelievers, precipitated by the rise of militant Islam before the British and French crushed it in the early twentieth century.[1]

This analysis is useful for various reasons. First, it allows for an examination of how the imposition of colonial rule altered the traditional judicial culture and the political division of the country. Second, it demonstrates the parameters and functions of the native courts as instruments of colonial rule. Third, an exploration of the dual legal terrain, or the two judicial systems—the Muslim court, based

strictly on sharia, and the native courts, which were a combination of customary laws, sharia, and English law. The story of native courts cannot be separated from the history of colonialism. European domination of Africa and Africans derived part of its strength from the willingness of colonial administrators to recognize the power of preexisting indigenous political and cultural institutions and selectively use them to confer legitimacy to the colonial project. To illustrate such changes in the legal sphere, an extensive assessment of how the new laws shaped African societies, including in the Gambia, is needed.

In 1890, British traveling commissioner John Henry Ozanne received a message from the Alkali (Alkaide, Alikalo) of Salikenye village, Central Baddibu District, North Bank Region, that a man had stolen a girl from his town at night and carried her off to Dasilami village in Jokardu District.[2] The man who had kidnapped the woman and taken her to Dasilami had been married to the girl for nine years and had to pay ten cents to the father. For three years, he kept on paying at intervals small quantities of kola nuts, pagnes (wraparound cloths), and *coos* as partial payment of the bridewealth.[3] Then the father of the woman got impatient at not receiving the whole amount and took back his daughter. The husband went away to make money in order to get her back. After three years of waiting, the father married his daughter to a man in Salikenye, and they had lived happily together for three years, during which time they had two children.

While the second husband was absent from Salikenye, the former husband seized the opportunity to steal back the woman. Ozanne told the Alkali and Almami to summon all the parties and settle the case.[4] The Alkali sat next to Ozanne on a chair; the Almami sat on the ground with a large Quran opened in front of him. The Alkali, the Almami, and several people addressed the meeting all in the same way, stating that they must settle the case "patiently" and that they must "do justice."

> At first all went quietly, then the first husband began to speak, and was with difficulty suppressed. The father of the woman tried to speak but was interrupted by the same man joined by his friends. In vain, the *Alkali* tried to keep order, the whole assembly arose, and every man talked as loud as he could. At last the *Almami's* people chanted a song of dirge, which was gradually taken up by those present, and as the people sat down, they continued singing as if nothing had happened. For a third time, the trial went on, but it did not continue long before all were on their feet again, quarreling and talking louder than ever.[5]

The Almami then got up, shook Ozanne by the hand, and said that he was very sorry but that he could not go on with the trial. Ozanne told the Alkali to dismiss the people, and that he would decide the matter himself. Ozanne handed the woman over to the relatives of the second husband and told the first husband to return quietly to Dasilami. The man professed to be satisfied with Ozanne's decision and promised not to cause trouble again.[6]

This case draws attention to the ways in which the British colonial authorities reconfigured the legal terrain and forged new forms of relationships in Senegambia. It also points out the central role of the British as new adjudicators in the Gambia Colony and Protectorate. Although this episode took place outside of Bathurst, the story shows that prior to the introduction of the Muslim court in 1905, local people contended with marital issues and had mechanisms in place to resolve such issues. Also, the fact that the Alkali and Almami sat together indicates that these mechanisms were in dialogue with Islam.[7] It also reveals that Islam and Islamic jurisprudence were fundamental to the judicial culture, as can be seen by the presence of the Quran and the Almami—a culture that was introduced in the area with the arrival of Islam in the eleventh century.[8] The case also gives some indication of marriage patterns, as it includes the payment of bridewealth in cash and kind.

Why were the Almami and the Alkali unable to resolve this particular issue? Was it because of the presence of the traveling commissioner? Or did the local authorities, by the time of this incident, know that power was in the hands of the British? Or, did the traveling commissioner become impatient and interfere in the process? The traveling commissioner decided to hear the case to see how the local population adjudicated their cases, but the outcome of the case may simply demonstrate the influence that British colonial officials held in matters of administration among the colonized. This can also be characterized in ways similar to what George H. Karekwaivanane and other scholars view as the setting of a colonized legal stage on which Europeans and Africans entered into a dialogue. According to Karekwaivanane, law also played an important role in defining relations of power as it empowered rulers to "command and demand" while obliging Africans to "obey and comply."[9]

In agreement with what Richard Roberts succinctly described as the changes in "landscapes of power" in the early phase of colonial rule, legal administration was of enough importance to colonial officials that there were several instances in which they interfered with traditional rule and transformed African judicial

culture.[10] For Roberts, the courts became part of the judicial and legal changes that resulted from the encounter between French colonialism and the dynamic local processes of change predating European conquest. The central question for Roberts is how colonial institutions, such as the new courts that came into existence in 1905, contributed to transformations in legal and administrative matters in French Soudan and how Africans negotiated these new terrains. Roberts argues that in using these new courts, "women and men not only acted in their interests, but also forced subsequent changes in the landscapes of power in the French Soudan."[11] As can be seen in the Salikenye story, the dispensation of justice rapidly devolved from local rulers into the hands of the Europeans.

The Gambia: Historical Overview

Lying horizontally just south of the westernmost tip of the West African coastline, the Republic of The Gambia covers a total area of a little less than eleven thousand square kilometers. Lying at thirteen degrees north of the equator, it is situated within the Sahelian Zone and surrounded by Senegal on all sides except the Atlantic Ocean on the west. The climate varies, with a dry period from November to May and a rainy season from June to October. Temperatures range from 25 degrees Celsius in February to 35 degrees in June and may drop to as low as 15 degrees in December–January. Annual rainfall normally fluctuates between 1,000 and 800 millimeters. At present, the population of the country is about 1.9 million, with a birth rate of 3.35 percent.[12]

The Gambia River extends approximately 1,100 kilometers inland. It divides the country into two almost equal parts and winds serpentlike on its course, from east to west, along a 400-kilometer length of land to reach a width of 24 to 48 kilometers at the mouth of the river. Its source is the watershed of the Fouta Djallon highlands in Guinea. The Gambia River used to be the principal determinant of settlement patterns and agricultural activities in the Gambia, with large villages tending to populate zones parallel to the river where arable land is easily accessible.[13] During the rainy season, floods leave land close to the river fertile for agriculture, except for those areas inundated by the rise of salt water and adjacent to mangrove swamps.

Historically, the habitation of Bathurst is connected to the history of European presence on the Gambia River. From the middle of the fifteenth century to 1900,

the region was greatly impacted by the presence of Europeans and their desire to acquire colonies. Before Britain finally took control of the area of what is now Gambia, it competed against other European powers (including Portugal, and the Netherlands) in an attempt to control the larger Senegambia region and coastal trading posts; indeed, Britain and France contended for nearly five decades during the seventeenth century for political and commercial control of the region.[14]

From the beginning of the fifteenth century to the early eighteenth century, local inhabitants viewed European presence in the Gambia River as a kind of cultural spectacle. Stories of these early cultural contacts tell of how Africans were astonished by the presence of Europeans along the coast and by their mannerisms. For their part, Europeans are known to have expressed negative characterizations of Africans and their way of life.[15] European trading posts dotted the banks of the Gambia River and were found in villages and towns such as Albreda, Berefet, Bintang, Bwiam, Balangharr, Kaur, Fatatenda, and Kosemarr. The Portuguese maintained their presence in the river until the early 1700s, during which period the Europeans competed fiercely for the possession of James Island (now Kunta Kinteh Island), situated twenty miles from the mouth of the Gambia River. The early quarreling over the island ended with its cession to the English in 1713 by the Treaty of Utrecht, but competition between England and France for control of the island continued during the 1700s and did not end until the French abandoned it in 1779.[16] Control of the island was important because whoever was in charge of the island monopolized trade on the river.[17]

One of the main activities of the Europeans during this period was the trade in slaves to supply the labor demands of the New World. Merchants traded slaves, gold, hides and skins, beeswax, and a host of other products for European merchandise.[18] However, after the abolition of the Atlantic slave trade by the British in 1807, British attention turned to stopping the flow of the slave trade in and out of the Gambia River, a business that other Europeans and their African counterparts continued to operate. It became necessary for the British to find an alternative location to James Island that was more suitable to enforcing antislavery legislation and to firmly securing British commercial interests along the river. Banjul Island, known to the Portuguese as Saint Mary's Island, located at the mouth of the Gambia River, became a perfect site for the purpose of guarding the mouth of the river and the British settlement.[19]

Contested Terrain: European-African Relations

As previously noted, the dispensation of justice rapidly devolved from local rulers into the hands of the Europeans. In 1893, barely three years after the Salikenye incident, in his reports of the South Bank Province, another traveling commissioner reports:

> With regard to [the] nature of jurisdiction it has been the custom for all complaints to be made to the Alkaide who holds courts or councils and orders the offenders to be punished. The Alkaide's eldest son holds the appointment of chief constable and has to see that the punishments are all carried out. In very few cases the Alkaides refer the cases to the chief. The Alkaides now fully understand that they have no power to settle cases in their towns, all cases have to be referred to me.[20]

This is testimony to the fact that the British had assumed new roles for themselves as referees in the administration of justice, or more equivocally as "controllers of customs" in the dispensation of justice, because all matters of law rested with the British.

In one report, the traveling commissioner of South Bank Province notes that "Though the local people objected at first to these British interferences, after some explanations, the people seemed satisfied and pleased that the government had come forward to help them. The *Alkaides* seemed specifically pleased at the idea that the responsibility of punishing their own people has been taken out of their hands." The commissioner adds, "The domestic quarrels, the laws of the Quran, seem well drawn up to satisfy both parties in these quarrels."[21] Here, it is shown that by this time, the British accepted the rulings of the ulama based on the Quran, but at the same time used their personal judgment to prevail on decisions made by local judges.[22] The passages further confirm the point that matters of jurisdiction were slipping away from traditional authorities to the new British rulers.

What is also apparent in these reports is that judicial authority traditionally had two main pillars: the Alkali and the Almami. The dispensation of justice in Muslim communities in the Gambia rested with the Alkali. The majority of people outside of Bathurst continued to rely on these traditional administrative structures, which were found in every village. Traditionally, the Alkali was the first stop in the adjudication of cases concerning family and land matters. It was the Alkali who gave permission to others who wanted to settle in his village, and it was he who

distributed land to the new arrivals. The Alkali also exacted and collected taxes and mobilized labor for the clearing and improvement of roads, causeways, and rest houses, particularly after the implantation of colonial rule in the late 1880s. The Almami, on the other hand, adjudicated disputes according to the dictates of the Quran. He was the most recognized religious leader of the community and usually presided over cases relating to marriage, divorce, and child custody because he solemnized births and marriages. The Almami also taught the Quran, led the community in prayers, and provided spiritual protection and guidance to the community.

In addition, the Almami had moral authority over the village community as the custodian and guardian of secrets connected with the making of amulets and charms, divination, and possession of mystic knowledge.[23] Seventeenth- and eighteenth-century English traders and explorers in the region mentioned the works of some marabouts in their reports. Richard Jobson commented that clerics had "free recourse through all places, so that howsoever the kings and Countries are at warres, and up in armies . . . still the Marybucke is a privileged person."[24] Mungo Park, traveling through the Gambia in the 1790s, was told that amulets could protect the owner from snake and alligator bites, hostile weapons, and thirst and hunger, and were generally worn to garner the favor of superior powers under all the circumstances and occurrences of life.[25] These marabouts were much sought after already in the nineteenth century because they knew such techniques as bleeding and leeching, they gave hot vapor baths for fever, and they were skilled in setting fractures and ensuring success in any enterprise.[26] More recently, historians of Senegambia have also commented extensively on the role and authority of clerics in the region.[27] Seemingly, marabouts continued to enjoy a rise in their prestige based on the large numbers of followers they attracted and the material wealth they accrued as a result of the belief that marabouts could fulfill the spiritual and material wishes of their followers.[28]

The Factor of Islam: Conquest and Adaptation

After the arrival of the religion in the eleventh century, Gambians, like many other Africans, accepted Islam. By the early twentieth century, Islam had become the dominant religion in the Gambia. Islamic institutions were functioning in many villages and towns, which flourished under the guardianship and teaching of

Islamic scholars. One of the clerical groups especially influential in the spread of Islam were the Jakhanke. Lamin Sanneh explains that the Jakhanke are a specialized caste of mostly Manding-speaking Muslim clerics and teachers who had, over a period of several centuries, identified with a vigorous tradition of Islamic scholarship, education, and clerical activity.[29] Islam diffused steadily through education, which mainly included the study of the Quran, the teaching of the Arabic language, and the ways and manners of Muslim life.

What also facilitated the spread of Islam in the region was the series of wars (1850 to 1901) fought mainly between the Soninkes, who followed traditional religious practices, and Muslim clerics and their followers, mostly scholars and reformists. Donald Wright, who has done extensive work in Niumi, the location of some of the most severe fighting between Muslims and "unbelievers" in the Gambia, recognizes that "the most important period for the religious spread in the state had been in the middle of the nineteenth century, when the wave of Islamic reform, abetted by the social and economic change that accompanied peanut production, swept through, slowed only by the British interference."[30] One of the key leaders of this aggression was Maba Diahou Ba (1809–1867), who waged a series of wars in Baddibu and Niumi (north of the Gambia River). Al-Hajj Umar Tall, the main catalyst for the spread of Islam in West Africa, was said to have met Maba, and Umar gave him the responsibility to enforce Islam, a duty that only kindled Maba's desire to wage war on his non-Muslim overlords.[31]

Wars between the clerics and nonbelievers continued on the south bank of the river with clerical leaders such as Foday Kombo Sillah (1830–1894) and Foday Kaba Dumbuya (1818–1901). Of the two, Foday Kaba, who came to dominate much of the south bank, had the longest reign of all the Muslim leaders, and his death in 1901 saw the complete stop of armed religious conflict in the Gambia. While Kaba was trying to establish his rule over the Gambia and parts of Senegal, another Muslim leader, Musa Molloh, living in the upper south-bank states, was also solidifying his rule.[32] The defeat of Foday Kaba and his supporters on the south bank of the river signaled the end of militant reforms in the Gambia and an end to confrontations between the Muslims and non-Muslims. This outcome gave the British a pretext to declare the whole of the Gambia a British colony.

The British, like the French in Senegal, had fairly similar attitudes towards their Muslim subjects. Scholars such as David Robinson and Jean-Louis Triaud have examined the conditions under which Islam spread in French colonial West Africa. They have in fact gone further to argue that the French colonial administration in

West Africa designed an Islamic policy that Robinson dubbed a "path of accommodation."[33] In accommodating Islam, the French administration spearheaded the establishment of an alternative Muslim educational system. In return for the support of Sufi leaders, the French organized earlier and more aggressively to create a modern school system that would combine Islamic and Western education.[34] The French also built mosques, sent Muslim leaders on pilgrimages, and gave rewards to marabouts in order to secure the loyalty of Muslim subjects.[35]

In the Gambia, it is apparent that the British system of rule was ambivalent and less systematic. British administrators seemed to lack the confidence implied in the French practices. The British made strenuous efforts to pacify Muslim leaders and control the local populations. In doing so, some British officials endeavored to work with Muslim elders in Bathurst, and these leaders, in return, often supported the colonial system. I think of this British approach as a rather crude "charm offensive" when placed beside the French example.

A case in point that demonstrates the working relations between the British and some Bathurst Muslim elders involved Sheikh Omar Faye. In February 1940, Faye was asked by Governor Thomas Southorn to embark on a tour of the protectorate to explain to farmers and chiefs "that His Excellency the Governor has helped them to get the Home Government in London to spend on their behalf £150 to enable farmers to receive an increment in the price of groundnut bushel from 1½ shillings."[36] Faye's role in touring the country was to inform the Muslim farming communities about benevolent gestures offered to them by the British. Apparently, the governor had complained that he had "toured many trading towns and has found that some people have not clearly understood this assistance given them."[37] In a way, this case illustrates how the colonial authorities depended on the influence of Muslim elders to help them win the hearts and minds of the largely Muslim population.

To show his personal support for colonial ambition and the support of the Muslim communities, Faye, in his report to the colonial secretary after meetings with the farmers, wrote that "following my explanations, the majority of the people have very much appreciated this kind act of the imperial government through the instrumentality of His Excellency the Governor."[38] As such, both the colonial authorities and the Muslim communities by deed and words made conscious efforts to allay each other's fears. For instance, colonial authorities always insisted on "dealing with a united body of undivided Muslim Community."[39] In 1923, the Prince of Wales visited the Gambia and assured the Muslim community of the "freedom to worship the One true God," and extended a message of goodwill to Muslims for

their loyalty to the king of England.[40] On the other hand, the Muslim community had pledged loyalty as Muslim subjects of a Christian government. Clearly, the colonial state always pledged neutrality in intra-Muslim disputes and upheld that the government could not intervene in religious matters except where there was a breach of the peace.[41]

Another example of the symbiotic relationship between colonial authorities and Bathurst Muslim elders was the saga of the Income Tax Bill of 1940. The Muslim community largely opposed the enactment of the bill because they found it exploitative and unnecessary. For example, it was alleged that the venerable imam of Bathurst was called upon by Governor Southorn "to pledge his support and that of the Muslim Community to the Income Tax Bill, to make it acceptable to the Muslim Community." Furthermore, the mutual relation reportedly extended to the Muslim community, generating support in the form of a petition to the imperial government in London "to shower more honors on the Governor and some of his associates to be promoted."[42]

Colonial attitudes toward Islam and Muslims varied from one conquered territory to another. The French in particular literally divided Islam between *Islam arabe* and *Islam noire*, simply, divisions between Arab and black Islam. According to Jean-Louis Triaud, the French equated Islam with barbarism and fetishism. "Islam was the vector and sign of backwardness, as compared with the industrial societies," he noted. "In the context of Black Africa, the place it occupied was different and more complex. Islamic culture was judged, on the one hand, to lag behind Western Civilization; but on the other, it was seen to be in advance of sub-Saharan societies designed as 'fetishistic.'"[43] As some colonial officials became more familiar with Muslims and their institutions, the religion was seen as one that could be a bridge between the "savages" and the modern (Western) world as a civilizing force, based on its system of education and codified laws.[44] In West Africa, Islam was at times seen as hostile to European colonization, and there was fear of Islamic militancy. Senegambia had seen attempts to spread Islam by militant Islamic leaders who attempted to impose theocratic states. Fear and anxiety about a potential Islamic backlash in some ways shaped British-African relations. Lovejoy and Hogendorn note that colonial officials closely watched radical Muslim preachers after the Mahdist uprisings in northern Nigeria and adjacent regions of French Niger and German Adamawa between 1905 and 1907.[45]

These patterns explain why European colonization and the seemingly contrary trend of Islamization flourished together: the colonizers understood that one

needed the other, and no one understood this better than the French. Whatever the circumstances in the Islamization of West Africa, it is clear that by 1900, Islam had become the dominant religion in the Gambia; clerics had established their own villages to teach the Quran and further spread the word of God. This was the case in Bathurst as elsewhere in the colony, especially after the British conquest of the region in the early twentieth century.

The Dual Legal Terrain: Sharia and English Law

The administration of the Gambia Colony and Protectorate, like many British colonies with Muslim subjects, had two modes of governing. In colonial Gambia, in addition to a separate legal system for Muslims in the colony, the British also had a legal system for non-Muslims, and these systems were replicated in the protectorate. In fact, in the native courts that were set up in the protectorate, a mixture of customary laws, sharia, and English law held sway.

As a result of the uneven legal terrain, issues at hand were not always clear-cut, especially when they impinged on English law. For many Africans, the boundaries between English law and sharia were not clear; on the contrary, they were often complex and confusing. Certainly, the advent of native tribunals did not mean that the local inhabitants had no alternative judicial or dispute-resolution mechanisms. For example, in his report of 1903, traveling commissioner A. K. Withers of the South Bank Province noted that "in Western Jarra, only one case was reported and heard by the court, this was a case of assault and was dealt with by me. The absence of court cases in this district does not show that there is no crime, but rather that the people and the head men settle cases themselves."[46] In another note, another commissioner wrote that "the complicated situations and claims which so frequently arise in connection with the inheritance, marriage dowry disputes are much better and more easily dealt with by a good native tribunal than by a European, who however long he may have known the people can rarely hope to fully understand all the intricacies of these cases."[47] As such, even when the Muslim court was created in 1905, the British continued to struggle to understand how Islamic law was to be interpreted.

The implementation and enforcement of colonial law was difficult due to lack of resources, and in terms of judgment because of the problem with translation. Archival records and oral sources from the Gambia show that the colonial legal

terrain was greatly influenced by the presence of the British and locals who worked in the colonial system. In fact, some Gambian colonial officials, such as chiefs, took advantage of the weaknesses in the law and made their positions a source of personal aggrandizement. Other local Gambian colonial officials would use personal contacts with British colonial agents working in the Gambia in order to gain favors. Some would exploit the fractures within the colonial law to abuse the population under their control, only to escape the wrath of the "new" laws by fleeing to French territory.[48] For example, in 1920, Chief Abdoulie Janneh was indicted for embezzlement and dereliction of duty. He was accused by the traveling commissioner of frequently fining people without accounting for the fines, presumably using the funds for his personal well-being. However, Janneh escaped the full penalty of dismissal and reimbursement by appealing to R. H. H. Whitehead, traveling commissioner of MacCarthy Island District, with whom he had developed personal ties. In a memo from Whitehead to the colonial secretary dated February 10, 1921, Whitehead asked for clemency for the chief, saying: "He has made effort and has accomplished some improvements in his districts, especially in Kaur. May I suggest that His Excellency the Governor will consent to a part remission of the fine from £80 to £63."[49] This case could stand as an example not only of the need to understand the role of individual officers in carrying out the "colonial project" but also of how some individual Africans used colonial rule to their advantage. Understanding colonialism requires looking at the individual lives of colonial agents. These agents are usually assumed to have been at best insensitive, clumsy, and unappreciative of the cultures in which they were privileged to work; at worst, they aided and abetted the gross extension of preexisting patterns of heartless exploitation.[50] Here, the commissioner made his appeal despite mounting evidence against Chief Janneh for his corrupt practices and abuse of office.

Also, what made the implementation of European law significant were social and cultural relationships, matters that affected the rulings of the local judges and their assessors. At times, popular feelings and relationships in the colony could find their way into the courtrooms and influence the outcome of cases, particularly cases tried by a judge and jury. For instance, Governor Cecil Hamilton Armitage, in a letter to the secretary of state for colonies dated April 18, 1924, describes a situation in which a local man suspected of stealing a pair of trousers from a European's house in Bathurst was acquitted and discharged by a jury comprising ten Africans and two Europeans, despite the overwhelming evidence of the guilt of the accused.

For this case, the prosecution had two witnesses: Mr. Mathias, the plaintiff, and his domestic servant. The only witness for the defense was the accused, who said that the plaintiff had invited him into the house and had taken the trousers from under a table, telling the accused that he had stolen them, and then had had the accused arrested by the police. As a result of the illogical ruling, the legal adviser made an application to the Supreme Court for cases to be tried by assessors instead of juries. This was because, in the opinion of the legal adviser, ethnic and racial factors influenced the judgment reached by Bathurst juries, "to make them indulge in such vagaries."[51]

In fact, such examples show the influence of tight-knit social relationships on the outcome of cases in the native tribunals or in the courts. Many of the native court jurisdictions were rather small, such that acquaintances or relationships could strongly influence the dispensation of justice. Rigid social relationships thereby further complicated the impartiality of the justice system. For instance, in cases where a chief presided over a case and imposed a fine on an offender who belonged to the griot group (the traditional bards), the chief was obliged by tradition to pay the fine on behalf of the griot. In other cases, if a chief fined a poor person, the griot could implore the chief to pay the fine, saying, "You know that this person is poor but yet you put such a heavy load on him."

Another case that shows the complexity of the jurisdiction of the Muslim court versus English law courts concerns whether a particular act constituted bigamy or not. Under English law, bigamy in colonial Gambia was considered a criminal offense, whereas it might not have been an offense under sharia. Under sharia, women could marry only one husband, while men could marry more than one wife. However, men could not marry a previously married woman whose earlier marriage had not completely ended. Sharia stipulates that for a marriage to be valid, any previous one must have been dissolved.

According to one case, on February 11, 1936, before I. C. C. Rigby in the police court at Bathurst, the accused Fatou Ture, a Muslim woman, was charged under the criminal code that sometime between the first day of October 1934 and the second day of January 1935, in the town of Bathurst in the colony of the Gambia, she married one Demba Danso during the lifetime of her husband, Almata Suso. The preliminary investigation started on February 10, and after the close of the prosecution's argument, the defense submitted that there was no case to answer on the grounds that the evidence did not satisfactorily prove that the marriage between the accused and Almata Suso was valid according to Muslim rites. Further, it was

not a valid marriage as known and recognized in English law or by the criminal code such that a charge of bigamy was warranted.

The police magistrate judged that there was a prima facie case and that he was going to commit the accused to the criminal sessions of the Supreme Court. Council for the accused, Davidson Carroll, submitted that there was no case that could be brought before a jury and that there was no evidence that the accused had committed any offense of which she could be lawfully convicted on the information upon which she was being tried. Mr. Carroll reasoned that

1. The section of the Criminal Code 153, under which the accused was charged, did not apply to polygamous marriages.
2. If it did, the prosecution had failed to prove that the first alleged marriage was valid, even in Muhammadan law.
3. The evidence of the prosecution showed that there had been what amounted to a valid and effective release.
4. The ceremony of the second alleged marriage by reason of the fact of it having taken place in Bathurst was not a "ceremony of marriage" known to or recognized by the laws of the colony as capable of producing a valid marriage.[52]

This story illustrates that the relationship between English law and sharia law was at best precarious because it was sometimes difficult to understand where one ended and where the other began. This particular case did not stand a chance in the English courts because, according to the Christian Marriages Ordinance of 1882, the only marriages recognized under English law were Christian marriages done in Bathurst; the litigants here were Muslims. Hence, why were such cases between Muslims on marriage not committed to the Muslim courts? Were the complainants aware that the English court would have been more sympathetic to their case, or did they simply overlook the Muslim court as capable of such arbitration? Moreover, what do such cases tell us about the relationships between European and Islamic laws and how the local population perceived these laws?

To appreciate fully the dualism of law during colonial rule, I turn to two more cases. At times, obscurities in English law when compared with Islamic law prompted some Africans to attempt to negotiate between the two in order to exploit limitations or loopholes. For example, in 1968, a case was brought before the Gambian court of appeals involving a monogamous marriage and the

husband's subsequent Islamic marriage to another woman—specifically, whether the relationship with the second wife constituted adultery, thus providing grounds for the dissolution of the first marriage.

In 1956, the appellant, Abdoulie Drammeh (the husband), was lawfully married to the respondent, Joyce Drammeh. Both parties then professed the Christian religion; the marriage was conducted in Britain. In July 1966, when both parties were living in Gambia, the wife presented a petition to the Supreme Court of the Gambia for the dissolution of the marriage. Her petition was submitted on the grounds that her husband had committed adultery with Mariama Jallow (who was a corespondent). The husband and the corespondent had been married in a Muslim ceremony in 1966. The case was heard by the chief justice, who held that the wife was entitled to have her marriage dissolved on the grounds of her husband's adultery committed before the date of the petition. A decree nisi (a civil court order—in this case, divorce—accepted in Islam) was pronounced. The husband appealed to the Gambian court of appeals, but the appeal was dismissed.[53]

A similar case brought before the Supreme Court of the Gambia involved Prime Minister Dawda Kairaba Jawara and his wife, Lady Augusta Jawara. The prime minister sought to divorce his wife following his conversion to Islam and her refusal to be converted in turn. Lady Jawara had earlier sought an appeal against a lower court ruling allowing her husband's petition for divorce. One of the results of this legal tussle was the enactment of the Dissolution of Marriages Act (1967), which was meant to make Sir Dawda's divorce claim a legal fait accompli.[54]

Although some of these cases came before the court during the years of Gambia's independence, they nonetheless show how litigants navigated the dual legal terrain of Muslim or sharia law along with British law in their efforts to find a legal exit from untenable marriages. The cases further illustrate the complexities that can arise from religiously based marriages, especially when one of the spouses wishes to revert to their former religion in order to allow a polygamous marriage life. Most importantly, the cases show that legal pluralism continued even after independence in 1965.

Native Courts: Parameters and Functions

To understand fully the rigors of navigating this legal dualism requires turning attention to native courts. Understanding the functions of these courts brings

clarity not only to how the law was applied but also to how the new law ignited changes in the general Gambian society. At the Berlin Conference of 1884–1885, European colonial powers agreed on ground rules concerning how to lay claims to territories under their control in Africa. The conference was also aimed at avoiding any military confrontation among the colonial powers in what has been called "the scramble for Africa." The British had controlled much of the Gambia long before 1884, but it was not until 1889 that the first Anglo-French Boundary Commission arrived to begin demarcating the borders between present-day Gambia and Senegal. Their work was not completed until 1904. The delay was largely due to the ongoing Muslim revolutions in the region (the wars between believers and nonbelievers, and also between leaders of these revolts and Europeans, during the 1850–1901 period). In 1893, in the midst of these upheavals, a protectorate system was declared, and districts were created out of the former precolonial states headed by chiefs who were appointed by the colonial governor. Treaties were signed with most of the local chiefs, who remained under the supervision of traveling commissioners.[55] During the period in which the Gambia remained under British rule, the British established legal institutions and apparatuses to administer the colony and protectorate in the name of peace and order. The British established a Muslim court in the colony and native courts in the protectorate.[56]

It should be stated here that the parameters and functions of these courts were not much different from similar courts in other parts of Africa, although the history of how they came to be established in the Gambia and their reliance on custom and tradition were somewhat different. Kristin Mann and Richard Roberts indicate that the early histories of African countries differed in significant detail, and that these differences affected their legal systems.[57] In the interest of tradition and custom, all the colonial territories and subjects had distinct social and cultural practices, making the administration of the courts dissimilar from one colonial region to another. The history of the native courts should be understood within the contexts in which they were created in their respective regions.

The evolution of native tribunals—the eventual codification of customary laws and the official recognition of traditional tribunals transformed into native courts—occurred during a period of increased British involvement in local affairs. Although the British administrators left the task of adjudication to local authorities, the British always maintained their presence through governors and commissioners. In the Gambia, the British initially had two traveling commissioners (a number that was subsequently increased), one for the north of the

Gambia River and one for the south. The role of the traveling commissioner was to advise the native courts and to administer the area under his jurisdiction. It is interesting that only the Gambia, out of all of Britain's African colonies, had traveling commissioners, because of the colony's low budget and its geography. Originally, the British would only pay for two commissioners, and because the Gambia was long and narrow and divided into two regions by the Gambia River, they had to travel to be in touch with chiefs.

The advent of native tribunals did not mean that the locals had no alternative judicial or dispute-resolution mechanisms. Certainly, local people dealt with these "new" trends with apprehension and uneasiness. For instance, as early as 1898, traveling commissioner Waine Wright, in his report to the administrator in Bathurst, noted:

> As your Excellency is aware in former times it was of all the old people [*sic*] to congregate when a case was being tried when each individual has something to say with reference to the case on hand. This has proved in some instances a continued hindrance to the native tribunal when sitting and the people have with difficulty been made to understand that only the native tribunal can be allowed to judge the case. However, now that they see that justice is done it is hoped that this hindrance will be a thing of the past.[58]

Wright's statement shows that the establishment of the "new" administrative structures was a slow and difficult process for the European officials because local people continued to be attached to the traditional judicial system. For example, in his report of 1903, traveling commissioner A. K. Withers of the South Bank Province noted that "In Western Jarra, only one case was reported and heard by the court, this was a case of assault. The absence of court cases in this district does not show that there was no crime, but rather that the people and the head men settled cases themselves."[59]

In a similar report, Traveling Commissioner Wright for the South Bank also showed his frustration by reporting that "The establishment of the native courts in Kiang and Jarra have been carried out but as of yet have not got into working order—but that could not be expected—For whatever the case or dispute they are likely to take days over it. All the headmen and others must have their say."[60] Clearly, Wright shows his disrespect for the traditional adjudication systems in place and even suggests that justice would be difficult to attain in these local

tribunals. The reports show that local people were also grappling with this phase of transition—from "the old order" to "the new order."

Colonial authorities, or the men on the spot, went to great lengths to work with local leaders. In particular, Waine Wright regularly toured his area of administration, imploring leaders of local tribunals to be steadfast and remain loyal to the British. In his annual report of 1899 to the governor, Wright reported:

> With reference to native courts, I have much pleasure in informing your Excellency that the people on the whole appreciate these and are gaining confidence daily: In some districts they work very satisfactorily, where the native tribunal have taken the trouble to learn some of the protectorate ordinances—of course there is still plenty of room for improvement, especially in other districts where I am afraid that they still settle cases in their native ways: It has been very difficult to get these courts to understand the ordinances as they can neither read nor write. However, I am pleased to say that they have shown a decided improvement during the past eight months.[61]

Despite these improvements, local people were still struggling to adjust and adapt to the native court system. One of the main issues was the question of codification, as, according to the commissioner, the natives could not read or write. The British colonial officials made efforts to translate the "new" laws into local languages to facilitate understanding of the ordinances and their adaptation in the native courts.[62] In one of his reports, Traveling Commissioner Wright noted:

> With reference to native courts, I have pleasure in stating that the routine is now generally established, more especially in two districts under my supervision. There however remains much to be desired in two other districts. It is to be hoped however that considerable progress will be made next year as then the "order in council" written in the Mandingo language will be distributed to each tribunal.[63]

This is one example showing that, despite difficulties in changing Africans' perceptions of the native courts, colonial administrators made efforts at codification and "translating the message" for a better understanding of native court rules and procedures. Traveling commissioners were also instrumental in defining and shaping not only the legal terrain but also the local social, cultural, and political

landscapes. In the realm of law, the British colonial agents took it upon themselves to cancel or change decisions made by the traditional authorities.

Another important task of the traveling commissioner was the settling of boundary disputes between villages, disputes over farmland, and even disputes about the border between French Senegal and British Gambia. In his reports, traveling commissioner Emilius Hopkinson noted: "I went to Mbolett village and dealt with cases about the boundaries and laid down some sort of general ruling about prior rights etc., and that these new towns could not expect to increase at the expense of the old ones, their original landlords."[64]

These are clear examples of how colonial agents transformed and shaped the legal, cultural, and political landscapes of the Gambia. The examples also show the judicial function of the traveling commissioners in the protectorate within the ambits of the native court tribunal system. The examples further illustrate the advisory role of the traveling commissioner over the judgments and decisions of native tribunals.

To further entrench their control over the protectorate, the British introduced the Native Tribunals Ordinance in 1902 and again in 1933. This development was important in transforming the legal landscape in two ways. First, it solidified legal rules and procedures.[65] Second, it established boundaries curtailing Africans' capacity to maneuver within legal processes. For instance, the 1902 ordinance created native tribunals for each district that had jurisdiction over both civil and criminal matters in the district. Tribunals had a membership of between three and seven individuals selected by the governor. The size of the tribunal depended on the size of the district, such that small districts like Nianija had only three members, while Illiasa had a full house of seven. The chief sat in the tribunal as president, and in case of a tie in votes as to a verdict, he was given a "casting vote in addition to his original vote." In criminal cases, the native tribunal had the power to hear cases that the police magistrate in Bathurst and other parts of the colony would ordinarily have heard. In civil cases, the native tribunal could hear cases that the Court of Requests in the colony would have been able to hear. For the native tribunal to be competent to hear a case, the defendant or one of the defendants would have to be a resident in that district. The commissioner could sit on the native tribunal, and he had the power to overturn any of its decisions that he deemed inappropriate. This is another indication of the considerable power invested in the commissioners by the ordinance.

According to the 1933 ordinance, a tribunal was composed of the chief and two other members and held court sessions at least twice a month. At the end of every month, the tribunals would continue to report cases to the commissioner. Fines assessed in criminal cases would still be paid to the government through the commissioner, and it would remain at the discretion of the tribunals to award compensation out of fines in such cases as assault and seduction.[66] In addition, the tribunal was to keep a book showing all fines paid. If the tribunal thought that a defendant was too poor to pay, it could make a note to that effect in its book. Also, a warrant would come from the governor telling the tribunal the circumstances over which it had power, what kinds of cases it could try, and other matters. Insofar as the tribunal had this warrant, its powers were legal. In case the tribunal was unable to carry out its duties according to the letter, based on the advice of the commissioner, the governor could curtail the powers of the tribunal.[67]

The native courts had the power to try both civil and criminal cases, but not cases considered "repugnant," such as murder and serious bodily harm. In all matters, civil or criminal, the tribunals were to use the procedures of Muslim law or native custom, except when they were trying cases for offenses against the law of the colony or protectorate. The tribunals were expected to try criminal cases for crimes that had taken place in their districts or close to their districts. Civil cases were to be heard by the tribunal of the district in which the defendant lived, or in whose district the dispute had first arisen. As for land-related cases, the tribunal of the district where the land was located was to be used. The governor retained the power to promote or demote a tribunal from one category to another depending on the competence of the tribunal. In criminal cases, tribunals could choose between imprisonment or corporal punishment (whipping). Imprisonment and fines had to be "sufficient" to the crime. In such cases, the commissioner could reduce a sentence, but would only do so if he felt the punishment to be cruel or unjust.[68]

The ordinances also gave power to any person to ask to be tried by the commissioner, but if the commissioner wished, he could send that person back for trial by the tribunal. Also, any person on trial could object to a certain court member hearing the case. If anyone made this objection, the tribunal could investigate and determine the cause of the objection, and if the cause was deemed legitimate then that court member was ordered not to render a decision on the case. This could mean that the case would have to be adjourned until a new member was found. More importantly, it could also lead to the commissioner using his power to try the case and impose fines as he deemed necessary, without the involvement of any

member of the tribunal. Sometimes, the ordinances created friction and tension in the community because litigants sometimes took advantage of the promulgations to accuse tribunal members of bias, especially if there had been past disagreements between these litigants and some members of that tribunal.[69]

Examples of cases that could be tried by the tribunals fall under the following categories:

CRIMINAL CASES	CIVIL CASES
Theft	Death
Assault	Marriage
Seduction	Divorce
Abusive language	Guardianship
Escape from custody	Dowry
Disobeying a lawful order of a native authority	Parentage[70]
Any cases formally allowed to be tried by a tribunal[71]	

The tribunal had the power to adjudicate twenty types of offenses, ranging from assault, defamation, seduction, sorcery, and witchcraft to the beating of drums without the permission of the village chief or headman. Chiefs collected fines imposed by the native tribunals and handed them over to the commissioner, who paid them into the colonial treasury. For many districts, such fines formed the bulk of their revenue, and in the 1940s, when district treasuries were established, court fines formed a source of revenue for district development projects.[72] Court records were taken in ajami—local languages written in Arabic script—until court scribes literate in English became widespread in the districts.

The efficiency and prestige of the native tribunals sitting as criminal courts had been a problematic issue for colonial administrators. Even though judgments were handed down, they were often not enforced, with some judgments lying dormant for as long as three and four years.[73] At their inception, native tribunals may have relied excessively on traditional conflict-resolution mechanisms in adjudicating between litigants, and as a result, many cases were left unattended.

Civil cases in the native courts mainly involved debt, and these were of two types: those between two individuals, and those between an individual and a trading firm. For the first, whether a judgment was enforced or not was not of great concern; the plaintiff would still have the satisfaction of having his debt recorded. Plaintiffs in the latter, on the other hand, were not content merely to have debts recorded;

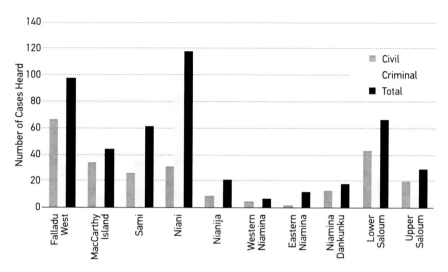

FIGURE 2. Cases Heard before Native Tribunals by District, 1943.

SOURCE: NRS, ARP 34/1, 1943, DIVISIONAL REPORT.

they required the debt to be paid to enable them to square their accounts. Here, it can be seen that the British were keen to support traders and private firms, as trading was a primary British interest in the colonies.

In another development, a provincial court ordinance was enacted in 1935 to try criminal cases in the protectorate in a court presided over by the commissioner, assistant commissioner, or police magistrate. The ordinance set out the grounds upon which the Supreme Court might order the transfer of a civil case pending before a provincial court to another court; such an order would satisfy the "more speedy and satisfactory administration of justice."[74]

However, a few years after the enactment of the ordinance, a colonial legal adviser complained that "owing to their length cases heard before a provincial court occupy a considerable amount of the time of the Commissioner who has many other matters to attend to. Secondly, some cases before a provincial court are of complex or difficult character which necessitates the professional experience of the Police Magistrate."[75]

As figure 2 shows, the native courts were busy, particularly in Fulladu West, MacCarthy Island, Niani, and Lower Saloum Districts. What is interesting about these numbers is the amount of criminal cases. At the outset, native tribunals were not given the power to deal with criminal cases, but some of these cases filtered

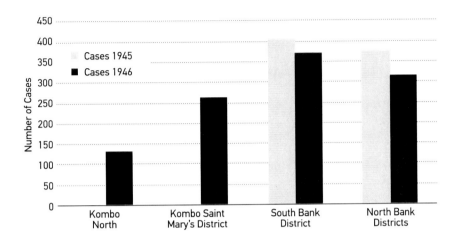

FIGURE 3. Native Tribunal Cases for Various Districts, 1945–1946.

SOURCE: NRS, ARP 34/4, 1946, DIVISIONAL REPORT.

through the courts nonetheless. This demonstrates that although the laws could be changed, Africans could alter the way they were applied on the ground. The courts were also popular because they were often nearby; Bathurst, where all criminal cases had previously been heard, was a long way from many districts. Moreover, the native courts were seen as more impartial in their judgments because of the Europeans' presence.

From the records, the provincial courts became busy immediately after their inception. For the first quarter of 1936, in North Bank Province, the provincial court heard seventeen criminal cases and seven civil cases.[76] The colonial authorities were particularly concerned about the size and jurisdiction of native tribunals. In Upper Saloum, the traveling commissioner advised that the number of members should not be more than was necessary for the efficient administration of justice, and that a panel should not be enlarged for political reasons. "The local areas of the native tribunals are generally speaking of small local jurisdiction and therefore tend to be far too parochial, and the members of the tribunals are often intimate of the parties to a case before they come to adjudicate and a stranger cannot therefore always be sure of justice."[77] Considering that most of the districts were small, comprising close-knit extended families, these factors were bound to have an impact on the dispensation of justice.

An important aspect of the courts was the issue of court fees and fines. According to the native court ordinance, there were no court fees, but under the regulations enacted under the protectorate ordinance, a native tribunal could require a complainant or litigant to deposit a sum not exceeding four shillings to cover the cost of service of any summons or any preliminary expenses; and, after a case was decided, the tribunal could order costs to be paid to cover witness expenses. Court fees were intended to meet the cost of any clerical staff of the court, but because no such staff was required in the native tribunals, no expenses were incurred and there was no need for court fees.[78]

Governor Herbert Richmond Palmer, writing to the secretary of state for the colonies in London, suggested that members of the thirty-seven tribunals in the protectorate be paid regular salaries rather than being paid for court sittings. He proposed that in each tribunal, the president and three members, including the clerk, should receive salaries fixed according to a ranking of the tribunal as grade A or B, depending on the volume of cases and the quality of the work of the tribunal. For example, on a Grade A tribunal, the president would receive £12 per annum and each member £3 per annum. By compensating chiefs and clerks as salaried workers, the British were hoping that these native tribunals could become more effective and productive, but even so, the British could count on the support and loyalty of the chief, other members of the tribunal, and the clerk. In short, through this policy the British fostered allegiance to the colonial state. Also, by dividing the tribunals into grades, the British set standards by stipulating what was important. While the composition of the native courts on paper consisted of the head chief as president and at least three other headmen, in practice the traveling commissioner could preside over the court in whatever district he found a court sitting or a case pending.

Conclusion

In the Gambia, traditional judicial systems changed under British colonialism.[79] Colonial legal advances transformed both the legal and physical terrain of what is now the Republic of The Gambia. The introduction of native courts, ordinances to sanctify the courts, and the physical presence of British officials on the ground curtailed African legal practices that had previously dealt with local administrative matters. Scholars have discussed the ways in which colonial officials hurriedly put together European and African legal systems and appointed leaders whom they

saw as fit to run these legal institutions. These local courts were run by Africans and apply African customary law, but they did so in a manner consistent with basic British legal principles and the objectives of colonial administration.[80]

Islam played a significant role in shaping the cultural, social, and religious attitudes of Senegambians, including Islamic scholars and qadis. This implies that the worldviews of these scholars and qadis were shaped not only by Islam or what they read but also by their African backgrounds, cultures, and outlooks. Thus, while their interpretation of sharia was often based on Islamic legal precepts, their African values, norms, and beliefs informed their decisions to various degrees. It is also possible that these qadis, having lived in the city for a period of time, could have been influenced by the colonial context. Ultimately, colonial domination, although real, is difficult to discern because it relied to a significant extent on reciprocal relations between British institutions and local practices. These issues not only made the running of the colonial system difficult but also made it hard for Africans to navigate the contours of this new legal terrain. In any case, Africans had limited options of effecting meaningful and sufficient changes because they often negotiated from a position of weakness.

CHAPTER TWO

Marriage Laws in the Gambia: Traditions and Customs

This chapter explores the relationship between traditional and Muslim marriages on the one hand and laws regarding marriage enacted by British colonial officials on the other. It is essential to recognize that the line between African traditions and Islam is blurry and difficult to disentangle as a result of many centuries of interaction. Nonetheless, certain aspects of traditional and customary marriages affected how and why litigants behaved and acted in certain ways, particularly in matrimonial issues and in court. British colonial officials made attempts to regulate marriage by promulgating several ordinances aimed at curtailing abuse against women and minors. Some of these regulations came into effect as early as the 1860s. As we have seen, while traditional, Muslim, and colonial practices tended to militate against a strong position for women in society, the new laws and institutions introduced by the British helped women challenge certain elements of patriarchal power. This was especially true when the legal system intervened directly in the home and marriage to punish the abusive treatment of women by their husbands, who saw this abuse as a right grounded in some aspects of tradition.

However, a recognition of traditional and customary marriage practices must grasp how such practices complicated or facilitated divorce in the qadi court. Also,

it is important to understand how these practices changed during colonial rule. To appreciate these changes, some examples are required:

> On June 21, 1934, Kumba Sey brought a case against Mamadou Jallow. According to Kumba, her husband had died, and Mamadou, her husband's cousin, wanted to marry her so he could inherit all of Kumba's husband's properties, including a large residential compound.[1]

In his testimony, Mamadou said that he and Kumba's husband were relatives. His father and the husband's father were from the same mother and father. The qadi asked Kumba to take possession of all her husband's properties, including the compound, and told Mamadou not to touch any of the deceased's properties, as he (Mamadou) could never inherit the deceased's estate.[2]

In another case, on July 8, 1952, Muhammad Beye brought his wife, Nyimanding Diko, to the qadi of Bathurst, complaining that after he married Nyimanding, he realized that she was four months pregnant by someone else. According to him, he did not disclose the matter to anybody, nor did he bother the wife with it because custom dictated otherwise. During this period, he gave her silver and shirts, and he fed her. He also bought for her a dress costing £2, 4s.; a three-meter cloth costing 10s.; and a dress costing £1, 4s. He also conducted the child's baptism at one pound, two shillings [*sic*]. He came to court to demand that the bridewealth he paid at the time of their marriage be returned to him.

In her defense, the wife denied her husband's allegations but agreed that she had received some goods from him. According to her, Muhammad gave her some kola nuts and 10s.; a dress costing £2, 4s.; another dress of £1, 6s.; a pair of shoes costing £1, 15s.; a scarf for 12s.; a piece of cloth costing 6s.; and another cloth of £1, 4s. In his judgment, the qadi ordered divorce but asked the wife to return £7, 18s. to the husband.[3]

It is clear from these cases not only that certain customs and traditions have deep roots in Gambian society, but also that these customs were given the power and authority of law through legal decisions. Furthermore, beyond the question of how women represented themselves in the Muslim court, these cases illuminate two important issues: how women used the courts to settle disputes within marriage, and what legal grounds women used to seek divorce. In the first case, the qadi relied on Islamic law, which gave rights to the woman (the litigant) to keep the properties left by the first husband. This represented a significant rejection of

tradition, clothed in the language of tradition. Had these issues been settled only by what tradition and custom dictated, the second husband (who was her first husband's brother) would have maintained control over both the woman and the property. Moreover, the outcome of the case varied from customs that stipulate wife inheritance (sororate marriage), where if a wife died, she could be replaced by her sister, and/or widow inheritance (leviratic marriage), where a man was obliged to marry his brother's widow. In the Gambia and in many parts of Africa, wife and widow inheritance is still common.[4]

In an interview with me, Alhagi Kantong Suware acknowledged the primacy of such traditional and customary values in marriage because of unforeseen complications that could arise in marriage, especially if it involves kin marriage. Alhagi Kantong reasoned that the traditions of wife and husband inheritance should be viewed from the position that they uphold the sanctity of kinship in that children born out of such marriages should remain with the husband's family line or kin group. In this way, tradition upholds such a system because it retains the upbringing of the children in the same family lineage.[5] However, these traditions could also be disadvantageous to women by the fact that when they refused to be inherited, they risked losing their husband's properties or parting with some of their children. Such women also might face the wrath of society as they could be characterized as "wicked women" because of their refusal to take care of their sister's children. Above all, these examples show that custom, tradition, and Islam are critical in appreciating marriage practices and how they are resolved in both the courts and in Gambian society in general.

In the second case, the husband did not disclose his wife's pregnancy because of his adherence to traditional values. However, he ultimately needed to break with tradition in order to get what he considered to be justice. In other words, in marriage, couples and families remained attached to customary laws and practices for the continuity of marriage or for its termination.

In the Gambia, the influence of custom and tradition is pervasive, especially in institutions as important to society as marriage and the family. Unfortunately, the court records do not provide information on how some of these marriages were arranged and coordinated between the men and women who eventually sought justice in the courts. And yet one cannot fully appreciate the public act of dissolving a marriage without also having some sense of its intimate and private origins in the lives of two people and their families.

Conceptualizing Traditional Marriage

The concepts of tradition and custom are complicated because of their seemingly endless reach through time, and because they are constantly debated. Some of the debate rests with ways in which colonial administrators in Africa went about reconfiguring African traditional practices for the functioning of colonial enterprise, and how African leaders used such practices to their own advantage. British colonial administrators, Terence Ranger has argued, invented African traditions for Africans through codification, thereby transforming flexible custom into hard prescription.[6] Other studies validate how those in positions of power have used tradition as a tool with which to subjugate the weak and marginalized in society. For example, Martin Chanock interpreted tradition as a set of devices employed by rural elites to enforce their claim on labor, specifically by elders over the young, by husbands over wives, and by property owners over domestic slaves.[7]

In this way, a link to certain traditions can endorse groups and individuals who maintained such traditions. When individuals, families, communities, or nations act in a "traditional way," we need to ask in whose interests it is to act this way, and who declares this to be "traditional." Also, because human societies are dynamic, so too are their traditions; this raises the question of why certain customs and traditions related to marriage persist to this day, while others grow weaker over time. This also means that tradition is not stationary but changing and dynamic. Why does tradition persist as it does in many African societies, especially in the area of marriage? What makes tradition particularly important is its longevity and endurance. Thomas Spear argues that tradition remains critical in understanding the historical processes of social change and representation.[8]

Anthropologists have long discussed the subject of marriage in Africa.[9] Tradition, custom, and Islam are viewed wisely as critical elements in the arrangement and dissolution of marriages. As indicated earlier, the Senegambia region has been part of the wider Islamic world for centuries, during which period Gambians have adopted and adapted to Islam and Islamic traditions. In this way, marriage practices such as issues of husbands' responsibilities toward their wives, divorce, and inheritance among Gambian Muslims continued to be done as enshrined in the Quran.[10]

For instance, in marriage, it is the husband's responsibility to support the family financially. In fact, the Holy Quran enjoins husbands to feed and clothe their wives and speak to them with words of kindness and justice.[11] Barbara Callaway also

indicates that "a man has not only moral but legal responsibility for the support of his family. The remedy for a non-support for a woman is divorce, which is granted by a qadi court and generally is not difficult to get."[12] Elke Stockreiter also concurs that since Islamic law attributes the role of sole provider to the husband, at least theoretically, marriage was a way for women to be maintained.[13] In addition, with regard to divorce, the Quran makes it clear not only that divorce is permitted but also that divorced women must be treated with respect and dignity.[14] In the Gambia, tradition supports the custom that husbands do not publicize the cause of divorce in order to protect women from harassment and to facilitate their remarriage.

Traditionally, marriage practices were not much different from what was inscribed in the Quran. As a result, what was traditional became Islamic.[15] Yet the qadis deliberated cases based on Islamic laws, but brought in other traditions and customary laws whenever necessary. In other words, in some cases, the qadi would refer the case back to the village where the marriage was arranged. However, in some instances, the qadi would decree divorce, especially when the case transcended the boundaries of marriage, or ask the litigants to reconcile if possible.

> For example, on June 7, 1934, Ousman Mbacke brought his wife Awa Bah before the qadi of Bathurst and complained that Awa left her marriage household and went to her mother. From there, she went to Brikama town. According to Ousman, Awa's reason for abandoning her marriage was that she was tired of the marriage.
>
> Awa in her testimony revealed that they had been married for many years during which she was constantly neglected, not well maintained, and not clothed by Ousman. She further disclosed that she reported the matter to her uncle, who advised her to be patient and stay in the marriage. Awa said that she came to court because she could no longer be patient.
>
> However, when the qadi heard the disputants, he asked them to reconcile and asked Ousman to take good care of Awa.[16]

Another interesting example was the case of Awa Fofana and her husband, Muktarr Senghorr. On July 22, 1952, Awa Fofana made claims against her husband in front of the qadi of Bathurst. Awa claimed that her husband did not maintain her well, providing no food or proper clothing, and that he did not even care about their two children. Also, she was pregnant at the time she pressed her case. Muktarr refuted his wife's claims and said that he routinely gave seven pounds monthly as required by tradition and Islamic law; he denied that the new pregnancy was his.

After seven months of marriage, the husband asked the wife in front of one Ousman, who told her that the pregnancy was *haram* (unlawful). They had been married for seven months, and the pregnancy was nine months old. The qadi asked the husband to give ten shillings to his wife for each child as their monthly sustenance and referred the case to the Police Court.[17]

In a similar case, on November 18, 1952, Haddy Sowe brought a complaint against her husband, Mbagic Mbayo. Haddy claimed that Mbagic had failed to maintain, clothe, or feed her for one year. Mbagic admitted his wife's allegations but said that he was poor and could not afford to maintain her. The qadi ordered divorce because the husband had failed in his responsibility.[18]

As can be seen in these cases, tradition and Islamic laws are key resources in the settling of disputes between husbands and their wives. In the first case, Awa behaved in the way required by tradition. That is, she reported the problem in her marriage to her uncle in an attempt to resolve the matter. In court, she was able to get the qadi's intervention for the husband to treat her fairly. In the second case, the husband also submitted himself to the dictates of tradition in fulfilling his responsibility as a husband, while the qadi ruled according to Islamic law by ordering the husband to support his estranged wife. However, it remains in doubt why the qadi referred the case to the police and not to the parents of the spouses so the case could be resolved traditionally.

The last case is a typical example of the exceptional difficulties that marriage presents for women, and also the conditions that led to their acceptance of the relationship even if they (the women) had to endure hardship. In this case, it is obvious that beyond the act of being granted divorce, there is little doubt that women suffered various types of mistreatments and also had to bear for a long period of time going without any source of maintenance while men could easily release themselves from the responsibility of feeding their families.

In traditional Gambian marriage arrangements, parents usually make the final decision. These preconjugal arrangements usually involve immediate parents and distant kin groups, and not the future couple. On many occasions, the bride and groom are not familiar with one another—no courtship takes place.[19] Among some groups such as the Fulani, Wolof, and Mandinka, marriage arrangements take place several years before the intended girl reaches the age of marriage. Among the Mandinka, the tradition of girls being married at a young age while they remain under their parents' custody is known as *londiroo* (to make it stand or wait, or betrothal) or *bulu mutoo* (to hold hands), during which the girl is obligated to marry

a cousin or some other person. In this arrangement, when both sets of parents agree, a piece of cloth is symbolically tied to the little girl's arms. This practice has long-lasting implications for the girl's and the boy's parents. The husband-to-be and his parents often see the young bride-to-be as an investment, and they assume the costs of bringing the child up and helping her parents. The traditional bond of *londiroo* guarantees that when the girl reaches the age of thirteen or fourteen, she can be married.[20] In such cases, divorce becomes problematic not only in the courts but also in the larger Gambian society because of the involvement of the extended kin group. And most importantly, when bridewealth is paid, it is usually shared among the wife's extended kin. Sometimes, how this money is to be paid back becomes an obstacle in the dissolution of a marriage.[21]

Furthermore, tradition and custom require prospective husbands to perform several years of labor for the intended wife's father, or pay bridewealth in kind or cash before a marriage can take place. This labor, although not mandatory, is essential in following the ethics established by tradition and custom, as tradition and custom are seen not only to bless the marriage but also to confirm to the girl's parents that the future husband of their daughter is a hard-working and responsible man. Such work might include helping the girl's parents on their farm, mending their roofs and fences, and giving them presents, items that can be considered bridewealth. Such bridewealth could be money or services transferred to the girl's parents by the parents of the husband-to-be in kind or cash before a marriage can take place. Bridewealth compensates the bride's kin for the resources that the girl's parents spent in bringing her up, and for both the loss of her future labor and the loss of her future children when the girl leaves the household. Therefore, marriage arrangements can be so expensive that when the question of bridewealth arises, it makes the issue of divorce difficult even today.

Further complicating marriage issues are a set of traditional marriage practices. Across Senegambia, a marriage custom exists that is known as "borrowing" (*fuuroo* in Mandinka and *ablee* in Wolof). In this case, the husband can ask for the wife or "borrow her" in order to live with her before the official marriage ceremony is organized. At times, it takes many years before the official ceremony takes place, during which time the couple might have children and the husband might even take another wife.[22] The following case is a classic example of how unpaid bridewealth can be a source of contention between a wife and her husband.

On March 17, 1952, Ancha Kouyateh brought a case against her husband, Samba Bah. Ancha alleged that Samba used to abuse her, and she came to court to know

whether she was Samba's wife or not. Samba in his defense denied abusing Ancha. Samba informed the court that he wanted to marry another wife but owed Ancha the remainder of her bridewealth. According to his testimony, Ancha refused to let him bring another woman to their house and she left her marriage household to go to her parents. Samba also reported that when Ancha left this time, he went after her at Jabou Sise's house, where they quarreled. Samba also said that he wanted to go to the police but was discouraged from doing so. When the qadi heard their complaints, he advised them to reconcile and respect the boundaries of marriage. Disputably, the wife showed a sense of awareness about her entitlement to the bridewealth and her efforts to claim it. However, since the records did not indicate whether the qadi ordered the husband to pay Ancha's bridewealth before taking another wife, it can be assumed that she was left in a disadvantageous position because of the reconciliation and the fact that she was encouraged to stay in a marriage tainted with abuse.

Another tradition that is worth considering in marriage is known as "runaway"—*fayi* in Wolof or *bori musoo* in Mandinka. In this instance, the wife runs away from the husband to her parents, not necessarily to end the marriage but to complain about her situation in the marriage household, in an attempt to mend the relationship. In some instances, the act of going away from the husband could lead to divorce if reconciliation fails.[23] To further clarify this relationship between legal change and the endurance of custom, we now turn to some examples that appeared in the court records.

On December 9, 1952, Sheikh Sidibe brought his wife Fatou Konte before the qadi of Bathurst and claimed that he paid £7 and 19s. as bridewealth. Sheikh alleged that Fatou had left her marriage household. He reported the matter to the Alkali of the village where they were living, but the Alkali did not do anything. He came to court so that he could reconcile with his wife. Fatou, in her evidence, declared that Sheikh was very aggressive and always beat her. She said that Sheikh used to beat her like a donkey. The qadi asked them to reconcile, but Fatou chose divorce because "she could not continue to live in misery and hardship."[24] The matter of spouses leaving their marriage households to seek help to amend their conditions is further illustrated in the following case.

> On July 5, 1955, Mam Coumba Sise appeared before the qadi of Bathurst and claimed that her husband, Bakary Sonko, used to beat her. She revealed that there was a day when they quarreled and Bakary beat her and wounded her face. She said that she

left her marriage household for two months, during which period Bakary did not maintain her. She alleged that her parents went to Bakary in an attempt to heal the relationship, but they found out that he had married another wife.

Bakary, in his defense, argued that he did not ask her to go. According to him, he came home one day and gave her fish money but she left with all her belongings. Bakary further stated that Mam Coumba had left her marriage household on six previous occasions.

In these cases, tradition is seen as a necessary instrument where wives can rely on the practice of *bori* or *fay* (runaway to get help) in order to alert their parents about the ills in their marriage. As such, parents of the wife would initiate negotiations through a third party to resolve the differences between the couples to make the marriage tenable. However, in Bathurst, the availability of an alternative option made it easier for many women to look beyond the advice of their parents in order to complain about their husband's behavior, as shown in the first case. In the second case, the traditional pattern was also not helpful to Mam Coumba, and therefore she turned to the qadi's court to claim her rights. Also, it needs to be underlined that often this traditional system left women in a disadvantageous position, as shown in the third case. Here, though it was the husband who brought the case to the qadi, the wife was able to break away from abuse and hardship. The tradition of *fay* or *bori* can also be disadvantageous to women because in a traditional Gambian setting, when a woman often left her marriage household, she could be labeled an unserious woman or a person who could not withstand the trials of married life. Labels such as these can make the remarriage of such a woman difficult.

Also, "traditionally," women are supposed to be subservient, obedient, and faithful to men.[25] The patriarchal and patrilineal nature of many African societies continuously creates an environment encouraging the oppression of women. Michelle Zimbalist Rosaldo and Louise Lamphere note that

> Everywhere we find that women are excluded from certain crucial economic or political activities, that their roles as wives and mothers are associated with fewer powers and prerogatives than are the roles of men. It seems fair to say, then, that all contemporary societies are to some extent male-dominated, and although the degree and expression of female subordination vary greatly, sexual asymmetry is presently a universal fact of human social life.[26]

Another way to illustrate the subordinate position of women in some African societies is to look into how traditional proverbs and sayings demonstrate society's perception of women. A common saying among the Asante in Ghana is "A woman sells garden-eggs, not gunpowder," meaning that women should do work that is appropriate for them and not interfere in men's affairs.[27] Clearly, this proverb charges that women's jobs, or jobs that are gendered as feminine within a society, are consistently devalued and given less credence—they are not masculine enough.

In the Gambia, legendary epics and songs popularize and valorize women who are obedient to their husbands. For example, the late kora maestro Lalo Kebba Drammeh performed a powerful song in Mandinka that urged women to be obedient to their husbands: "Musu soŋ bali te kanda wuluu la" (A disobedient woman will not give birth to a prosperous child). Likewise, there are similar adages in Wolof that admonish women to be hardworking and faithful to their husbands: "Ligaay yaay, agni doom" (Mother's hard work benefits the child [in the physical and spiritual sense]). There is a popular belief among Gambians that if a woman suffers in her marriage but nevertheless remains faithful to her husband, her children will prosper and she will enter paradise. Such beliefs are so entrenched in the society that they are determining factors in relationships between men and women.

However, it should be clearly noted that not all forms of matrimonial traditions and customs are disadvantageous to women. In some aspects of marriage traditions, the norm favors women. For example, the elders of Medina village told me in an interview that although Islamic law does not give rights to a wife to inherit her deceased husband's property, customary law allows her to get a share of the property.[28] According to custom, a woman can remain in her husband's house as long as she remains single, and sometimes for the remainder of her life if she has passed the age of menopause. The qadis therefore, in dispensing justice, had opportunities to sometimes consider customary and traditional practices in making judgments. Most of the qadis were products of local Islamic schools (*dara* or *karanta*), where they studied not only Islamic sciences but also aspects of tradition and custom, particularly in marriage, inheritance, divorce, and property rights.

Ordinances Related to Marriage and Family, 1862–1965

For colonial rule to function, British administrators devised ways and means to control Africans. Laws and regulations curtailed the movement of African subjects.

and affected many different aspects of African life. The Kombo Militia Ordinance of 1862, for example, enabled the formation of a volunteer reserve force; the Protectorate Ordinance of 1894 carved up the country into divisions and districts; the Protectorate Trade Licenses Ordinance of 1895 regulated commerce; and the Slave Trade Abolition Ordinance of 1894 (repealed in 1906) and the Affirmation of the Abolition of Slavery Ordinance of 1930 targeted egregious violations of human rights.[29] In many ways, the promulgation of these ordinances was meant to regulate control of the local population and to promote trade and the cultivation of groundnuts. From the mid-nineteenth century, groundnut cultivation (for export) became the mainstay of British economic activities in the region. The production of the crop required a large reservoir of labor, which in the nineteenth century was mostly done by freed slaves.

As scholars have demonstrated, some of these laws were meant to control families in order to control their labor; in this sense, colonial rule negatively impacted Africans, especially women. Elizabeth Schmidt suggests that European colonial officials and African leaders, especially chiefs, collaborated in using the new courts or European legal systems to control women's movement and thereby exploit their labor.[30] Emily Burrill, Richard Roberts, and Elizabeth Thornberry also note that

> One of the structural processes that shaped domestic violence during colonial and postcolonial periods was the insertion of the household into the broader structures of colonialism—where colonial governments sought to collect revenue (in the form of taxes) from Africans to pay for colonialism and the household head was normally responsible for payment. Taxation added to the financial challenges of the household head, who in turn likely drew on his household labor to help generate the cash or the commodities required to pay the tax.[31]

There is evidence of this process unfolding in the Gambia. An 1895 ordinance introduced the yard tax, levied on individual families domiciled in a compound (yard). By the same token, the law also targeted "strange farmers"—young men mainly from outside of the Gambia who came seasonally to cultivate groundnuts.[32] Many of these laws were meant to control populations in order to utilize them in the cultivation of groundnuts—Gambia's only cash crop.

When British colonial authorities allowed the establishment of the Muslim court, they relied on African leaders who they assumed were knowledgeable about customs; the colonial administrators then codified customary law and called on

judges they appointed to apply it. In Muslim areas, that law was sharia and was applied in qadi courts that to this day oversee civil disputes. Nonetheless, the European-instituted laws had far-reaching consequences, and, as Martin Chanock proposes, law was the cutting edge of colonialism. He notes that as an instrument of the power of an alien state and as part of the process of coercion, law also came to be a new way of conceptualizing relationships and power, and a weapon within African communities that were undergoing fundamental economic and social changes, many of which were interpreted and fought over in moral terms by those involved.[33] In spite of the exploitative character of these new laws, it is essential to recognize that women also used the courts and law to their advantage to claim and negotiate their rights.[34]

European presence in colonies like Bathurst also provided windows of opportunity for women to free themselves from strict male control or to negotiate their positions within their households, taking advantage of marriage laws enacted by the British. For instance, during this period, a plethora of ordinances on marriage issues were enacted, including the Marriage Ordinance (1862), the Married Women's Property Bill (1883), and the Muhammadan Law Recognition Ordinance (1905), as well as the Civil and Christian Marriage Ordinance (1938) and the Dissolution of Marriages Act (1967). Matrimonial ordinances, like other ordinances introduced during the colonial period, were aimed at facilitating colonial rule. British administrators sought to control marriage because they were concerned with issues of polygamy, child or early marriage, and slavery and concubinage.[35] It can be argued that the byproduct of some of these laws was improvement in the lives of women, especially those trapped in bondage. In the early 1900s, slavery was still an active institution in the Senegambia region.[36] In fact, one of the last Muslim militant clerics, Musa Molloh, had many women and children in his custody at the time of his capture by the British.[37] A large number of the women were his slaves. Scholars also indicate that during slavery, men could sell their wives, children, and servants, and that the kidnapping of small children disguised as adoptions occurred during the colonial period.[38] In an attempt to stop slavery and abuse of women, the British introduced ordinances to ban the trade.

One of the first such laws that was enacted was the Marriage Ordinance, in 1862. The ordinance provided that if a person under twenty-one years of age wished to contract a marriage, the consent of the parents or guardians or judge of the Supreme Court was necessary. This law was supposedly meant to curtail child

marriages and subsequently child abuse, as children could not be married until they reached the age of consent.[39]

The originator of the law was Governor George D'Arcy, who was eager to please the powerful Islamists on the north bank, such as Maba Diahou Ba (who by this time was one of the leaders of the wars between Muslims and non-Muslims, and these wars involved the Europeans). However, the legislation did not have much impact on the status of married women as it did not nullify marriages concluded before its enactment. The law that affected them most was the Married Women's Property Bill (1883), which gave widows property rights. Nana Grey-Johnson notes that "the passage of the bill in the legislative council guaranteed legal protection to women across the colony against husbands and male siblings who used every means to rid gullible women of their personal property and hard-earned finances."[40]

This ordinance deserves closer scrutiny, not least because it was the positive result of a petition sent to Governor Valerius Skipton Gouldsbury by a group of twenty-two Bathurst residents from all walks of life, including merchants, traders, shipwrights, teachers, and pensioners, who expressed deep concern about the suffering of wealthy Bathurst married women who had lost their riches to greedy husbands and male relations. Their petition, dated January 22, 1883, asked the Bathurst governor to enact a law that would protect such industrious women from financial ruin induced by extravagant spouses. Moreover, the gentlemen who supported the petition, including J. D. Richards, Samuel Bah, Foday Dabo, John Faye, Harry Finden, Samuel Joof, and C. Bright Lewis, believed that such a law would give women the right to acquire and hold property of their own, and therefore become economically independent. The colonial government reacted positively and swiftly because women merchants, especially kola nut and tobacco dealers, accounted for over 40 percent of the revenue from import customs duties at the time, and were therefore deemed to deserve protection from financial ruin and bankruptcy.[41]

The importance of marriage continued to grow in the eyes of the colonial administrators. In 1905, the colonial authorities introduced the Muhammadan Law Recognition Ordinance, which gave legitimacy to children born in Muslim marriages as a way to protect children. However, Muslims saw this legislation as grossly inadequate, as it did not in itself consider Muslim marriages as valid or legal. Pressure from the Muslim community in Bathurst led by Sheikh Omar Faye and Ousman Jeng resulted in the enactment of the Ordinance for Muslim Marriages and Divorces (1938), which made such marriages legal and valid and required that

they should be registered.[42] Perhaps Faye's and Jeng's efforts were intended to please the British or to gain recognition among fellow Muslim leaders, with whom they were in contention. The British also passed the Infanticide Act, enacted in Britain in 1934, which made baby killing a capital offense. Subsequently, this led to the Criminal Code (Amendment) Ordinance of 1938, which also made the act a capital crime in the Gambia.[43]

The Civil and Christian Marriage Ordinance of 1938 sought to integrate civil marriages and Christian marriages (celebrated in a church or chapel). However, the laws again favored colony women over women in the protectorate because, until 1957, all four churches allowed to administer Christian marriages were in Bathurst. Therefore, on many occasions, the governor declared null and void marriages that had been officiated in churches outside the colony. Nevertheless, although this legislation was significant in matrimonial issues, it hardly affected Muslim women, most of whom lived in the protectorate and could construct civil marriages in mosques and homes without marriage certificates.

Another law that gave hope and furthered the interest of women was the Muhammadan Marriage and Divorce Act of 1941. Thanks to this law, women could not only divorce but also safeguard their property because the laws could be enforced through the injunction of the court. The Dissolution of Marriages Act of 1967 gave the Supreme Court jurisdiction to dissolve a monogamous marriage in which one spouse converted to a religion recognizing polygamy while the other spouse did not. This was generally seen by critics as a rushed attempt to facilitate Prime Minister Dawda Jawara's divorce of his wife, Augusta, following his conversion to Islam and her refusal to be converted. Earlier in 1967, the Gambian court of appeals had allowed an appeal by Lady Jawara against a lower court ruling allowing the prime minister's petition for divorce. The bill was passed by MPs and soon became law. The preamble reads:

> Notwithstanding the provisions of any other enactment having the force of law in The Gambia, the Supreme Court shall have the jurisdiction to dissolve by decree any marriage at the instance of another party thereto in the following circumstances:
>
> (a) The marriage was in monogamous form recognized by the law of The Gambia; and
>
> (b) Since the celebration of the marriage one of [the] spouses has in good faith and to the satisfaction of the court become converted to a religion which recognizes polygamous marriages and the other spouse has not become converted.[44]

Women activists such as Cecilia Cole (who became the first female Gambian deputy speaker of Parliament in 1997), Mary Samba, and Diana Christensen believed that the dissolution bill was first and foremost a discriminatory and sexist law that was designed to stifle women's marriage rights. But above all, women challenged the bill because it was seen as discriminatory, especially against Christian women who might wish to convert to Islam. The bill required that Christian women must first get a divorce from their Christian husbands of good faith before they could marry again in Islam. However, a Christian man could marry as soon as he embraced Islam—a religion that permits polygamy. In answer to the protests, members of Parliament were adamant that the bill was meant to solve some of the problems arising from the existence of polygamous and monogamous marriage systems in the Gambia.

These colonial mechanisms (ordinances) were in effect a form of control and appropriation. The regulations could be categorized on two levels. On one level, colonial administrators were able to contain local populations by defining the legal terrain and thereby delimiting its boundaries. As Kristin Mann and Richard Roberts conclude, these rules were not only reproducible, but unalterable.[45] Mahmood Mamdani also aptly described this process as the "containerization of the subject people."[46] This meant that Africans lost all possibility of self-governance and freedom to traverse legal boundaries according to their customary and traditional practices because of alterations that Europeans had made in the realm of law. Also, these promulgations gave chiefs, as well as interpreters and messengers, the ability to empower themselves by exploiting people of lower status in colonial society.

Nevertheless, the issue of control over colonial populations is a complex one. In the case of the Gambia, these laws not only helped women challenge male patriarchy but also gave them opportunities in their matrimonial homes, especially with respect to property rights. Many women brought cases against their husbands over personal items such as jewelry, and against their parents over matters of inheritance. The laws also gave women and children opportunities to escape from servitude. In colonial Gambia, another important consequence of the attempts to regulate marriage was the question of how Islamic law should be interpreted.

Problems of Interpretation

In colonial Gambia, officials provided two avenues to resolve marital issues. In the colony (Bathurst), a Muslim court was established, while native courts operated in the protectorate. Although the British provided these opportunities, they left the running of these institutions in the hands of local leaders and clerics, who were the traditional rulers. This could be partly due to the fact that the colonial officials were few in number and had very little knowledge about customary and Islamic laws.

Up to the 1950s, British officials in Bathurst were struggling with issues of how to interpret Islamic law in these courts.[47] In a letter from the commissioner of the Upper River Division to Sergeant Trove Jones, senior commissioner of Bathurst, the commissioner discussed his difficulty in resolving a case involving a woman who had obtained a divorce in a local tribunal on the grounds of maltreatment. A few days after the divorce was granted to the woman, she voluntarily returned to the man and lived with him for two years, during which time they were not officially remarried. After some time, the woman ran away to another person's compound and refused to have any dealings with the first man. The man wanted the woman back, or if not, he wished to sue for divorce and return of bridewealth, which had not been refunded at the time of the earlier divorce. The woman contended that

> She was free to do as she likes as she had never been remarried and she had several witnesses who deposed that the man had no claim over the woman as there has been no remarriage and that for the last two years she and the man had merely been living together.[48]

The man disagreed, relying on learned teachers who informed him that in Islamic law,

> If a woman is divorced with the fault on the husband's side—and if the woman voluntarily reconciled to the husband within three months of the divorce and goes to live with him, the marriage is thereby mended and they are once more truly man and wife without going through any further ceremony as enshrined in suratul Nissa—the sura concerning women.[49]

Hence, the problem of interpretation was challenging, and at times opinions were sought from Muslims in other parts of the region. In January 1952, the court

in the Western Division had to seek answers to issues of bridewealth and divorce from the amir in charge of the Ahmadiyya Movement in Sierra Leone.[50]

As a result of these complications, some government officials were in favor of the qadi of Bathurst traveling around the country to interpret Muslim law for the people.[51] However, such senior officers as A. C. Spurling, attorney general, expressed concern that "the Muslim law administered in a native tribunal must be the law as it resides in the breast of local pundits, so long as it is not repugnant to justice and morality, which of course Muslim law, except in some of its criminal punishments, is not."[52] Spurling reasoned that the law practiced in Bathurst should not be the same as in the protectorate, because to him "the Muslim law is so much entangled with developing native custom that it varies on minor points and sometimes on greater ones from district to district."[53]

As noted above, different opinions existed among colonial officials as to how Muslim law was to be interpreted, and they would usually let Africans deal with such issues. Thus, although in theory the new legal codes constrained populations, in practice there was considerable autonomy for Muslim jurists to interpret cases in accordance with tradition. Meanwhile, for women in colonial Bathurst, the codes offered considerable opportunities to reassert and strengthen their rights when other forces were eroding them.

Conclusion

Both the different forms and the changing nature of traditional (or customary) law are problematic. What is tradition in one family or village may be different from that of other families and villages. In other words, the difficulty is to distinguish what is a new import from Islam and what is tradition. These differences can make the arrangement or dissolution of marriage problematic and at times challenging. That is why, when individuals, families, communities, or nations act in a "traditional way," we need to ask in whose interest it is to act this way.

Besides showing how tradition and custom can be appropriated, this chapter also illustrates their persistence over time. There are difficult challenges that can arise in determining where traditions begin and where external forces bring a "modernizing" change. Also, it is difficult to differentiate what is Islamic and what is tradition because of hundreds of years of cultural fusion and diffusion between Muslim and African cultures. In light of the difficulty in defining custom and

tradition, I use these terms to refer to practices passed down from earlier generations to the present generation.[54]

In colonial Gambia, women used the courts to challenge elements of patriarchy within households. Women also used their experiences in the court to create new urban networks and form friendships and social exchanges with other women, a process facilitated by the close-knit nature of Gambian society and the cramped living conditions in the colonial city. In many of the cases I have presented here, women often consulted their friends, sisters, and other relatives first before turning to the court. The communication and solidarity between women symbolized the construction of definitive relationships that allowed women in difficult marriages to open up and get advice from their fellow women. Nevertheless, it is clear from these examples that a combination of customary and traditional obligations put women in disadvantageous positions with regards to marriage. The choices available to a woman about whom she could marry, the amount of bridewealth to be paid, and the decisions of how a family should be raised still depended on the husband.

Making the City: The Gambia Colony and Protectorate

A village song, fashioned by the Mandinka of the region of Baddibu, lying along the north bank of the Gambia River some forty miles up from the river's mouth, castigates those who leave their peanut fields to go to Bathurst to pull and push donkey carts in order to earn a living.

Laa wuloo ye meŋnu bayi,
wolu taata mbaamu ñoroo la.
Tiñang baŋ laa wuloo ye meŋnu bayi,
wolu taata mbaamu ñoroo la.
Those driven away by the fear of farming
Have gone to push and pull carts.
Those driven away by the fear of farming from sunup to sundown
Have gone to push and pull carts.

The song was a reaction of Baddibu's agricultural community to the growing migration of their young male population to find paid labor in the bustling colonial city of Bathurst.[1] It mirrors how, increasingly throughout the twentieth century, the city became an attraction for various reasons, including opportunities for salaried

work, menial jobs, social amenities (schools, a hospital, and cinemas), and a legal infrastructure created by the British colonial presence. Due to these prospects, many young men living in the rural areas of colonial Gambia, known as the protectorate, would move to the capital city when the rains ceased and the crops had been harvested. Their primary goal was to find jobs at the docks and the Public Works Department, the latter created by the colonial government in 1922 for infrastructure development, as porters, temporary workers, or petty traders. Through this wage labor, they provided financial help to their families back home or established their own households in Bathurst or in their farming villages.

A few years after its establishment in 1816, the tiny colonial city of Bathurst was transformed into a multiethnic and multicultural society. The city's population included migrants from such different cultural backgrounds as English, French, Portuguese, Lebanese, Syrian, Moroccan, and diverse groups of Africans. Some of these Africans were immigrants from Senegal, Mali, Guinea, Sierra Leone, and Nigeria, but most of them came from within the protectorate of the Gambia, and they spoke Mandinka, Wolof, Jola, Serere, Fula, and Serahulle, among a number of other languages. In addition, a small but sizable group of liberated Africans (often referred to as Aku) also formed part of the city's population.[2] Although most of the Aku and other Bathurst residents from various ethnic groups were non-Muslims, the majority of the town's residents were followers of Islam. From its early years, the city could boast of Islamic schools called *dara* (Wolof), where students learned the Quran and methods of the five daily prayers. The schools were headed by Islamic scholars, most of whom came from the protectorate and other parts of West Africa. Some of these scholars, knowledgeable in Islamic law, greatly influenced legal discussions and redefined intrareligious relationships in Bathurst. The arrival of these local scholars coupled with the establishment of colonial legal institutions impacted and transformed the legal terrain in colonial Gambia. In fact, the creation of the Muslim court in Bathurst in 1905 sharpened the tensions within the city's Muslim community.

These new configurations not only made the city attractive to migrants but also opened opportunities for competition and rivalries over government positions, land issues, and personal matters. Hence, the implementation of the law became an important sphere that mattered to both the women and the men who brought their cases before the qadi or the chief justice.[3]

Generally, when we think of migration to cities, it is in terms of young men who migrate. This, however, conveys only part of the story. Most migrants to the city brought their wives with them, consequently igniting chains of movement

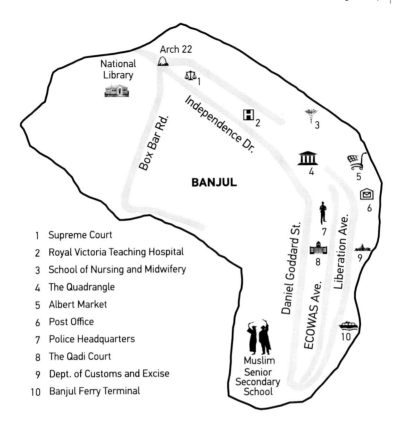

MAP 2. Map of Banjul Showing Location of the Qadi Court

1 Supreme Court
2 Royal Victoria Teaching Hospital
3 School of Nursing and Midwifery
4 The Quadrangle
5 Albert Market
6 Post Office
7 Police Headquarters
8 The Qadi Court
9 Dept. of Customs and Excise
10 Banjul Ferry Terminal

by women between Bathurst and the protectorate. In addition to the prevalence of the Muslim religion, issues of slavery and caste were important and defined relationships in many parts of the Gambia, affecting how the city's population articulated their identities, and how they positioned themselves in the changing colony of Bathurst. This is important to understand because issues of slavery and caste continue to define relationships in many parts of Gambia to this day.

The Colony of Bathurst: Settlement Patterns and Issues of Identity

In 1815, the British governor-general of the English operation along the Gambia River, Sir Charles MacCarthy, ordered Alexander Grant to sail down from the

island of Gorée, just off the Cape Verde Peninsula to the north, with a detachment of seventy-five men from the Royal African Corps to look into the possibility of establishing a military garrison in the Gambia. Grant was an officer in the British Imperial Army. In 1816, Captain Grant entered into a treaty with Tumani Bojang, the king of Kombo, for the cession of the island for an annual fee of 103 iron bars.[4]

A settlement was quickly established on the island, and Grant renamed it Saint Mary's Island. He called the new town Bathurst, after then secretary of state for the British colonies Henry Bathurst. Grant proceeded to construct an army barracks on the island housing six cannons. The six-gun batteries are now on the World Heritage List together with James Island and the "ceded mile."[5] The streets of Bathurst were laid out in a modified grid pattern and named after the principal allied generals of the war against Napoleon.[6] The nature and diversity of Bathurst's burgeoning population are significant because questions of ethnic origin remained essential in the religious and political differentiation between the groups who settled in the city. In fact, the disagreements between these contending groups continuously impacted the affairs of the Muslim court.

Most of the Africans who populated Bathurst were Wolof. The majority of the Wolof who were among the first settlers in Bathurst in the 1820s came from the northern territories of the Gambia River and from the French colony of Senegal, particularly Gorée and Saint-Louis. They and other Africans, including liberated Africans, were sent there by European employers and biracial slave owners to work as artisans on the construction of the town, or as domestic servants, and tended originally to live in an area of north Bathurst known as Jollof Town. Among these numbers were also the *signares* (African women married to Europeans).[7] In 1881 the Wolof population in Bathurst numbered only 829, rising to 3,666 in 1901.[8] In 1911 it increased slightly to 3,705, but declined to 3,069 in 1921. Then it increased significantly to 10,130 in 1944, declining slightly to 9,544 in 1951. By 1963, the Wolof population in Bathurst stood at 11,311.

The Wolof were previously established in the lower Gambia valley and in Senegal, where they continue to be the most numerous ethnic group. They established a kingdom in Saloum, next to the Serere, who inhabited the coastline north of the Gambia. A sizable population of Serere also lived in Bathurst. Today the Wolof are the third largest ethnic group (about 16 percent) in Gambia.[9] The Wolof, like their Mandinka neighbors, live by a rigid social hierarchy—nobility, freemen, artisan groups, and "slaves." Descendants of former enslaved persons continue to be regarded as slaves (*jam*) and occupy the lower end of society.[10] The

nobility are freedmen known as *jambur*, and they occupy the highest and most privileged position. Between the freemen and the slaves are the artisan groups: gold-, silver-, and blacksmiths (*tegga*), leather workers (*udde*), and musicians and praise singers (*gewel*).

The Mandinka comprised another major group in Bathurst. The Mandinka first settled on the northern slopes of the Fouta Djallon plateau, the saddle between the valleys of the Niger on the east and those of the Gambia and Senegal on the west. The original country of the Manding is believed to be in the Niger valley.[11] From here, the great Manding Empire emerged, which saw the westward movement of some Mandinka peoples to their present locations in the Gambia region. They were certainly fully established on both banks of the Gambia River when Portuguese explorers first arrived in the fifteenth century.[12] The Portuguese reported encountering Mandinka kings on the river who claimed to be vassals of the "king of Melle." In 1620, Richard Jobson also reported that the "Mandingo" were the "lords and commanders" of all the Gambia.[13]

Mandinka rule extended over the conquered territories, greatly influencing the political, cultural, and social life of the region in a movement that has now been broadly defined as the "Mandingization of the subregion."[14] Traditionally, Mandinka society is socially stratified into three broad classes—the nobles (*sulalu* or *forolu*), consisting of kings and rulers, religious leaders, and a warrior class; the artisan class (ñamalolu), consisting of gold-, silver-, and blacksmiths, and griots; and the slave category (*joŋolu*), consisting of the descendants of the enslaved.[15] Today, the Mandinka make up about 42 percent of Gambia's population, mostly living and farming in rural areas.

Bathurst had a very small Jola population. The Jola are widely believed to be the longest-residing people in Gambia (more than any other resident ethnic group) and are found predominantly along the south bank of the Gambia River in the Foni District of the West Coast region. The Jola tend to live in fragmented villages or small hamlets consisting of a few huts and houses divided into family groups scattered over a few square miles, independent of each other. The Jola are not known to be hierarchical.[16] Today, they make up about 10 percent of the country's population.[17]

The population of the colonial city also had a small number of Fula (Fulbe, Pulaar) speakers. Fula, who make up about 18 percent of the Gambian population (including various Fula subgroups), are mainly pastoralists, following a sedentary agricultural life and tending to live in small communities. The Portuguese in

Senegal reportedly came into contact with the Fula from south of the Gambia, which suggests that the Fula must have migrated to the Gambia region before the fifteenth century.[18]

The Fula have long been associated with Islam and Islamic revivalism in West Africa. Spencer Trimingham links the rise of militant Islam in the eighteenth century with the Fulbe-speaking peoples, particularly the Torodbe, the Tukolor clerical class who may have settled the northern part of Senegal.[19] David Robinson states that Fulbes led most of the Islamic revolutions or revolts (jihads) that swept across West Africa in the eighteenth and nineteenth centuries.[20] According to Arnold Hughes and David Perfect, in the Gambia region some Fula subgroups were Islamized by the 1860s, but others remained animist well into the twentieth century. By and large, the presence of the Fula was felt in the 1870s and 1880s, when a famous Fula leader, Musa Molloh, established a Fula kingdom north of the river centered on Fulladu. As a result, by the 1960s, the majority of the Fula in the Gambia lived in the Upper River and Central River regions.[21]

The settlement of Bathurst soon began to attract people from elsewhere in West Africa, including British colonial officials and immigrants from the protectorate. The population mix resulted in intermarriages but also differentiation, because many of the settlers remained rooted to their traditions and cultures, facilitated by the way the city was divided into ethnic settlements. In their most recent book, Hughes and Perfect show that the population of the colonial city increased steadily in the 1800s. In 1819, three years after its establishment, the settlement had an official population of 704 and it increased steadily to 2,825 in 1833 and 3,514 in 1839. Moderate growth continued well into the 1850s, augmented by the frequent arrival of shiploads of liberated Africans—enslaved Africans captured at sea by cruisers of the Royal Navy as a part of British antislavery efforts. The population of Bathurst only grew from 4,262 in 1851 to 4,591 in 1872, but then rapidly increased to 6,138 in 1881; 6,239 in 1891; and 8,807 in 1901. The sharpest population growth occurred largely as a result of Bathurst's strategic importance as an air and naval hub for Allied forces during World War II, increasing from 14,370 in 1931 to 21,152 in 1944. After the war the population of the colony declined slightly to 19,602 in 1951, but increased again to 27,809 in 1963 and 39,179 in 1973.[22]

It should be emphasized that Bathurst also had a sizable Christian community, a group that continued to play an important role in the development of the city mainly because of their role in education and politics. During the colonial period, Christian missionaries provided education in both the colony and the protectorate,

especially in places like Georgetown (Janjanbureh), MacCarthy Island District. These early missions included the Roman Catholics, Methodists, and Anglicans.

Soon after its founding, Bathurst became in practice the seat of government services with the construction of official buildings, including parts of the quadrangle (government houses), a hospital, and barracks. However, from 1821 to 1843, the administration of the tiny settlement was transferred to Sierra Leone. Bathurst became a distinct colony in 1843, with its own governor, legislative council, and judicial system, and remained so until 1866, when the administration was again transferred to Sierra Leone. In 1888 the administration was brought back to Bathurst, and in 1889 the city was finally declared capital of the Crown Colony and Protectorate of the Gambia.[23] Hence, as explained above, the city's population expanded significantly between 1900 and 1944.

As the urban population increased, the chances of intermarriage between Muslims and Christians also increased. In fact, many matrimonial issues involving Muslims and Christians ended up in the qadi courts. One such interesting example was the case of Habibatou Loum against her husband Ousainou Loum. On June 26, 1934, Habibatou brought a case against her husband before the qadi of Bathurst. Habibatou complained:

> My husband converted to Islam so I could marry him. After some time, one Neneh Dibba came to me and told me that my husband was not sincere in his conversion. I confronted my husband about it and we quarreled. I went away from him for 1 month and 3 weeks. I went to the Imam and told him that I want Ousainou to divorce me since he has not even paid the bridewealth.[24]

The husband, in his defense, stated: "We had a fight, she tore all my clothes and she left."

After the qadi had heard the disputants, he ordered divorce. Certainly, this case shows that marriage between Muslims and Christians occurred, but it also shows the complicated nature of this union. In Islam, Christian men can marry Muslim women if and when the Christian man converts to Islam, but a Muslim woman cannot marry a non-Muslim man, as stated in the Quran: "Lawful unto you in marriage are not only chaste women who are believers but chaste women among the people of the Book."[25] In addition, complications can arise from how the upbringing of children born into such marriages is culturally done. The difficulties can also hinge on whether the children should follow the father's or the mother's

religious traditions. Other problems can involve questions of how such couples should exhibit their faith. Should they all attend church on Sunday, or should they all go to the mosque on Friday? Added to these issues are a whole set of cultural and social issues that exposed such marriages to public scrutiny.

Another relevant example is the case of Sainabou Badjie and Mansour Sarr. On March 27, 1953, Sainabou brought her husband Mansour before the qadi of Bathurst. Sainabou claimed that Mansour Sarr refused to sleep with her and also refused to maintain her. Sainabou also alleged that Mansour drank alcohol. Mansour in his response denied what Sainabou said and revealed that whenever he came home late, his wife always refused to open the door. The qadi advised them to go home and reconcile.

Critical in this case is the question of culture and religion seen in the scrutinization of the use of alcohol and Mansour's personal character. "How would society judge me knowing that as a Muslim woman, I am married to a man who goes out and comes home late every night and drinks alcohol?" Such a perception not only complicates marriage in this largely Muslim society but also calls into question the virtue of women in such a relationship. It can be added that traditional thinking has more tolerance for men who drink alcohol than women. Therefore, women who stay in such marriages open themselves to societal criticism and oftentimes rejection.

During the period under study, it also sometimes happened that people belonging to different ethnic groups or religions would marry and have children and common property. Usually, problems of inheritance would occur, particularly after the death of one of the partners, or if one partner wanted to switch back to his or her original religion. On June 30, 1953, Aminata Sonko brought a case to the qadi, explaining that her husband, Muhammad Joiner, had converted to Islam so that she could marry him. However, Muhammad did not respect her or care about her. He would go out late every night. Whenever they quarreled, Muhammad would tell her that he could always marry another wife.[26]

Similarly, on March 30, 1954, Mariama Demba testified under oath that her husband, Muhammad Jobe, had converted to Islam so they could get married, but that he converted again to Christianity after a month of marriage. The qadi ordered divorce and asked the husband to pay his wife five pounds.[27]

Another case in point is the matter of Isatou Hydara and her husband, Ousman Mbacke.[28] On December 15, 1953, Isatou brought a case against Ousman and in her testimony said:

One day my husband asked us to visit my aunt. The following morning, I greeted [my husband] and he said I am a fornicator and I have a child out of wedlock. He further told me that "I don't know whether you are a Manjako [an ethnic group mainly in Guinea-Bissau] or Bambara [a Mande ethnic group]." I went to my mother's house but [my husband] never bothered to come for me.

The husband took an oath and stated:

One day I came home and found my son Tijan Mbacke severely beaten by somebody but he was also beaten by Isatou. I intervened and Isatou became angry. She broke a bottle and wanted to stab me. I left the house and went to Bakau [in Kombo]. When I came back the next day, Isatou already emptied the house of its contents and went to her mother.

When the qadi had heard the disputants, he ordered divorce and asked the husband to pay £20, 9s. to the woman and also 20s. each month for the maintenance of their two children.

In the first case, it seems that the question of disagreement between Aminata and Muhammad centered on whether Muhammad was sincere in his conversion.[29] Also, as he became Muslim, Muhammad needed to care for and maintain his wife as specified in Islamic texts. The second case was clearly a matter of Islamic legal teaching that specified that Muslim women cannot marry Christian men. Essentially, the husband, by converting back to his former religion, annulled the marriage.

Of great interest in the third story is not how the case ended but the point that the husband implicitly was not comfortable with his wife's ethnicity. It seems as if the husband is suggesting that some ethnic groups are better positioned to be violent and disobedient. At times, the terms Bambara and Manjako can be used in derogatory ways and as such their use can be offensive. Also, the case is an indication of the difficulties in cross-cultural marriages in Bathurst at the time, and how ethnic factors made relationships in the city complex and often touchy.

These cases are significant in illuminating social relations in Bathurst and the role of the Muslim court in adjudicating between the city's residents regardless of their religious affiliations.[30] Here, it is clear that both Christians and Muslims recognized legitimate claims of identity (in circumstances in which it was important for each to define himself or herself according to his or her religion), making interethnic marriage complex and contentious. Moreover, these are indications of

changes that were happening in the colonial city as a marriage between a Muslim and a Christian would be difficult in the rural areas. As such, issues of ethnicity and faith became more complex. By and large, what became important was how the city's residents identified themselves notwithstanding the fluidity of identity and fluidity in other social relationships formed around ethnicity, place of origin, and marriage.

Caste was another important social marker that continues to affect relationships in Banjul. Some of these forms of social relationships filtered into matrimonial relationships, further complicating household issues. For example, in an interview with Algaji A. M. Sering Secka, he lamented about an incident involving a man his father had brought up. When the man reached adulthood, he could not find a wife in Bathurst because it was assumed that he was from a griot caste just like the family that brought him up.[31]

Social differentiation impacted relationships between men and women, such as between freedmen and their wives of slave origin. Toward the end of the slave trade in the early 1800s, some former masters manumitted their former concubines and married them. Many freedmen also married former slave women. Many of these marriages were marked by domestic violence, with wives suffering physical and verbal abuse. Elizabeth Schmidt maintains that historians need to strive to understand household dynamics, because gender relations within the household by extension help shape the broader society. She notes, "Unless we understand the interrelations between women and men, we cannot fully understand the structure of a given society."[32] For example, we need to understand how and in what manner the household is constructed. We need to know who could marry whom in such a society and the conditions necessary to allow a marriage to take place. It is therefore imperative to understand the social structure of Gambian society and how these positions affected or aided women in their marriage households.

By and large, slave identity also became an important social marker in the colonial city. Indeed, over the course of the nineteenth century, many of the African residents of the city settled there in order to escape from domestic slavery, seeking British protection from persons in their village wishing to retrieve them. The arrival in the city of these former slaves reignited old forms of social relationships such as slavery, because domestic slavery persisted in the region until the early 1900s.[33]

To illustrate, on May 2, 1907, a man by the name of Samba Darbo appeared before the qadi of Bathurst and argued that he should be allowed to exercise

custody over Isatou Jarju. Samba claimed that he bought Isatou from Foday Kaba Doumbuya, to whom he had paid $66.[34] Samba claimed:

> My wife Isatou Jarju was given to me by Foday Kaba and I have two children with her, Musa Darbo and Babu Darbo. She ran away from me and took away with her my children. I came to Bathurst in search of her and found that she had already married another man named Baboucar Jallow. I prefer having her back, or, if she refuses, I want my two children.[35]

At that point the woman interjected and said, "You had wanted to sell me and my two children and knowing it I ran away with my children and came to Bathurst." The qadi then advised Isatou's elder son, Babu Darbo, to go with his father, but he refused. He insisted on not going to his father because there was nobody there to take care of him. The qadi asked Musa Darbo, the younger one, if he would go with his father. He also rejected going with the father and preferred to remain with his mother. The qadi advised Samba to be aware of the claim he was making about his wife and two children, because Isatou had said that she and her two children were slaves. The qadi advised Isatou to return to her house (to the present husband) with her two children and raise them, relying on the passage in the compendium of the Sheikh Khalil,[36] "and the mother will be entitled to the custody of a male child."[37]

As illustrated in this story, the court's actions in many ways provided an opportunity for slaves, including women in bondage, to challenge their slave status, since the legal basis of slavery had been abolished. In this case, it is clear that the qadi was relying on the legislation against slavery, admonishing Isatou's husband to be cautious in using the name of Foday Kaba, a militant leader reputed for slave dealing. Also, the qadi's questioning of the sons measures well with Islamic codes and the tradition that the son after the age of maturity should stay with the father. Perhaps, and most importantly, Isatou and her children would have remained in bondage if they had not escaped to Bathurst.

Clearly, Samba's claim for his wife provides a lens through which not only slavery and other forms of relationships can be viewed but also the enduring reach of slavery in the Gambia. Isatou's readiness to come to court to respond to her (former) husband's claim in my view represents two different periods in history—or what the Mandinka characterized as *moofiŋ tiloo* (the days of the African) and *tubaabu tiloo* (the days of the Europeans). Purposely, Samba came to court with the days of the African in mind, a time period that included slavery,

bondage, and servitude. This was a period when some traditional African rulers exercised power with impunity. This can be seen from the qadi's intervention that he (Samba) should be cautious of the claim he was making against his (former) wife because the days of slavery were over and that there was a new law in existence: the law of the Europeans.

Second, it is reasonable to suggest that Isatou responded to her husband's claim with knowledge that slavery was outlawed. In fact, during her testimony, she made it clear that the reason for her escape to Bathurst was because she refused to be kept in bondage. Perhaps Isatou and many other women like her were aware of a government circular dated January 2, 1899, in which the administrator of the colony and protectorate wrote to all traveling commissioners to prosecute men who brought slaves into the protectorate or exported slaves. The administrator added that slaves should be given the option of either going back to their own country or coming to Bathurst, Kombo, or elsewhere, but they were not to settle near where they had been freed.[38]

Third, beyond the problem of servitude is the question of identity. While Samba wished to identify Isatou as a person in bondage, Isatou categorically rejected her slave status by rebuking Samba. In colonial Africa, efforts by former slaves to free themselves from bondage were not exclusive to the colony of Bathurst alone. Similar situations existed elsewhere in colonial Africa, such as on the Island of Pemba, on the east coast of Africa. According to Elisabeth McMahon, this was a time of major changes that obligated the people of Pemba to create new kinship networks and reconfigure their ethnic identities.[39]

In the Gambia, by virtue of the 1899 edict, the colony of Bathurst became a safe haven for many former slaves, many of whom came there because they had limited access to land back in their villages. Consequently, the enduring reach of slavery was ingrained in the colonial city and became one of the social markers that determined ethnic, social, and personal relationships.

In fact, as Alice Bellagamba observed, until quite recently, a slave remained a slave in the eyes of the local society. In order to change his or her social position, a slave had "to pay for his/her neck," as idiomatically expressed in Mandinka (*kang foroyando*). The freed slave would then undergo a ceremony in which the owner would publicly assert the changes that had occurred in their relationship.[40] A continuing relationship had been established between the former masters and former slaves. Klein reasons that maintaining this sort of relationship served as an "insurance policy" for former masters and slaves and their descendants.[41]

Though an 1894 ordinance banned the slave trade in the Gambia, the trade continued well into the beginnings of the twentieth century. The outlawing of the trade by the British, as in many parts of Africa, did not translate into the dramatic eradication of slavery. The historiography underscores that the end of slavery was a slow and continuous process with no decisive conclusion. Scholars have also examined how former slaves adapted to the new conditions and opportunities that the establishment of colonial rule and the abolition of slavery provided.[42] These remarks concur well with reports by colonial officials on the ground. In the Gambia, the traveling commissioner in his report to the secretary of state for colonies indicated his wariness that the end of slavery would bring disaster in the protectorate. He stated, "It will not be practicable to do away with slaves at once, as it would bring ill-feeling which should be avoided."[43]

Paul Lovejoy and Jan Hogendorn argue that in northern Nigeria emancipation was expensive, and it took a long time for slaves because it was achieved in part by self-purchase.[44] They also argue that emancipation affected people in different ways, particularly female slaves. Women slaves, for whom departure was likely to mean the loss of their children, were unlikely to leave a homestead. Parents also remained with the former owners but accumulated the means to buy the freedom of their children. Transactions in females were easier to hide than dealings in males, and slavery and slave dealing often continued for many years under the guise of marriage, or a man might ransom a woman slave through the courts simply to acquire her as a concubine.[45] In fact, Richard Roberts and Suzanne Miers state that as the political economy changed, so slavery, never a static institution, also changed, becoming sometimes harsher and sometimes more "benign." Slaves were bound up in a complex, ever-shifting web of social relations, fashioned by political and economic conditions.[46] More recently, Emily Burrill also points out that the continuation of slavery in the early years of colonial rule throughout French West Africa was due in part to the fact that in practice and policy, France vacillated between complicity with slavery and the eradication of the practice.[47]

In the Gambia, slavery continued well into the early 1900s. Donald Wright writes about the continuation and the problems of slavery in the protectorate long after the trade was abolished.[48] Alice Bellagamba also notes that Musa Molloh (the militant Islamic leader) kept several women as his wives, and the sources point to the fact that many of Musa's slaves were women and children. These women secured their freedom only after the World War I, when the relationship between Musa Molloh and the colonial administration deteriorated.[49] It is reported that militant Islamic

leaders such as Foday Kaba not only continued pillaging towns and villages, but carried on with the slave trade inland long after the British abolished the trade in 1807.[50]

The problem was so serious that until the first few decades of the 1900s, many people continued to remain in bondage and could be moved from one owner to another. A directive to traveling commissioners dated November 1, 1899, states:

> A register of slaves should be kept by each Commissioner showing name, age, sex, owner and residence of each slave and should be periodically inspected. A person not registered as a slave when the register was started by the Commissioner in his District cannot at any subsequent date claim not to be a slave. On the death of the owner of any slave, the Commissioner should take care to inform all his slaves that they are free. All persons born in any district since the date of the proclamation of the slave ordinance in that district are freeborn (in January 1895). Any headman who neglects to report any case of slave dealing in his town should be punished.[51]

Clearly, there were directives to eradicate slaveholding, but it is obvious that the efforts were precarious as they turned slaves against their masters. Also, efforts to end the slave trade resulted in a significant increase in the population of Bathurst.

The settlement pattern in colonial Bathurst reflected this kind of diversity, demonstrated in the way people belonging to the same ethnic group clustered together in their neighborhoods. As more people arrived, the British allocated ethnically designated areas where immigrants could live. Geographically, the landmass of Bathurst was small and waterlogged, allowing little space for agriculture or crop cultivation. Despite the land constraints, British officials allowed separate residential areas ("towns") to spring up. For instance, wealthy settlers apportioned a separate space for trading and residence known as Portuguese Town. There was Melville Town, allocated mainly to the artisans, servants, and dependents of the early merchants, which became Jollof Town because of the predominance of Wolof in the area. Mocam Town, which later became Half-Die (because of a cholera epidemic in 1869 that killed almost half of the inhabitants of this area), was for poorer Africans. There was also Soldier Town, named after the servicemen who settled there.[52] With the onset of colonialism in Africa, colonial officials brought with them not only ideas (which were often contradictory) about how Africans could be ruled, but also ideas about how African spaces were to be planned. Writing about colonial settlement patterns, Bill Freund notes that "architectural adaptations on the one hand

influenced the increasingly important and emblematic way of life of an emerging African elite and, on the other hand, would be an effective weapon for intensified racial segregation and separation from Africa as a dominant European presence established itself."[53] Garth Myers also pointed out that "the construction of order in British colonial cities in Africa used architecture, landscape, and design features in political ways; shaped space in domestic and neighborhood environments; and gendered environments, to further the 'cultivation of public opinion on the spot,' to make the populace accept British rule and good will as commonsense reality."[54] One of the contradictions of spatial separation was that although Africans were placed in segregated locations, they interacted with Europeans on a daily basis as house workers, laborers, and clerks. These examples also show how differences in physical spaces characterized colonial policies and attitudes by keeping African communities at a distance, but at the same time keeping a watchful eye on them.

The population growth of Bathurst should also be seen against the backdrop of the mid-nineteenth-century religious wars, or the wars between the Muslims and non-Muslims, which disrupted economic activities, resulted in pillaged villages and hamlets, and caused social and political upheavals in the region. As a result of these wars, hundreds if not thousands of people migrated to Bathurst to seek refuge. For example, in 1887, when Said Matti (1850–1897), one of the leaders of these Muslim revolutions, sought sanctuary in Bathurst from the British, he also brought his family and supporters.[55]

Prominent among the new settlers in Bathurst were high Islamic scholars (the ulamas). These were the imams, the "petit" marabouts (junior clerics including Islamic teachers), and the qadi. The colonial government, in consultation with the Muslim community, often appointed the latter to their positions. In the case of qadiship, the post after its creation was ranked as third grade on the government's pay scale and carried a salary of one hundred pounds sterling per annum. Not only was this sum of money substantial at the time, but the position had prestige and honor.[56] Another issue that also factored in the competition among Muslims was the person's place of origin. Over time, the first Wolof settlers came to view others as not indigenous, and therefore not entitled to such positions as the qadiship. Hence, positions like qadiship and other leadership posts remained entangled in contestations between Bathurst Muslim elders for several years. Like most of Bathurst's African residents, these qadis mostly came from the hinterland, in the rural areas. Many of them came from the well-known clerical villages in the Gambia's North Bank region, including the villages of Daru, Medina Serigne Mass,

and Fass Omar Sakho. Many of the qadis came from prominent Muslim families with relatively strong local and regional ties. Like most young Muslim children, the qadis often studied the Quran in these villages before moving to places such as Futa Toro, Saint-Louis, Mauritania, or even North Africa for advanced training in *fiqh* or Islamic jurisprudence.[57]

This group of Islamic clerics learned Arabic in both its written and spoken form in Islamic schools called *dara* or *karanta*. Arabic has now become the medium of instruction in the proliferating alternative and formal Arabic/Islamic educational institutions known as madrassas. Often, the qadis were themselves teachers and had sizable followings both in and outside of Bathurst. They commanded respect for their knowledge; it was not difficult for colonial officials to distinguish them from the larger Muslim community. The Europeans saw Islam as a more "civilized" religious practice than any other religion besides Christianity, and thus would have looked upon Muslim religious training and Muslim courts as, in a sense, "progressive" institutions for Africans in their colonies.

Women in Colonial Bathurst, 1816 to 1965

As in other colonial towns in Africa, women formed a significant percentage of migrants to Bathurst. While the typical African colonial city initially contained far more men than women, scholarly studies have shown that towns provided African women with the opportunity to make money outside the confines of kinship and marriage. Some of these women played prominent roles in strengthening colonial rule and shaping the city, not only as wives and mothers but as businesswomen, vendors, domestic workers (for Europeans), brewers, and prostitutes.[58]

African women have often been portrayed in the academic literature as submissive, passive victims of male domination, weak and unable to speak for themselves.[59] However, with regard to legal ramifications, the history of Bathurst presents a unique tale of the opportunities afforded to women in challenging discrimination and violence. A number of women refused to be taken advantage of and brought cases to the European courts long before the Muslim court was established in 1905. In the late nineteenth and early twentieth centuries, the Bathurst newspapers were filled with reports of women who stood up for their rights and had to face English law to defend themselves against those who had allegedly wronged them. For example, in 1871, the *Bathurst Observer* reported on the trial of Marie Susan, a Bathurst woman

who went to court to challenge a wrongful imprisonment for contempt of court for "insisting on testifying in court in Wolof during hearings." Another woman, Binta Suwareh, was tried in the same year for allegedly trading in slaves. She hired the Bathurst lawyer Chase Walcott, who successfully defended her. In another landmark case, in late 1887, Horrijah Jobe, a young woman selling *coos* (millet) in the market, exchanged a plateful of *coos* for a leather bag with a strange man. The lady took the bag to a butcher friend's shop to sell it, and a man called Ebrima saw it and claimed that the bag had been stolen from him, with sundry items such as pagnes (cloth wraparounds), bangles, manilas, and cash in the amount of two pounds sterling. Ebrima reported the matter to the interpreter, Mr. Cashier, who arrested and detained the lady until other market women contributed the two pounds that Cashier had demanded from her for her release. Horrijah was so embarrassed by her detention that she decided to empty her savings to hire Bathurst lawyer Renner Maxwell and a leading scribe, John C. Gay, to help her properly articulate her case before the court and see that justice was done. The court heard testimony from eight people, including market women and white colonial officials. Cashier was found guilty of false imprisonment, extortion, and abuse of office, and was dismissed from his job. Horrijah emerged as a local hero in Bathurst for her successful stand against abuse of the rights of ordinary people by low-ranking colonial officials such as constables and interpreters.[60]

During the period under study, Muslim women in Bathurst attended local Arabic schools and became familiar with Islamic ideas and practices regarding the position of women in Islam. Colonial and Islamic laws enabled women not only to divorce their husbands, but to own and maintain property. Gambian women organized mass demonstrations against price increases in the 1920s and also frequented the courts to claim their marital rights and to mend conflicts within their families.[61] These examples are telling in that they show how women traversed the new legal landscape by contesting mistreatment and questioning issues important to them. Throughout the colonial period, women's lives were shaped by the laws, and they also used their agency to shape legal debates and create new discourses.

The opportunities local women had to contest their positions within the household can be attributed to a number of factors. The first was the presence of Europeans in the court. The British administrators usually observed court sessions, and at times a court decision was overturned by the higher court of appeals, where "Islam had no place." Second, the way Muslim judges interpreted the law often reveals a great deal about their educational background, their *tarikh*, and how

FIGURE 4. Bathurst Woman, 1940s.

SOURCE: USED COURTESY OF THE NATIONAL CENTRE FOR ARTS AND CULTURE, BANJUL, GAMBIA.

they used their positions as influential members of the Muslim community and the colonial society in which they lived.[62] Many of the qadis in the Gambia studied abroad at renowned Islamic centers in North Africa and the Middle East, thereby influencing religious and theological ideas and Islamic practices in the Gambia. Further, appeals cases in the Gambia at times established legal precedents used by other European colonial powers in Muslim societies, and vice versa. In this way, both the people and legal issues in Senegambia continued to be connected to the wider Islamic world.

Due to increasing migration from rural areas to the city, many women found themselves entangled by not only the web of the law but also civil conflicts raging at the time between Muslims and non-Muslims, as well as by wars between Europeans and Africans. Twentieth-century colonialism further disrupted a society that was

already fractured by years of conflict between Muslims and non-Muslims and divisions brought about by wars of European conquest in the Gambia. Additional factors contributing to social change include the disaggregation of kin groups and families and evolving definitions of rights that developed in response to the pressures of taxation, cash cropping, and urban and rural wage-labor employment. Related to these transformations were changes in identity, individuation, and the weakening of marriage bonds. For example, records show that most women went to the courts to seek divorce either for lack of maintenance and maltreatment or because the husband had abandoned his wife and family.

Marital Questions in a Changing Society

To understand how women used the courts, and to perceive the nature of marital problems in Bathurst during the colonial era requires further explanation of some important issues surrounding marriage. When the city of Bathurst was being settled in the 1800s, women and men brought their own understandings, ways, and practices of marital forms with them to the city. It is important to grasp these different experiences because they formed the basis upon which marital relations were built and contested in the courts. Above all, it is critical to better understand how marriage and marriage practices changed as colonial rule was being strengthened.

The creation of the Muslim court and the new legal developments transformed marriage discourse—what was being said about marriage and how married couples talked to each other—and thereby stimulated changes in women's livelihoods in many ways. First, the location of the court in an urban context marked a shift from customary ways of adjudication and from customary laws to the more formalized procedures of court hearings in institutions designed specifically for court matters. These new configurations included written and codified laws with bureaucratic structures that allowed qadis to refer to legal texts rather than basing their judgments on traditions, customs, and relationships. For example, as a present-day judge indicates, a major difference between Muslim judges today and the earlier qadis lies in codification:

> In the past there were no rules for proceedings; judges in those days based their proceedings according to what they knew in sharia law. The qadi court rules were not codified in those days. Now we have codified qadi court rules. We go

through those rules and make our actions and judgments justified according to the procedural rules.[63]

For Qadi Ceesay, the courts should rely on codified rules in all aspects of court procedures. Court decisions should be based on written statutes and guidelines rather than individual perceptions. Other qadi interviewees also agreed that their level and type of education distinguishes them from former qadis, as they have to be well versed in both sharia and common law, unlike past qadis, who were mostly knowledgeable in sharia.[64] As one of the qadis noted:

> In those days, our people were having their education here in the Gambia, Senegal, and Mauritania, and were very vast in sharia. What they lacked was formal training as judges. This is the formal training that we are undergoing in order to be more efficient. This is what brought these changes. After training from advanced universities people are beginning to appreciate our courts, as good enough to handle their problems.[65]

This informant seemed to be of the view that modern formal training is relevant in understanding and executing judicial matters. Nonetheless, despite the different systems of education that Muslim judges were trained under, the British relied on them to help run the colonial system. In West Africa, both the French and British depended on the knowledge and wisdom of Muslim rulers, which gave succor to the colonial system.[66]

The institutionalization of the court further set it apart from the traditional courts in that the new court provided some level of assurance not only for redress but also as a means and opportunity to appeal adverse decisions. Traditionally, village elders and clerics conducted local courts and made decisions based on their knowledge of customs and the Quran.[67] However, by the early twentieth century, local legal structures and institutions were crumbling under colonial pressure and increasing urbanization. Because of the presence of the British, and the limited venues for traditional judicial processes in the city, women tended to go to the newly created courts.[68]

The presence of Europeans provided an alternative authority to which women could turn in quarrels with their spouses or parents. As mentioned above, British officers sometimes sat in court to observe court proceedings and made comments whenever they saw it necessary. Gambians also responded to the courts because

the courts resonated with forms of traditional conflict resolution that involved third parties as mediators. Traditional Gambian society has a tendency to perceive mediators as trustworthy, knowledgeable, and therefore impartial. Mediators often cite the Hadith (the sayings of the Prophet Muhammad), which teaches that Muslims should be peaceful and should not argue with each other. Gambians hold common beliefs about divine rewards for peaceful people and temporal punishment for those who dispute with others.[69] Often, these strategies are based on proverbs and sayings. For example, an old Mandinka adage stresses that *hani ñiŋo ning neŋo I ka ňoo king ne* (at times one accidentally bites one's own tongue). In a sense, this is to say that conflict must necessarily occur between people who live together. It is a fact of life and therefore becomes inevitable. The Wolof also say, *su jege doon taxa doon xarit, kon ndox du togg jën* (if proximity is a measure of friendship, then fish would not be boiled in water). These sayings are based on the perceived notion that no matter what happens, members of the community must continue to live together.

It is important to recognize the minimal freedom women had to express themselves before these formalized courts came into existence. Such expression was not available to them in traditional courts. In many traditional African societies, women, and young women in particular, had the greatest difficulty making their voices heard due to the patriarchal nature of society. The new colonial legal systems, as Richard Roberts has shown, created opportunities for men and women with both old and new grievances to bring them forward in ways that were not available to them in the precolonial period.[70] Allan Christelow also notes that "the choices and strategies of litigants and the existence of potential alternative sources of judicial authority in the form of the qadi's court, the British administration, and the British courts all had influences in shaping legal realities."[71] Given this context, women in bondage and women and men with matrimonial problems went to the court whenever the opportunity presented itself, challenging preexisting legal structures and influencing court decisions.

However, it must also be pointed out that the British courts could also be places where conflicts were created, or more generally, could be instruments that produced conflicts within communities, for instance when people who normally accepted adjudications from local and religious leaders now took their cases to the new colonial courts. For instance, on April 1, 1913, during a court hearing between Muhammad Sawo and his wife, Jatou Gaye Sise, the qadi asked the couple to reconcile, but Sawo insisted on a divorce simply because his wife had brought the

matter to court.[72] In essence, he was implying that his wife should not have brought the matter to court in the first place. To Sawo, the wife's appearance in court in and of itself warranted a divorce. Indeed, it is important to understand cultural contexts and social relations, as they determined marriage patterns in colonial Gambia. Social and economic status of the accused was also important to local communities and usually affected the outcome of court cases.

The arrival of more settlers in the colonial city sparked the emergence of new patterns of social relations, mainly as a result of intermarriage between men and women from families with different customs. Hence, relationships that were mostly harmonious might begin to fracture along ethnic, social, or political lines. Because of the city's small size, settlement followed patterns of relationships, whereby new migrants followed in the footsteps of their kin and tended to live in relatively segregated neighborhoods. Such ethnic ghettoization necessarily led to relationships that were based on kith and kin. As the city grew, marriage patterns followed kinship lines and ensured the endurance of customs and traditions.

Nonetheless, these dense settlements also had underlying layers of tension and conflict that manifested in quarrels among family members and neighbors. Causes included disagreements over the upbringing and behavior of children, jealousy, and even the disposal of dirt, as it was the habit of women to sweep in and outside of their houses every morning. The disposal of dirt and other private household waste into public areas was often a topic of contention among neighbors and the city's administrative officials.[73]

It is also important to note that marriage dynamics became more problematic as more and more people from different cultural and social backgrounds moved to Bathurst. In this new multicultural urban community, strangers could more easily meet and marry without parental guidance. Caste groups and freeborns who could not have been traditionally married in villages could marry in Bathurst with less fear of censure. Also, in the city, some Muslim elders or clerics could formalize marriage, as they would probably be less conservative than their counterparts in the countryside. Besides, potential suitors would not have to undergo all the traditional rituals required for a marriage to be endorsed and blessed by the parents and the extended kin group. This freedom created a situation in which marital problems were compounded by the absence of "traditional support mechanisms"—whereby family members, elderly women and men, and village elders intervened in marriage disputes to solve them before they reached the formal or European-established courts.[74]

Lack of these support mechanisms in Bathurst, combined with the impact of colonialism and a growing sense of job insecurity in a wage-based economy, made marriages difficult, and at times men and women found it hard to remain in untenable marriages.[75] As some women took advantage of the few economic opportunities offered by the colonial city, they also became vulnerable to patriarchal jealousy, authority, and control. In this context, women went to the court because of its perception as a potentially fair and just arbitrator of conflicts between the city's residents.

Conclusion

In many ways, Bathurst, like other African colonial cities, came to be a place not only of contacts and fusions but also of differentiation and diffusion. During the period under study, Bathurst and the rest of the Gambian protectorate were undergoing tremendous sociopolitical and economic changes that impacted African-European relations as well as intra-African relations. The most important social development was a series of population movements from the rural protectorate to the city as a result of a number of factors, including fighting between Muslims and non-Muslims, and between Africans and Europeans.[76]

In essence, as the population of the tiny city increased, competition for space and the few jobs created by European officials and businesses also increased. Likewise, the sociocultural landscape of the city changed. Over time, many of the city's African residents became Muslims, and Islam became a major social marker of the city's identity.

Bathurst became an attraction to many migrants, including local Muslim scholars who ended up providing Islamic legal services to the city's dwellers. Activities in Bathurst also affected the rural and urban cultural landscapes as a result of the oscillating movement of people from the countryside to the city and vice versa. Most importantly for our purposes, Bathurst's residents were experiencing new ways and means of legal adjudication brought about by British colonialism. Some scholars have discussed how colonial officials hurriedly cobbled together European and African legal systems and appointed leaders whom they saw as fit to run these legal institutions. These local courts were run by Africans and would apply so-called native customary law, but they were expected to do so in a manner consistent with British legal principles and the objectives of the colonial administration.[77]

Significantly, these changes occurred in the Gambia when, as in some other African colonies, slavery and slave trading persisted, the effects of fighting between the Muslims and non-Muslims were still raw, and when many families had begun to unravel, and large numbers of Gambians converted to Islam.[78] In the midst of such upheaval, people migrated to Bathurst to seek refuge and start a new life.

Qadi Court: Crisis of Legitimization

I n March 1928, a group of Muslim elders in Bathurst (Banjul) filed an application in the Supreme Court for an injunction to restrain Omar Sowe, the spiritual leader (imam) of the city's central mosque, from leading prayers in this mosque. The elders alleged that Sowe condoned adultery, which, in their view, was a capital offense under Islamic law. The elders further alleged that the imam had officiated at the baptism of the illegitimate son of a Muslim elder and legislative council member, Ousman Jeng. Those most vocal in their accusations accused Jeng of adultery after he had fathered a child outside marriage. In addition, they accused the imam of solemnizing the birth of the child and officiating at Jeng's subsequent marriage to the woman who had borne his child.

Dismissal of the case in a lower court did not discourage the opponents of Jeng and Sowe. They proceeded to the Muslim or qadi court, only to see the case thrown out again; the colonial governor suspected that the qadi (Muslim judge) was a close friend of the complainant and therefore unable to render fair judgment.[1]

Following this legal setback, a section of the Muslim community represented by Momodou Jahumpa and Essa Drammeh were joined by numerous other Bathurst Muslim elders from the Juma (Mosque) Society. Jahumpa and Drammeh, along with the juma elders, made an appeal to the Gambia's Supreme Court, but the court ruled

that "Islam has no place in a British court."[2] Supreme Court Judge Aitken reasoned that the court had no power to decide right or wrong from a purely religious point of view and held that the alleged misconduct of the imam in condoning adultery was precisely a question of religion and not a question for a secular court. Following this, the petitioners alleged, "Islam was thrown out of court, trampled underfoot to vindicate the offending Imam, that it was a great insult to Muslims of Bathurst who have been greatly embittered."[3]

After all the legal maneuvers failed, the accusers petitioned the Prince of Wales and British MP T. Horabin, who raised the matter of the divisions between Bathurst Muslims in a British House of Commons debate in the 1930s. The crisis culminated in such high tension between Bathurst's Muslim community and colonial authorities that the latter were worried about a Muslim uprising. This fear of civil unrest led the colonial government to deploy the Gambia Company (of the Royal West African Frontier Force) in Bathurst and police guards at Government House. The government also replaced the guards at the bank and treasury with soldiers of the Royal West Africa Frontier Force, most of whom were not Muslim.[4] As for Jeng, he was not reelected to his legislative seat in 1932 after he ran out of favor with the Muslim community that he represented.[5]

What is particularly remarkable about this incident is how Africans in general and Gambians in particular navigated the new legal terrain developed by the Europeans, and the amount of furor the case generated. The incident is clearly a microcosm of the tension that existed between individuals, community groups, and the then recently established colonial court in the Gambia in the early twentieth century. It reveals the contentious nature of the establishment and implementation of the new European law and shows that relationships in colonial Bathurst were complex, interrelated, and dependent not only on traditional, individual, and communal mores and beliefs but also, to a large extent, on the new political circumstances brought about by the presence of the British. It also reveals colonial authorities' interference in the Muslim court system and their ambivalence toward it in contrast to their efforts to appease Muslim elders and to ensure that peace and tranquility prevailed in the colony.

The case shows the importance of Islam to certain groups of people in Bathurst at that time and demonstrates that Muslims were divided over political and religious representation. The case was important to Muslim elders because of their concerns about what they saw as a collapse of moral authority in society, and their belief that those who are charged with upholding moral authority in society should lead by example.

The growth and development of the Muslim court and its judicial parameters—functions of the court and opportunities for appeal—show that the establishment of the Muslim court by colonial officials marked a shift from a reliance on custom and tradition to a more formalized public institution. The differences and frictions in the city's Muslim population emerged as conflicts and tensions that were perpetuated by the establishment of other, similar Islamic institutions like the Bathurst Mosque and the Muhammadan School. In other words, control over the management of these three institutions (the Muslim Court, the Muhammadan School, and the Bathurst Mosque) remained at the center of contestations in the intra-Muslim struggles. Hence, to understand the connection between the Muslim court and these institutions involves understanding not only the changes that followed their establishment but also the dynamic relations between the city's inhabitants. The British responded to some of these problems because they were concerned about the proper functioning of the colonial state, including the maintenance of law and order. In part, the study of the Bathurst Muslim court serves as a window through which to view the broad parameters of intra-Muslim divisions and the processes by which men and women positioned themselves in the changing colonial city.

If one hopes to comprehend the process by which these transformations occurred and to gain a broad picture of the political, economic, and social changes introduced during the colonial period, as suggested by Carol Dickerman, then the courts themselves—their composition and context—merit scrutiny, for they testify to the dynamic interactions between the colonial government and Africans and provide much insight into how British rule worked.[6] To describe the transformation of norms and customs into laws, one must analyze not only the body of rulings but also the institutional context, the courts themselves.

The Centrality of the Qadi Court: Origins and Development

For colonial rule to be effective without an army of administrators, the British had to incorporate African ideas of law and custom into the new European-introduced legal systems. European administrators struggled with the question of how customary law could best be used in African courts. This, according to Brett Shadle, was the case in Kenya, where from at least 1920 but especially in the 1940s and 1950s administrators were concerned with the codification of customary law and vigorously fought against it. British officials believed that reducing African custom

to written law and placing it in a code would crystallize it, altering its fundamentally fluid or revolutionary nature.[7] Despite this ambivalence in colonial policy, Kristin Mann and Richard Roberts argue, the invention and eventual codification of custom solidified fluid cultural and legal ideas and relationships into reproducible rules. These rules were not only reproducible but unalterable.[8]

From 1816, colonial administrators had to grapple with how to govern colonies like Bathurst and other African possessions "on the cheap." Clearly, the colonial power had to maintain law and order on the ground, but politicians insisted that colonies be self-reliant. That is, metropolitan taxpayers would not be called on to maintain the empire. As a result, British administrators decided to govern through indirect rule. That is, they allowed traditional African leaders to maintain their positions when and where possible, and to apply African law to local matters, while compelling them to carry out British policy and aims. Needless to say, the system transformed the nature of tradition, as African leaders were called on to do the bidding of a foreign power. Further, in the realm of law, tradition was transformed as a new class of African judges administered what was, supposedly, age-old customary law.[9] Hence, British administrators sat down with Africans who they assumed were knowledgeable, codified customary law, and then called on judges they appointed to apply it. In Muslim areas, that law was sharia and was used in qadi courts that to this day oversee civil disputes. In places like northern Nigeria, the colonial authorities added another complication by defining customary law as including Islamic law, the glaring differences between the two systems of law notwithstanding.[10]

In Bathurst as in many parts of Africa, European rule gave birth to a court system that relied on sharia/Islamic law. What complicated the relationship between Islamic law and European law even further is that sharia not only encompasses secular aspects of the law such as taxation, homicide, and inheritance but also includes social and ritual components. What foods may one eat? What clothes may one wear? How and when should one pray? Also, Islamic law offers a variety of traditions (Hanafi, Maliki, Shafi'i, and Hanbali), and they serve as the basis for distinct ritual-legal communities within the wider community of Islam. Each tradition has developed a corpus of texts dealing with both general methods of legal reasoning and specific legal questions.[11]

At the inception of colonial rule in Muslim areas in Africa, Europeans expressed the need to work with African leaders by the institution of Muslim courts for the maintenance of law and order. For example, Great Britain established such a court

in its massive colony of Nigeria in 1903, the same year that France instituted similar courts in the four French communes of Senegal and in the larger French Soudan.[12] France's creating these courts, argues the historian David Robinson, fostered an atmosphere of dependence that encouraged Senegalese Muslims to accept the compatibility of foreign rule and Islamic culture.[13] During the late eighteenth and early nineteenth centuries, the colony of Bathurst had all the important legal institutions—the magistrate court, the Supreme Court, and the police magistrate court—for the perpetuation of such an order.

These legal institutions, in the view of Bathurst Muslim elders, were Christian, and in 1905 they initiated negotiations for their cases to be heard by a qadi rather than in these British courts.[14] The Muslim population in Bathurst by early 1911 numbered 4,993 out of a total population of 7,700.[15] It was these Muslims who began to demand the institutionalization of Muslim affairs. For nearly a century, the Muslim population had had their cases heard by the European courts, a source of dissatisfaction among Muslims who did not wish to be judged by non-Muslims. Europeans eventually gave in to the demands of Muslim elders in Bathurst to establish a Muslim court in the city, and it would take a few decades for another court to be established in Kombo under Section 61–67, Part 7, of the Kombo Saint Mary Division Ordinance of 1946.[16]

The Muslim court derived its powers from, and functioned under, legislation such as the Muhammadan Law Recognition Ordinance (1905), the Muhammadan Court Rules (1917), and the Muhammadan Marriage and Divorce Act (1941). The court had jurisdiction in all cases and matters, contentious or not, exclusively between Africans relating to civil status, marriage, succession, donations, testament, and guardianship. The court had no criminal jurisdiction.[17]

In matters of appeal, decisions of the court went to the Supreme Court. A *tafsir*, or person learned in Muslim law, sat as assessor to the judge of the Supreme Court in all such appeals for advisory purposes only. No appeal was possible in matters involving less than five pounds sterling except by leave of the court. The qadi was considered a civil servant, third grade, with an annual salary of one hundred pounds. An Arabic clerk, fourth grade, who received a salary of fifty pounds annually, was also attached to the post.[18] The majority of the cases brought before the qadi were marital disputes, divorce suits, child custody disputes, maintenance, abuse, and settlement of dowry. This process has precedents in other British colonies. Muslims in Freetown, Sierra Leone, and Lagos, Nigeria, petitioned the local colonial governments to have Islamic law govern their legal relationships. The Sierra Leone

administration obliged with a Muslim marriage ordinance that recognized three areas of Islamic law—marriage, divorce, and intestate succession.[19] In the Gambia, the court was located in Bathurst, but its jurisdiction covered both the colony and protectorate, as evidenced in the numerous cases brought before the qadi in Bathurst from the protectorate. Moreover, the court's jurisdiction extended beyond the city's Muslim population to those Christian men and women who were either married to Muslims or had civil disputes with Muslims.

To understand fully the role played by the Muslim court in shaping the history of Bathurst, it is important to grasp the textures, passions, and routines of everyday life in the colonial city. What was daily life like for a cross-section of women and men in Bathurst, and how can these experiences be gleaned from the court records? One fascinating example was the case of Sainabou John, a Christian woman who, on August 14, 1913, appeared before the qadi of Bathurst and swore on the Bible that her husband, Ousman Njie, used to punish and insult her:

> One day, he said to me, "I will put my foot into your mother's private part." He also used to refuse me to visit even my parents and beat me while I was pregnant. I left and went to my parent's home and my father refused me to go back to my husband because of the punishment and the state of my pregnancy. I gave birth and the baby died.[20]

The qadi asked the husband to respond to his wife's claims. Ousman said that the reason for beating Sainabou was that she used to urinate in bed. The qadi then asked the witnesses, and they all testified that the husband used to mistreat the wife. Then the qadi ordered divorce and warned the husband to pay for the upkeep of the children. Another intriguing example was the case of Muhammad Dimbalan and his wife Fatou Secka. On August 18, 1927, Muhammad brought his wife, Fatou, in front of the qadi of Bathurst. In his testimony, Muhammad complained:

> My wife always refuses to sleep with me. I came to her during the night in question but she refused. She told me that she was breastfeeding. I told her that if she had warned me of her behavior, I would not have married her. I tried to have a relationship with her but she kicked me. I got up and beat her. I left and went to one of my friends, who asked me to go and talk to my brother Ebrima Dimbalan about it. Ebrima asked me to be patient. I also went to one Liban Sise and told him that now I am afraid of Fatou. He also asked me to be patient. Then I went back home.

In the morning, I purchased breakfast but she did not eat. She also refused to draw water for me in order to take a shower. After that I went to the river and washed. One Isatou Lam told me that my wife did wrong by not giving me water to wash.

In her defense, Fatou said:

My husband came home one night and wanted to sleep with me. I asked him to wait till the following day and he said no. He insisted that I must sleep with him. I told him that my child is sick and the bed is too small. He told me that he has been waiting for four months at no avail. Then he got angry and beat me but I did not kick him. The following day he asked me to cook but I could not because the child is sick. Above all, he has not been supportive. He always refuses to give us money and food.

When the qadi had heard the disputants, he ordered divorce.[21]

A similar interesting case involved Kodou Fye, who, on October 6, 1927, brought her husband, Modou Secka, to the qadi of Bathurst. In her testimony, Kodou reported: "We have been married for a while now and we had a child who passed away. For two years now my husband cannot perform in bed. I told the Alkali [head of the village] about my husband's impotency so he could talk to him about it." In his defense, Modou said: "We have been married since 1920. In 1921 we went to Kuntaur and Jorr [Central River region]. At Jorr, she contracted leprosy and had a miscarriage. Would she become pregnant if I am impotent?" At that point the wife interrupted and said, "My husband is lying; even one Fatou Jeng knows that my husband is impotent." The husband then informed the qadi: "The reason I don't sleep with her is because of her sickness." The qadi advised the wife to seek treatment, but she chose divorce.[22]

These cases signify the dynamic interplay of social relations in early Bathurst and the role of the qadi court in dispute resolution. Besides showing the inconvenient aspects of everyday life for women at the time, the first case brings to light the relationships between Muslims and Christians, as they both could bring their cases to the qadi court. It is curious that while the wife contended the husband's abusive practice and his disrespect for her parents, the husband was categorical about the wife's bed-wetting habit. Also, it would be interesting to know whether the husband's contempt for the wife's parents hinged on the wife's Christian background or his disrespect for the wife. Traditionally, husbands are expected to give respect to

their in-laws based on the principle that by giving a wife to a man, the in-laws have created a world for the man. Furthermore, it is abnormal in traditional Gambia for couples to insult each other's parents. In some quarters, it could lead to a divorce.

The third case summons a controversial and complicated issue of impotency because it means that the husband cannot fulfill his marital duties. However, this case is problematic because both the husband and wife accused each other of being sick. The wife in her statement insisted that the husband was impotent, while the husband also argued that the wife was ill. According to Islam, when a man cannot fulfill his marital duties for reasons of impotency, a wife can release herself from such a marriage. Why did the qadi ask the wife to seek treatment and not the husband? Why did the wife admit being previously pregnant but claimed the husband's impotency? Why did the husband also publicly allege the wife's sickness? Though answers to these questions will always remain in doubt, they highlight interesting gender dynamics in the social relations of Bathurst. By revealing each other's sickness in court, both husband and wife violated marriage norms, because such issues bordered on matters that were traditionally discussed only in private. The public discussion of such cases made the resolution of marriages difficult and problematic.

Importantly, the second and third cases revealed that though marriage was the affair of a man and his wife, it was also a community concern. In these instances, both the husband and the wife consulted friends, relatives, fathers, and in-laws to make the marriage amenable. As is clear in both cases, women could also utilize their disadvantaged positions in court to argue for more rights and/or better treatment.

As the evidence demonstrates, the Muslim court became critical in the settlement of domestic feuds and conflicts among urban residents, and the court was essential to the maintenance of peace and stability in the colonial city and protectorate. One of the main reasons why British authorities instituted the Muslim court was to maintain what they considered as peace and stability in a region fractured by years of religious conflicts and tensions, not only among Africans but between Africans and Europeans. In some ways, these conflicts generated mistrust between Europeans and the larger Muslim communities.[23]

The imposition of colonial rule compelled European officials to work with African chiefs and rulers, including Muslim clerics who had been acting as judges before the arrival of the colonizers.[24] In order to ensure that the qadi courts would be legitimized and trusted by Muslims, the colonial administration chose qadis

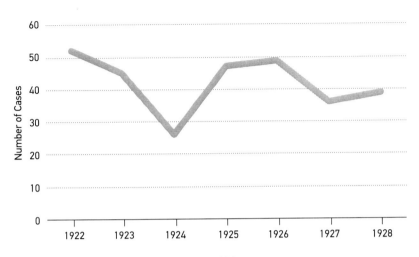

FIGURE 5. Number of Qadi Court Cases, 1922–1928

from among Muslims based on their Islamic education and connections. Qadis enjoyed respect and recognition from the society due to their intellectual and cultural contributions, and they were also esteemed for their esoteric knowledge. Qadis were people with whom colonial rulers could work to contain Muslims and to peacefully administer the colony and the protectorate. The relationship between the British and qadis also shows that colonial rule was made possible partly because of the results of Muslim leaders' involvement in the colonial machinery.[25]

From the time of its establishment, the court remained busy. For instance, during the first five years of existence (its first sitting was in 1906), it dealt with 79 cases, and from then onward the number of cases kept a slow but steady growth. From 1922 to 1928, the court dealt with 294 cases.[26] During the 1930s, the number of cases increased slightly. After only 18 cases in 1933, the numbers increased to 44 in 1934 and 52 in 1935. From 1937 to 1939, the court heard 452 cases.[27] Figure 5 shows the distribution of cases from 1922 to 1928. However, in the 1950s, the number of cases increased significantly. For instance, in 1952 alone, 164 cases were handled by the court, increasing to 182 in 1953 before they dropped to 136 in 1954 and 124 in 1955. The cases decreased slightly for the next three years, but increased to 159 in 1959 and 165 in 1960. The inconsistency of the number of cases in a particular year largely depends on the number of cases brought before the court and the willingness of the qadi to try the cases in court, or in his ability to try a high number of cases. At times, qadis advised litigants to settle their cases at home in a family environment,

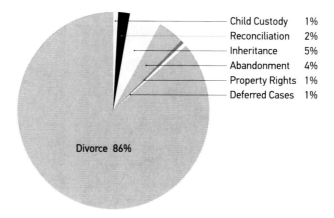

Child Custody 1%
Reconciliation 2%
Inheritance 5%
Abandonment 4%
Property Rights 1%
Deferred Cases 1%

Divorce 86%

FIGURE 6. Number of Qadi Court Cases, 1952–1955

or they referred cases to village heads, the police court, and the Supreme Court. Also, the frequency of court hearings depended on the age of the qadi, as younger qadis tend to hear more cases.[28]

From the time of its inception, the qadi court remained central to addressing not only the matrimonial problems of the Muslim communities, but other social problems such as slavery and other property rights issues. Despite its role, the court has often come under criticism from some colonial officials. A Supreme Court judge in a report of 1929 said that "In practice the Qadi decides nothing except how to end or mend unhappy marriages. In order, he functions solely as a matrimonial referee. It seems curious that it should even have been deemed necessary to constitute a special court to deal with such matters."[29] Another major consequence of the difference between Muslim elders was the idea from then Chief Justice Aitken in late 1929 to abolish the Muslim court. However, the governor insisted that it would be a mistake to do so because it had a certain value, even if at times it was more of a club than a court. It was a meeting place for Muslims, and it was something that they felt was theirs; its abolishment would have been regarded as a retrogressive step.[30] Figure 6 shows the distribution of the types of cases.

The results in this chart concur well with the earlier opinion of the Supreme Court judge. During these years, over 86 percent of cases ended up in divorce, bearing in mind that child custody is an issue of divorce and women would choose divorce in most abandonment cases. The divorce cases usually involved domestic quarrels over abuse, jealousy, and maintenance. The high rate of divorce did not

mean that most women went to the court to seek divorce. According to the records, some women went to court to ask the qadi to reconcile them with their husbands, but in the process of adjudication the matter would end in a divorce.

At this point, it is interesting to look at whether the type of cases that came before the court varied in the gender of those who brought forth cases, or whether cases increased over time. Comparing the court record books of 1927 to 1930 and from 1952 to 1955 gives an indication of these variations. Records from 1927 to 1930 show that almost equal numbers of men and women were bringing forward cases against spouses, but from 1952 to 1955, more women brought claims against their husbands than vice versa, and these cases usually ended up in divorce. It is reasonable to suggest that, over time, more women than men trusted the qadi court as a place where they could receive a positive outcome. But the increase in the percentage of cases brought forth by women could also be the individual effort of the qadi at the time, Mass Abdou Rahman Jobe, who because of his social connections in Bathurst and his education may have shown more leniency toward women.[31]

However, despite British doubts about the function of the qadi court, Muslim matrimonial issues eventually became the concern of colonial officials. In 1937, a marriage license to be issued by native tribunals was proposed. According to the opinion of many colonial officials, the license was meant "to reduce the number of thoroughly unsatisfactory matrimonial cases which are so common in Native Tribunals, and marriages could not be recognized in a Native Tribunal, and no case would lie for a claim for refund of dower if not issued a marriage license."[32] However, the local traditional authorities (chiefs) opposed the marriage license on the grounds that "it is bringing government into a matter where it has no concern and that marriage dower should be recorded according to custom."[33] This is an indication that the British were either not sure of what policies to implement or had no clear understanding of Muslim issues or Islamic laws. This lack of a definitive understanding of Muslim law led to difficulties in how Muslim law should be interpreted.

British Officials, Muslim Leaders, and the City of Bathurst

One needs to appreciate why the British colonial administrators were quick to accede to Muslim demands for a separate legal system and school, and why the Muslim elders remained entangled in personal disputes. Here, it is essential to

examine how and why the struggles and contestations between the Bathurst Muslim elders, Christians, and the colonial establishment related to the political, social, and economic issues of the time.

Muslim elders of Bathurst were concerned about politics and wanted to be represented in the Legislative Council, to sit side by side with their fellow Africans. African representation on the Legislative Council started in 1867, but until 1920 the legislators were always Christians, such as Samuel Forster and S. Hortin Jones. Muslims felt underrepresented and left out in making important decisions about issues that concerned them, and so they made efforts to be politically represented.

Socially, the Muslims were concerned with having a Muslim-friendly educational and legal system, as many of them preferred not to send their children to Christian missionary schools (Stanley Street School, Dobson Wesleyan School, Methodist Boys and Girls High School), and they were not satisfied taking their civil complaints to the European court system, which they considered Christian. The elders also demanded Muslim schools, since they saw education as a vehicle that could allow them to compete with their Christian brothers and sisters in politics and job opportunities offered by colonial rule. Above all, an educated Muslim class could also increase their chances to have a seat in the Legislative Council. Importantly, the Muslims realized that in order to gain influence, they had to be employable in the colonial civil service, and therefore they had to be formally educated. Arnold Hughes and Harry Gailey indicate that Muslim elders were worried about their Christian brothers and sisters occupying most of the jobs available to Africans. They note that leaders like Momodou Jahumpa sought to play on the grievances of Bathurst Muslims, particularly with respect to the dominance of the smaller Christian community in public life and modern employment.[34]

How and to what extent the Muslim majority could be a part of the economic establishment of the colony was also a subject of concern for some Muslims. Most of the import and export trade from the mid-nineteenth century to the early twentieth century was in the hands of the European firms such as Barthez, Bathurst Trading Company, and Compagnie Française de l'Afrique Occidentale. Aku (liberated African) merchant families such as the Carrols, Joneses, and Goddards, also had a hand in such trade. Another merchant group was the Bathurst Muslim Wolofs, who were dependent to a large extent on the European firms and Aku merchants to finance their trade, particularly in groundnuts.

British colonial officials were also interested in working with and appeasing the Muslim community because of the challenge of maintaining peace and order.

The British were worried about a repetition of the wars between Muslims and non-Muslims in Senegambia that had persisted throughout the second half of the nineteenth century. The British were involved in these wars, which had led to mistrust, anxiety, and apprehension between the Africans and the colonial establishment. The colonial government was also keen to maintain peace because the fighting had adversely affected trade in the protectorate. In fact, in some reports, continuity of trade appeared to be the main concern of the British. In 1867, Governor Samuel Wensley Blackall reported: "I am sorry to find in my arrival here two 'tribes' with both of whom this government is at peace. They have commenced war again and British trade has been interfered with. I do not wish to interfere in their quarrels; I am in neutrality as long as both parties will respect the property of British merchants and not permit their trade to be interrupted."[35] In his reply to the governor, Chief Arafang Jorbateh made it clear that

> Because we want to protect the White man's trade and goods, we have built a stockade near the Wharf of MacCarthy Island and we have lost twelve men killed by the marabouts on account of the White people who are our friends. As this stockade is now built on the wharf, the White man's goods will be safe in our hands from attacks by Jamally marabouts.[36]

Consequently, these conflicts elicited a dramatic response to Muslim elders' demands in the establishment of the Muhammadan School in 1903, which offered both Quranic and Western education, and also the formation of the Muhammadan Court in 1905. The quick response to Muslim demands can also partly be explained by the goodwill of British governors such as Sir George C. Denton (1901–1911), who was particularly interested in Muslim affairs. It was under Denton's watch that both the Muhammadan School and Court were established.[37]

Muhammadan School

The establishment of the Muslim court, the Muhammadan School, and the Bathurst Mosque in many respects together symbolize the tensions that were already brewing not only between Africans and Europeans but also among the Africans themselves. The settlement of Bathurst in 1816 saw the development of Christian mission schools at the request of Sir Charles MacCarthy, the first

governor of the Gambia. For instance, in 1821 the Society of the Friends of Wesleyan Missionaries opened the first schools in Cape Saint Mary's and Bathurst, and later at MacCarthy Island in the interior of the country.[38] Unlike their Muslim counterparts, the Christian community therefore enjoyed many years of Western education, which made them employable in the colonial service. In fact, Lamin Sanneh points to similar developments in Sierra Leone, where one of the paramount desires of the Muslim population was to emulate Christian performance in modern education. To Sanneh, the Christian example was the direct, although sometimes hidden, stimulus for Muslim efforts in achieving their desire to gain European education.[39]

To this end, the colonial rulers met an earlier demand of the Bathurst Muslims for a Western school where they could study the Quran in the evenings and read the Western curriculum in the mornings. This meant that Muslims would study in English schools and be trained in British education and culture, yet retain their Muslim identity and culture. This led to the establishment of the aforementioned Muhammadan School. However, because of its central position as an employer of high-ranking Muslims and a champion of Muslim identity, the school quickly became a center of contestation.[40]

The Muhammadan School came under the control of the trustees of Bathurst Muslim elders. It enjoyed a grant-in-aid of five hundred pounds annually given by the government of the Gambia, and twenty pounds annually for repairs. The governor in 1929 ordered that the management of the school and the board of trustees must include Ousman Jeng, a member of the Legislative Council; the European inspector of schools; and the imam of Banjul, Omar Sowe. However, some Muslim elders, including Momodou Jahumpa, a trustee of the Muhammadan School, rejected the governor's decision. Jahumpa in particular was accused of hiring out the school building for dances to pocket the revenue and gain from other benefits. Jahumpa and his supporters in the Bathurst Muslim community, in a petition to the secretary of state for the colonies dated September 2, 1929, argued that neither the subvention made toward the upkeep of the school in the cause of education, nor Ousman Jeng's nominal position on the Legislative Council was sufficient authority against the trustees' legal right to substitute a school board in the best interest of their religion and their community.[41]

Another demand by the Muslim elders of Bathurst, which was also met by the colonial authorities, was to have a member on the Legislative Council. In 1920 Governor Cecil Hamilton Armitage granted Muslim elders the privilege of electing

by public vote a representative of Muslim interests on the Legislative Council; Ousman Jeng won the seat, beating Sheikh Omar Faye among other candidates. However, after Jeng's first term on the council, the government disregarded the electoral process and simply reappointed him by nomination, despite the protests made against this procedure by Muslim elders. Jeng continued to sit on the council until he was replaced in 1932.[42] These issues show the self-interest hidden within the guardianship role that the British used to justify their rule over others. While the colonial power established cultural institutions—schools, courts, and assemblies—to administer community affairs and gave Muslim leaders some political and administrative authority, ultimate power of selection and appointment remained firmly in the hands of the British, who could (and did) change the rules whenever they saw fit without consulting their colonial subjects.

The controversy surrounding the Muhammadan School centered on allegations of adultery against Jeng and Imam Omar Sowe's support of such immoral conduct. Furthermore, Jahumpa and his colleagues believed that these offenses were against Islam and therefore sufficient cause to exclude Jeng and Sowe from the management of the school.[43] By invoking Islamic laws, Jahumpa and his colleagues were fervent in their determination to remove Jeng and Sowe from office.

The problems of the Muhammadan School became so serious that the matter found its way to London. On April 11, 1930, in the House of Commons, Tom Horabin asked why the government of the Gambia permitted the use of a school building (the Muhammadan School) for a meeting of the Ship Owners' Association while refusing the use of a similar facility to the Bathurst Trade Union.[44] It can be seen here that the quarrels surrounding the school spilled over into relations between different social groups and institutions in Bathurst—the Ship Owners' Association, the Bathurst Trade Union, and the Bathurst Mosque. The Bathurst Mosque was considered an especially important institution to control because of the size of its congregation and its centrality in the lives of Bathurst Muslims.

The Bathurst Mosque

Pivotal to the conflicts among Bathurst Muslim elders were the position of imam and the membership of the Bathurst Mosque. The development of the Bathurst Mosque was directly connected to the growth of the Muslim court system, as they were the two most revered Muslim institutions in the city and control over

them was zealously contested. The leaders of the two institutions were always in agreement whenever there was dispute among Muslims. Perhaps it was important for the qadi and the imam to always remain in a favorable light in the eyes of the colonial government as responsible Muslim leaders; the qadi, after all, was on the government's payroll. Although the imam was not on the government's payroll, the British authorities had a vested interest in the management of the mosque in order to keep a watchful eye on the activities of the Muslim population.

The story of Bathurst Mosque, located along what is now Independence Drive, started in 1854 when the governor allocated a plot of land for the mosque to three Muslim elders who requested it on behalf of Bathurst Muslims. A grass hut was built on the site for worship. Soon it became apparent that the building was too small, and Imam Makaude Amar led efforts to build a permanent structure in the mid-1880s. Money collected among the faithful yielded enough to begin construction. The direction and control of the building project was left in the hands of the master carpenter, Momodou Njie of the Muslim Carpenters Society. Every member of the community who was able to give labor for free in God's name did so. The mosque was built by the community for the community. Therefore, it could not be the property of any person or society.[45]

The next imam of the mosque was Ousman Gormak Njie, who was in turn replaced by Momodou Njie. Momodou Njie remained as imam for twenty-six years; during his time, extensive alterations and refurbishments were done by his Muslim Carpenters Society with funding from Muslims, merchant firms, government officials, and Governor George Denton. Therefore, it could be argued that the Muslim community gave the Carpenters Society the honor of selecting the imams of the mosque. After some time, one group splintered off from the Carpenters Society, namely, the Juma (Mosque) Society or Meri Kebbeh Society, which was not registered but which claimed to be an ally of the Carpenters Society. It was the Juma Society in 1930 that brought the case against Jeng and Imam Omar Sowe. The society had members like Meri Kebbeh, Momodou Jahumpa, Cham Chareh, and Masatey Jahateh.[46]

The emergence of voluntary associations in Bathurst was part of a much larger process that saw new social networks emerge in most, if not all, colonial African cities. Such associations, Bill Freund notes, were eminently practical in the creation of networks that sustained economic linkages, and as providers of prestige and status.[47] In Bathurst, members of these associations supported each other socially and economically by attending other members' social functions (naming and

FIGURE 7. New Banjul Mosque.

marriage ceremonies, and death rituals) as well as standing together in opposing other associations.[48]

What also makes the mosque essential not only in the development of Bathurst and Gambian society generally is the quest to control the position of imam. The imam is regarded as spiritual leader and moral guardian, and it is generally believed that the position carries weight in the eyes of God. Therefore, its control is usually hotly contested, as those of low caste and slave origins are normally barred from being imams. Indeed, the control of imamship in Banjul has long remained embroiled in controversy. For example, according to my informant, Sheik Omar Faye, a former Muslim legislative member and revered Islamic scholar, he was once denied the post of imam of the Bathurst central mosque because of his caste origins.[49] The controversy surrounding the Banjul Mosque resurfaced recently. A conflict arose over who should inherit the mantle of imam as potential candidates were disqualified based on their caste and place of origin. The crisis eventually summoned the intervention of the national government.[50]

Contested Terrain: The Intra-Muslim Rivalry

The intra-Muslim dispute, which for years had afflicted the social and religious establishment of Bathurst and divided their ranks into rival factions, was finally settled in September 1935, when, at a meeting of nine hundred Muslims representing all sections of Bathurst, a new Muhammadan Society was formed with a view to promoting unity, order, and good government for the Muslim community of Bathurst.[51]

As in other African colonies with Muslim subjects, Bathurst Muslims found it difficult to work with colonial officials at a time of acrimonious intra-Muslim tensions. Ousman Kobo notes that Muslims in colonial Ghana largely saw themselves as a community united by a common faith, witnessed in 1948 by the formation of a Muslim Association to claim government support to rebuild their homes devastated by an earthquake. In this venture, the Muslims also sponsored candidates for municipal elections in Accra and Kumasi, and these candidates went on to win a number of municipal council seats in these two largest cities of the Gold Coast.[52] However, it would seem reasonable at this point to ask why it was easier for the Muslim communities in Bathurst to deal with colonial masters than to work together as a community; the many different Muslim associations that were created in Bathurst and the divergence of views among the Muslim elders worked against community unity.

The problems that emerged in the Bathurst Muslim court were of a different nature than the conflicts and tensions that troubled the Muslim court of Kaye, Senegal. Rather than fighting to become colonial citizens, the Bathurst Muslim elders were struggling to have a separate legal system that would address the needs and aspirations of Muslims in the Gambia Colony and Protectorate.[53] Consequently, as colonial rule progressed, it became apparent that the local Muslim community remained divided over issues such as the qadiship, management of the Muhammadan School, the imamship of the Bathurst Mosque, and political representation in the Legislative Council. First, the political differentiation centered on the moderate versus the radical tendency among African elders in Bathurst, an issue that affected both the Christian and the Muslim communities. The moderate faction was perceived to be closer to the colonial establishment and included Sheikh Ousman Jeng, the first Muslim member of the Legislative Council, and Sir Samuel Forster (a Christian), the longest-serving Legislative Council member (1906–1940). The radicals, who were seen as anticolonial, included Sheik Omar

Faye, a Muslim legislative member, and Edward Francis Small, a Christian trade unionist.

Ethnically, Muslim leaders remained divided over places of birth and caste origins, which in many African societies engender friction and acrimony. For example, part of the opposition to Jeng's appointment as a Muslim member of the Legislative Council was based upon perception that he was of metalsmith origin, which disqualified him for a leadership position. Also, some of his opponents, such as Sheikh Omar Faye, were seen to be of griot (musician) origin, which was also largely regarded as low caste. As J. Ayo Dele Langley suggests, the cleavage in the Muslim community derived not only from caste and class divisions, but also from differences of a religious nature.[54] For example, each faction leader belonged to a different Islamic *tarikh*, namely Tijaniyyaa and Qadiriyya. As discussed previously, most local clerics embraced either one or the other of these two religious orders.

Muslims also opposed each other in holding key positions in government. For instance, Cherno Jagne, one of the Bathurst Muslim elders, wrote to the acting colonial secretary in 1935 regarding the retention of one Mr. Ousman G. Njie on the staff of the Muhammadan School:

> I am to state, Sir, that my fellow signatories desire me to express to you, for the information of His Excellency, our great disappointment at this decision, for us, even had Mr. Njie possessed all the merits (which we did not concede) attributed to him by His Excellency's adviser, we, as Muslims, feel it against the dictates of our religion, to place our religion, to place our children, under the control of one, whose status in Islam today, is that of an enemy of the faith, under the present circumstances, the only courses open to us, as parents and guardians of the pupils, is to reluctantly remove our children from the school, thus taking them from the "orbit" of Ousman Njie's influence.[55]

The retention of Njie on the staff of the Muhammadan School continued to be a source of dissent among the Muslim communities. Njie's case was another example of the infighting between the Jeng and Faye factions (Jeng's was pro-government, whereas Faye was seen as an agitator).[56] "In Bathurst, colonial municipal politics revolved around the Muhammadan Community which had its internal differentiation and cleavages," Langley wrote. "Some of these differences were over opposition or support by leading Bathurst Muhammadan elders to the Nationalist Association of the NCBWA (National Council for British West Africa, established in the 1920s)."[57]

By and large, differences in the Muslim community in Bathurst essentially turned on the question of elective representation. As explained in the opening story of this chapter, part of the underlying tension behind this cleavage was the accusation leveled against Ousman Jeng of adultery and Imam Omar Sowe of condoning the infidelity. In Bathurst, the majority of the Muslims followed the conservative "no change" line of Ousman Jeng, but an influential minority desired a modest form of elective representation. Momodou Jahumpa, Essa Drammeh, and other Muslim elders persisted in their effort to disallow Jeng and Sowe a place in the leadership of Bathurst Muslims. After all the legal maneuvers failed, the accusers petitioned the Prince of Wales and British MP Tom Horabin. The petitioners were acting on the presumption that a charter of religious right and liberty had been given to them by the Prince of Wales on the occasion of his memorable visit to the Gambia; he declared on that occasion:

> The King is my father, under whose rule you have complete freedom to worship the one True God, has charged me to give you a message of good will, for he has heard with pleasure that you dwell side by side with other races and religions in peace, keeping the law which is administered to you by the Qadi in your own court.[58]

The accusers hoped that their petition would be upheld, because they regarded this allegation as a matter of public importance affecting the policy of the administration and the mutual loyalty that bound all the Muslims living under the Christian government. One of the main concerns of Jahumpa, Drammeh, and their supporters was for Jeng and Sowe to be tried in an Islamic court; if found guilty, they would be no longer recognized by the government as leaders and representatives of the Muslim population.[59]

The problems between Muslim elders were so serious that colonial authorities attempted on several occasions to bridge the gap, but these reconciliation meetings were held under police guard. At one point, the colonial government warned the Muslim leaders who were quarreling over the leadership of the Bathurst Mosque of impending consequences if the Muslim elders disturbed the peace in the city, as the government would not "tolerate for one moment disorder or breach of the peace or any other act or word that might cause a breach of the peace."[60] Although opponents of the imam of the Bathurst Mosque tried to sway the colonial government to their side, the governor insisted that he would not "close the door of the mosque or any other church or interfere with religious freedom of any denomination."[61] Concerned

about maintaining peace and security, the colonial administration refused to be dragged into the fight between different Muslim groups.

Though these conflicts between Bathurst Muslims expressed shared identities, it can reasonably be argued that place of origin was the most important factor of differentiation. What the disagreements demonstrate was the difficulty in building clear-cut ethnic and religious identities because of the fluidity and changing nature of ethnicity and religion. Whereas the place of origin remained fixed, ethnic and religious identities continued to change as people formed new alliances due to marriage and social, political, and economic demands. In other words, an individual cannot change his or her place of origin, but can change his or her status by embodying new social, political, economic, religious, and ethnic elements and by forming new relationships.

Deborah Pellow, writing about identity formation among Muslims in Ghana, suggests a group rather than an individual configuration because of the ambiguous and fluid nature of these relationships. In certain situations, an individual may express his belongingness as a Hausa, in others as a stranger, or as a Muslim. However, Pellow recognizes that these boundaries do each provide a frame of reference and suggest an underlining of identity in the presence of difference or opposition, the we/they distinction.[62] Essentially, it was the place of origin and being indigenous to Bathurst that remained central to the divisions among Muslims who were also mainly of Wolof ethnicity. Perhaps what made the idea of origins of locality essential in the divide was the way the city was populated. According to an interviewee, colonial officials, in an attempt to clear or limit the number of migrants to the city, would stand at the ferry terminal in Bathurst with loaves of bread. As soon as the ferry emptied its cargo of immigrants to the city, they would be handed a few loaves of bread and sent back with the returning ferry to the north bank side of the river.[63] This could mean that those born in Bathurst began to see themselves as sole inheritors of the city and its advantages.

Conclusion

The story of the qadi court is important because of its centrality in the dispensation of justice in colonial Bathurst, by resolving matrimonial and other legal cases. To a large extent, the court was critical in maintaining law and order, which the British deemed essential in running the colonial city and the protectorate. The creation of

the court was also important because of the multiple changes it brought to Bathurst, including how the British designed regulations such as appointments, appeals, and jurisdiction. In many ways, the study of the court not only helps us understand the history of social relations and political power in Bathurst but also highlights the complexities of the European and Muslim legal systems in a colonial context. To a significant extent, the story of the court also brings to the fore a sharper sense of the contestations between Bathurst Muslim elders and emphasizes how some Muslim elders cooperated with Europeans to take advantage of social, economic, and political opportunities that were now available under colonial rule.

Desirous of the positions occupied by their Christian counterparts, the Muslim elites also wanted to be part of the colonial system and to benefit from it economically and socially by becoming salaried workers and businesspersons. Hence, Muslim parents went to great lengths to send their children to Western secular schools, which accommodated the needs of Muslims by allowing their children to study basic Islamic sciences and the Quran while simultaneously studying Western educational curricula. Bathurst Muslims responded to these new opportunities so they could be gainfully employed in a colonial economy.

Politically, colonial rule brought with it new forms of representation and leadership to which the local population needed to adjust and adapt. With the establishment of the Muslim court in the Gambia, the colonial governor appointed the qadi and his assessors, paid their salaries, and also helped in the construction of the main Bathurst Mosque and the Muhammadan School. In this evolving situation, the qadi, who remained part of a diverse Muslim community, became a critical figure in European-African relations. All of these factors were important for the establishment of the Muslim court with regard to the interaction between Europeans and Africans, the disagreements between the Bathurst Muslims, and most importantly the education and views of the individual qadis.

Qadis, Complainants, and Settlements: Case Studies

T he voices of women in the qadi court, the disputes that emerged, and the ways they were resolved are of particular interest in the study of the Gambia. This includes relations between men and women, in particular how women used the court to articulate their household grievances. After the Muslim court was established in 1905, women and men brought forward complex, contentious, and lengthy court cases involving such issues as marriage, polygamy, bridewealth, maintenance, divorce, child custody, maltreatment, caste, and slavery.

In addition to a statistical overview of trends over time, it is equally important to look at individual cases during the colonial period that treat these incidents as the human dramas that they were. How and why did these individuals take their cases to these courts? What does a closer look at human particulars tangibly elucidate about the subordination of women in Gambian society and how they countered their subordination? In other words, how did women negotiate their position within their marriage households? As evidenced by cases brought before the Muslim court, women and men in Bathurst contested, challenged, and negotiated marital and other social matters, which transformed dynamics within Gambian households. The court provided women with both a forum for the articulation of their rights and a process that worked at least to a certain degree to protect them.

The making of qadis and their pivotal role in the adjudication of women's claims are also of interest. I maintain that actions by the court to support women's claims gave legitimacy to changes taking place between men and women in early twentieth-century Gambian society. Examination of these legal cases reveals that the court provided opportunities particularly for women to seek justice and claim fair treatment from their husbands and parents. Women were still struggling against male dominance and patriarchal relations, particularly in the marriage household. Testimonies of plaintiffs and the accused provide insight into not only the relations between men and women, but also what types of cases were brought before the colonial courts. These cases also reveal a great deal about marriage and divorce practices in the Islamic communities under study, because the issues of slavery, caste, marriage, polygamy, mistreatment, child custody, bridewealth, and maintenance were nearly always at the heart of the legal disputes.

One of the most telling examples was the case of Sainabou Amah and her husband, Draman Jallow. On September 12, 1907, Sainabou appeared in the Muslim court of Bathurst to testify against her husband, Draman, stating under oath that her husband came to her during the hours of sleep, wanting to spend the night with her. Sainabou refused, saying that it was his other wife's turn. The husband insisted and accused Sainabou of infidelity, stating: "You refused me but you don't refuse those men who used to cover you as fowls." After saying this, Sainabou testified that he struck her. The next morning, the husband called one Matar Sillah and said to him, "Tell Sainabou to go to the market. If she does not go, I will thrust her into her mother's posteriors until daylight."[1]

In her testimony, Sainabou further revealed that when her husband came home in the evening, he said to her, "I know that I won't be able to keep you again but I have given you two pagnes (wraparounds), return them to me and a pair of earrings and an umbrella. You can as well go back to your mother." Sainabou responded that she would not go and had no property to pay as long as she remained married.[2] Draman retorted, "Go home! If you go home, you, your sister, and your mother will commit fornication and adultery and then you will get the means of repaying me." The husband further said to her: "Your elder sister used to commit fornication with your father, Macordeh Amar, and your mother was so addicted to fornication that she killed your father; your mother also committed fornication and adultery with goldsmiths and slaves." In her testimony, Sainabou further said that Draman had driven her out and taken all the property he had given her.

In his defense, Draman said that on the day in question he had had a fever,

and the other wife's turn was over so he had gone to Sainabou's house and lain down on a sofa. There, Draman questioned Sainabou's conduct: "At first I used to thank you, but whenever your mother came from Bakindiki village, you never used to do anything good." Draman further testified that late that evening, he had gotten up and gone to Sainabou's bed and sat down until 1:00 a.m. He had asked Sainabou to massage him, but she said no. According to Draman, he got up and wanted to make love with her. Sainabou kicked him with her foot, which had a heavy anklet. When he wanted to hold her, Sainabou screamed and said, "Oh you have broken my hand."

When the qadi had heard the disputants, he called upon the witnesses to bear witness to his judgment. The qadi ordered the wife to return to her husband; the witnesses had stated that her husband used to abuse her, and the qadi cautioned the husband to refrain from abusing his wife. The qadi had the legal authority to stop the husband from abusing his wife; he also had the authority to send someone to watch the husband. The qadi cited the Mukhtasar of Sheikh Khalil, which states: "Where a woman is ill-treated by her husband, it is lawful for her to take him to the Qadi, and if the Qadi is satisfied that the ill-treatment was proved, he should prevent [the husband] from doing so and send someone to watch the husband and prevent him from committing further ill-treatment [so that] the marriage could continue. But where the woman stated that, because of ill-treatment, she wanted a release, such a wish should be granted; this also applies to the husband."

However, two years after the conflict was resolved in court, Sainabou left her husband's house again, allegedly due to continuous abuse. Draman then went to the qadi to seek her return, but the qadi ended up granting the wife a divorce, as she did not want to return to her husband. At the same time, the qadi ordered Sainabou to return to her husband the bridewealth of $403 and 3 shillings [*sic*], relying on the statement of Sheikh Khalil that "release is lawful."[3]

This case serves as a good example of how the court altered relationships between husbands and wives in colonial Bathurst. It demonstrates that, although women remained unequal partners in marriage and household maintenance, the court gave some of these women the opportunity to terminate their marriages in ways they never had before. Despite the high cost of a bridewealth, women could still divorce and refund the bridewealth in installments.[4]

The case is also a window into how these judgments were enforced. Qadis had access to the police, who rendered their service whenever called on to do so. The close relationship between the police department and the Muslim court was

facilitated by the physical proximity of the two institutions and by the qadi's status as a senior-ranking colonial officer.

This long and contentious case also reveals layers of claims and counterclaims by the spouses. Underneath these claims were a host of issues—polygamy, domestic violence, infidelity, social insecurity, property rights issues, and jealousy—that in one way or another complicated marriage and relationships in multicultural Bathurst. Furthermore, the story speaks to a number of social and cultural issues such as slavery and its legacies.[5] It shows that slavery was contentious and made marriages between former slaves and former masters problematic, if not impossible; this holds true today. Today, it is still socially unacceptable for a marriage to occur between a person of slave descent and a person of free origins.

Added to the issue of slavery was the problem of caste. In his story, Draman Jallow, the complainant's husband, vehemently rebuked and accused Sainabou's mother of having relations with slaves and goldsmiths.[6] Also important to note is the point that, whether Draman's rage came out of jealousy or not, the story gives clues about matrimonial issues in Bathurst at the time and reveals efforts by the husband to control the body of the wife, or to control her sexuality. This aspect of control is seen in the husband's tirade regarding the (alleged) sexual conduct of his wife's family.

In addition, the story gives insight into the high rates of bridewealth in Bathurst at the time, which often made it more difficult for women to sue for divorce.[7] If new degrees of freedom were available to women, they came at an extraordinary financial cost, limiting their realization to an elite few. Even today, the fact is that if a woman initiates divorce, she has to return the bridewealth that the husband paid at the time of marriage, and this is usually wealth that has already been spent or consumed. In this case, the woman and her parents must find ways to refund the money. As Jane Guyer has shown, both British and French colonial legal practice increasingly favored marriage by bridewealth, which reinforced marital stability, limited women's ability to be "capricious," emphasized male authority, and established a clear interfamily public contract marking the relationship. Guyer believes that in all customary systems, bridewealth rights are heritable and realizable in the material sense and also have fundamental implications for the legitimation and intergenerational transfer of property.[8]

Moreover, the woman seeking divorce must observe *iddah*, a three-month waiting period after divorce to ensure that she is not pregnant.[9] Such issues complicate divorce in the courts, especially when social relationships come into consideration before a judge's decision. For example, on March 24, 1954, Muhammad Jatta came

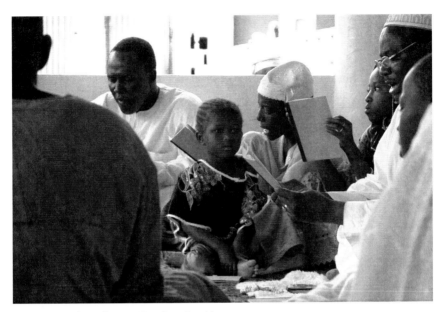

FIGURE 8. Traditional Quran Reading, Gambia.

before the qadi of Bathurst and reported that he had divorced his wife, Mariama Jaitending, some time earlier. However, during the period of the *iddah*, they had relations and Mariama became pregnant. Mariama's guardian wanted a divorce, but the qadi ordered reconciliation. The question here is how the qadi justified ordering reconciliation, because during the period of *iddah* there should be no relations between the divorcing husband and wife, although the man is legally obligated to feed and clothe the woman.

Thus, there are many ways through which men may divorce their wives, or ways in which wives may terminate their marriages. Principally, a divorce (*Talaq*) is common in which the man declares his intention to divorce his wife by writing or pronouncement. Also common is *Faskh-e-nikah*, where a wife can annul her marriage through the qadi court as long as she can prove her husband's maltreatment towards her, or the husband's failure to fulfill his marital duties can be proven. It is also usual for a husband and wife to separate by way of consent (*khula*), and this can also happen at the instigation of the wife when she agrees to return the bridewealth. Another way through which divorce can occur is *Tafweedh-e-talaq*, where the authority to divorce is transferred to the wife.[10]

Making and Recruitment of Qadis

Several important questions need to be explored in order to understand how qadis acted as the interface between colonial authorities and subjects. When the Muslim court was first established, the colonial government turned to some of the Muslim clerics whom they assumed were conversant with Islamic law and appointed them as judges. Allan Christelow sees the recruitment and involvement of qadis in the colonial system as a device to defuse tensions between colonial agents and the larger Muslim population. Since the chief enemies of colonial officials were rural religious leaders, the Europeans understandably saw urban Islam (which had exhibited a tendency to accept change and a willingness to compromise), with its emphasis on law and book learning, as a progressive force. Christelow adds that the office of judge was one that the state had not only the right but the obligation to fill with its own chosen candidate, and qadis could be seen as judicial bureaucrats, administering a uniform code of law.[11]

By and large, these judges came to be seen as intermediaries between the larger Muslim community and colonial interests. The British appointed and paid the salaries of these judges, and they used them to communicate with Muslims throughout the colony and protectorate.[12] The colonial government also relied on these individuals to translate Islamic law and interpret custom in order to codify it for the smooth administration of the colony and protectorate, a frequent pattern of administration in British Muslim colonial territories. This meant that the British keenly followed the qadi's decisions and kept an eye on the outcomes of litigation. In postcolonial Kenya, according to Susan Hirsch, the qadis' courts operated under the close supervision of the secular state. Supervision took a variety of forms: qadis had to comply with the edicts concerning the administrative operation of the courts, their work was periodically reviewed, and any appeals of their decisions were heard in the Kenyan High Court rather than in an Islamic court of appeals.[13]

Relevant to the compatibility question was the type of religious education the qadis received. Several Muslim clerics from the Gambia had gained their religious education in parts of the Muslim world through a process John Ralph Willis describes as "traditional wandering and Shaykh seeking."[14] This practice of seeking knowledge is exemplified in the career of Al-Hajj Salim Suware, who, according to Lamin Sanneh, visited Mecca seven times and traveled widely in West Africa, including eastern and western Senegambia. Also called Karamoko Ba (Great Teacher), he studied the Quran, literature, grammar, law, theology, and the Hadith

(the traditions of the Prophet Muhammad) under many scholars and at different religious centers. After acquiring knowledge in a number of Islamic sciences, Karamoko Ba had a flourishing career in the nineteenth century as teacher and preacher in many countries before founding a famous school at Touba, Guinea.[15]

Many other clerics like Al-Hajj Salim went outside the region, as far as the holy places of Mecca and Medina on the Arabian Peninsula, and pursued their religious studies in the Hejaz, Cairo, and other centers of the Middle East.[16] Richard Jobson, writing in the seventeenth century, described how clerics had "great books, all manuscripts of their religion . . . and were wandering from place to place."[17] It is assumed that these books would have come from Arabia and through North Africa by way of the trans-Saharan trade—trade routes that linked West Africa to the outside world—before the coming of Europeans to Africa. Willis argues that by the nineteenth century there were a number of highly sophisticated Muslim scholars in the Gambia who were well versed in the basic tenets of Islam. But there was only a small number of these students who went on to more advanced studies. This was done largely to make sure that clerics and their offspring monopolized knowledge, which could be used as a means of exerting power and exploiting the labor of their numerous students.[18]

Subsequently, a local clerical class emerged whose members were welcomed into communities for the different services that they provided. These services ranged from teaching and prayers to the distribution of medicines—including the making of amulets to be worn on the body for those in need. These clerics were much sought after in the nineteenth century, for they knew techniques like bleeding, leeching, and administering hot vapor baths for fever, and they were skilled in setting fractures and, it was believed, ensured success in any enterprise by blessing it.[19]

As a result, Islamic education was encouraged at all levels, as a person cannot become a Muslim if he or she does not acquire a basic knowledge of Islam. David Skinner highlights the centrality of education and learning to Islam: "Learned men are considered successors of the prophets, and the best among the people are those who learn the Quran or teach it, since reading and memorizing it is a way to paradise, and the Quest for *Ilm* [religious knowledge] is a duty of every Muslim."[20]

Traditionally, Gambian children were sent to a cleric for religious instruction somewhere between the ages of seven and thirteen.[21] The child (*talibe*) was taught by the cleric to recite prayers and passages from the Quran and to write Arabic characters on a wooden board with reed pens and ink made from soot—all for the purpose of being raised as a "good" Muslim. The young students provided firewood

for their teacher and for the firelight by which they studied.[22] Clerics also depended on students to work for them. They did this by preaching and establishing the ideology that the *dara* was a place where one was required to totally submit oneself to the whims of a cleric.[23] As Seringe Amadou Bamba indicated in his teaching,

> All men could not follow the path of total dedication to spiritual matters, but they could place themselves in a position of total submission to a religious teacher (Sheikh), putting their lives in this world and their hopes in the next world in his hands.[24]

Since we have seen the ways in which power and authority were contested in marriages, it is important to link this to the master-student relationship in which these future barristers were trained. Through this strictly hierarchical system of education, the reproduction of Muslim judges was linked to the broad parameter of Quranic teaching and learning. It is probable that some of these students were heavily influenced in ideology and training by their masters, because students were required to totally submit themselves to the whims of a teacher. The ways in which students relate to their masters and study from precedents likely have a lasting impact on them as future judges. Students' conceptions of law and justice were thus shaped by their masters and their own cultural backgrounds.

It could also be argued that students' views of relationships and their practical ideas for solving cases are rooted in African traditions and customs, particularly what could be accepted under orthodox Islam and an African version of Islam.[25] It should be remembered that some of these judges were not products of any formal sharia institute, but instead had been taught, mentored, and trained by individual clerics at informal Quranic schools in Senegambia.

This search for Islamic knowledge continued well into the twentieth century with the aid of the colonial educational system and the madrassas—the proliferating alternative and formal Arabic/Islamic educational institutions. Presently, these institutions are common throughout Gambia.[26] By the 1950s, a number of Gambian students who had studied in these madrassas were being sent to study in the Middle East and North Africa. After graduation, some of these students returned and continued to influence Islamic theology and practice in the country by serving as religious teachers in government schools and madrassas, and as imams and Muslim judges.[27]

Another important aspect of the recruitment and composition of the Bathurst

qadis is the issue of ethnicity and the question of origins. Since 1905, out of the eight qadis who have presided over the Bathurst Muslim court, only one qadi was not of the Wolof ethnic group. He was Mandinka from the town of Serrekunda, a suburb of the capital. It is unclear whether the recruitment of all the Wolof qadis, who were related in one way or another, was by intent or was a result of their level of education and training. Most of them had their roots or studied in the same few villages, and had perhaps the same masters in succession.[28]

Traditional Islamic education is structured in such a way that, more often than not, it is the direct descendants of the masters, such as their sons, who inherit the most knowledge and the greatest position. Even today, it is generally believed that masters pass on *baraka* (a word indigenized from Arabic that means blessings or grace) more to their sons than to their other students.[29] The master-student relationship therefore usually brings about a strong bond between the two, as well as a strong reliance on the wisdom and advice of the master, such that every action or decision of the student is dependent on the advice and teaching of the master. More importantly, four of these qadis (who have presided since 1905) are related by blood or kinship. All of these four qadis can trace their ancestry to Sheikh Mass Kah, an Islamic cleric who lived in the late nineteenth and early twentieth centuries.[30]

Negotiating Rights and Claims: Settlement of Divorce

In this section, I showcase a sample of contentious cases in matters of domestic abuse, jealousy, and child custody and property rights in conjugal relationships between husbands and wives. During the first five years of the court's existence, women brought a large number of these cases, but so did men, including one case of domestic abuse. Traditionally, such a case would, even today, generate resentment and opposition from the male population. Men who get beaten by their wives are usually ridiculed and scorned by the public because they are seen as weak and powerless. Also, there is a cultural belief that children begotten by such women cannot be successful in life—they are destined to become failures.

The majority of the cases sampled in this chapter are divorce settlements— cases brought by women or men to attempt to amicably resolve tensions and frictions in marriages or to release themselves from untenable marriages. These types of problems include domestic abuse and maltreatment, property rights issues,

FIGURE 9. Frequency and Type of Cases Brought before the Muslim Court, 1906–1910

and child custody. They also involve quarrels between cowives and their children, as well as jealousy and unfaithful husbands.

It is interesting to ask what made it possible or what motivated these women to bring their cases to the qadi court at a time of social transformation? Prior to the establishment of the qadi court, Bathurst women had frictions with British law, and these experiences enabled them to channel their grievances to the new qadi court. Also, in Bathurst, the mounting economic and social pressures added to friction within families, as people struggled for the few available jobs the city had to offer. Men would also run away from their wives or disappear for long periods of time. Women would go to the court to complain about a husband's failure to clothe, feed, and house them and their children, or they would bring cases against their family members for problems relating to child custody and inheritance. Common in the records was domestic abuse.

A fascinating case that illuminates domestic abuse and some of the challenges faced by women in Bathurst during the early 1900s involved a man who alleged in the qadi court that his wife was being mischievous; but the woman used the occasion to inform the court of her husband's maltreatment. On September 24, 1908, Ebrima Jallow appeared in court and stated simply, "My wife, Hoorijjah Nyass, showed me malice and continued with it for one year and refused to approach me. I did nothing to her to cause that. This is my case." In her defense, Hoorijjah testified:

> My husband used to beat me and tie me, before going to work he used to lock me inside the house until his return, he used to take a stick and put it inside my private parts. I ran and went to my father's house, he came and met me there and flogged

me and my mother and shaved my hair with a knife and threatened to kill me. He also said he preferred to remain alone. This is my case.

The qadi then advised Hoorijjah to get two witnesses to support her statement, giving her five days to do so. When she failed to produce the witnesses, the qadi ordered Hoorijjah to give her husband the amount of bridewealth she had received ($68), telling her that no one had heard that she had ever been molested by her husband, relying on the advice of the Mukhtasar of Sheikh Khalil: "release is lawful." Hoorijjah was unable to pay the whole amount of bridewealth and was allowed to pay in installments (one cow valued at $15; one silver anklet valued at $17, 3s., 3p. and two silver bangles valued $13, 6s, and $20); it took her almost a year to complete payment.[31]

Much can be learned from the details of this case about marriage dynamics in Bathurst. Above all, it shows that women struggled to remain in marriages even as they reported constant abuse. While the husband had three witnesses supporting his statement on the amount of the bridewealth he paid, Hoorijjah's failure to provide witnesses for the alleged abuse led to her having to repay the bridewealth; but she was eventually accorded a divorce because of the mistreatment she claimed.

In her work on the Muslim tribunal of Ndar, Senegal, Ghislaine Lydon notes that for the most part, women only rarely produced witnesses to testify about their husband's violent behavior because physical abuse was typically carried out outside the public eye.[32] Why was it not possible for Hoorijjah to provide witnesses in a case that involved domestic violence? Does the failure of witnesses to show up in court say anything about social relations in Bathurst at the time, or about whether Hoorijjah was telling the truth about the ill treatment? What does the case reveal about the relationship between the court and the public? To this day in Gambia there is general resentment against people who take their cases to the courts without first resorting to the arbitration of religious and local leaders, especially in clerical villages (established by a cleric devoted to teaching of the Quran).[33]

Ebrima and Hoorijjah's case sheds light on aspects of everyday life in the colonial city, especially in regard to the relations between men and women. Here, while the husband said little about the nature of the problem between him and his wife, Hoorijjah provided details of mistreatment at the hands of her husband; yet no witness came forward to support her statement. These cases show that women labored under a heavy burden when asked to prove their claims. The disadvantaged

social position of women made others reluctant to come forward and support a woman in her claim against her husband. Further, the private nature of domestic abuse, even today, can make it difficult to provide eyewitness accounts.

Another case of maltreatment involved Kebba Bah and his wife, Fatou Loum. On September 10, 1953, Kebba took oath against Fatou Loum before the qadi of Bathurst and said:

> I quarreled with my wife then I beat her. She went to her parents and stayed there for twenty-four days. I asked her father whether Fatou is not my wife but he said no. Then I asked him to return my bridewealth. During these periods, I traveled to Gunjur [Kombo, West Coast Region] for nine days and returned on the tenth day. Then I heard that Fatou wants to travel to Ntoro [North Bank Region] but I refused. So I came to the court because I want my wife more than the bridewealth.

In her defense, Fatou said:

> He locked the door and beat me with his shoes and kicked me at my waist. I went to the hospital after which I told him that he is no more my husband. I went to my father and asked him to please return Kebba's bridewealth to him. After two days, Kebba sent somebody to collect the money and who took the money to Ntoro. The money was given to Kebba's father, Ismaela Bah, but he refused to accept the money because he did not want the marriage to end.

The qadi asked Fatou whether Kebba had paid the bridewealth in full, and she answered in the negative. She said that the total amount of the bridewealth was £23, 8s., and Kebba had only advanced £3 as well as CFA300.[34] The qadi asked Fatou whether she wanted to stay in the marriage or whether she preferred a divorce. She said that she wanted a divorce. However, the qadi asked Kebba and Fatou to go back to the village of Ntoro (North Bank Region) where the marriage was contracted to resolve the matter.[35]

Though this case was referred back to the village where the marriage took place, it clearly pinpoints the prevalence of domestic violence and how women struggled to deal with it at the time. What is revealing about the extent of abuse in this case is the courage of the husband to admit abusing his wife in front of the qadi. However, this could also suggest that men like Kebba had the conviction that women could be punished as a result of any disagreement.

Another case that illustrates abuse was a matter involving Mariama Ndure and her husband Mbye Jeng. On September 20, 1952, Mariama appeared before the qadi and complained that Mbye used to abuse her and did not maintain her well for two years and ten days. In her testament, Mariama alleged that Mbye used to beat her and once squeezed her throat. Mariama further held that Mbye came home one day, knocked on her door, and said he divorced her. Mbye in his argument refuted Mariama's allegations. He said that he used to give her maintenance, and the previous Friday he gave her money to buy some fish. When the qadi heard the disputants, he asked them to reconcile. Mbye agreed to reconciliation but insisted that Mariama should live in a different compound. Mariama refused the proposition and demanded a divorce. She paid nine pounds and three shillings to Mbye.[36] From this testament, it is fair to conclude that abuse of women took different shapes and forms. In addition to physical punishment, men also mistreated their wives by neglecting them in everyday interactions such as denying them conjugal rights or maintenance (food and clothing), as well as refusing to sleep with them.

Also prevalent in the court records were cases relating to jealousy. In these circumstances, relationships were at times sour and hard for women because of the violence and divorce that came with it. Issues of jealousy and wife control could be complicated in court because such cases usually were coded in a language that each partner constructed to fit her or his narrative.

As an illustration, on February 26, 1907, Haddijatou Njie brought her husband, Matarr Njie, before the qadi of Bathurst. In her testimony, Haddijatou claimed:

> My husband denied that he put me in the state of pregnancy and refused me maintenance. He ill-treated me and also took from me a pair of gold bangles against my wish and put me out of the yard. Afterwards, he asked me to go to my parents. I then said to him, "I will not go on my own accord unless I am killed and my body taken there."

The qadi asked Matarr to respond to his wife's claims, and he did so:

> I am not aware of any quarrel between myself and my wife. I passed the night with my other wife and when I went home in the morning, I did not find Haddijatou there. I asked the neighbors and they told me that they did not know her whereabouts. I then sent Lytee Loum, Mandou Ngum, and Goran Nying to speak to her

to come home. The people I sent there told her mother that Haddijatou should come after her delivery. After the delivery, I sent one Tamsir Saherr Jobe to go and name the child. After that I told her to return home but she refused.[37]

When the qadi had heard the disputants, he asked the woman if she had witnesses to support her claims with regard to what her husband had allegedly done to her, but she had none. The qadi gave judgment, asking Haddijatou to return the bridewealth to her husband. Haddijatou said that she had no money to pay her husband. Matarr then said in front of two witnesses that he would forgive her the payment of the bridewealth.

Likewise, on May 19, 1927, Kumba Jaw brought her husband, Muhammad Jallow, before the qadi of Bathurst and complained that she and Muhammad had quarreled over laundry. The husband became furious and asked her where she had gone the previous day. According to her testament, the husband reacted, "Where were you yesterday? I heard that you killed a fowl there and ate it there." According to Kumba, the husband insulted her mother. The husband said, "I will fuck your mother." Then she got angry and left.

Muhammad, in his defense, stated,

> We were in a village and the owner drove us out. We came to Banjul and one Aku [Creole] gave us a place to stay. I asked her where she was and then she said she was washing one Baba Sey's clothes but I previously asked her to stop washing Baba's clothes. She also owed money to other people. One Fatou Jallow came here to collect her money and she waited for her for a long time. When Kumba came, I asked her where she was and she replied: "I went about my business." Then I told her that she has to return to the village.

The qadi asked Kumba to return to her husband, but she refused and chose divorce. The qadi then asked her to return sixteen shillings to Muhammad.

In another example, Sergeant Samba Pallah brought a case against his wife, Penda Ann. On July 17, 1934, Sergeant Samba reported that

> We have been married for six years. I used to do everything for my wife. However, this year, whenever she cooks, she takes food to somebody else. One day, I followed the maid as she was taking the food to this person. She took the food to a man living at 19 Hagan Street [Banjul]. I came home and told her that I have seen what she is

doing. I went to the Imam to discuss the matter but she asked me to divorce her. However, the Imam asked me to be patient.

Penda Ann responded:

This is my husband and we have been married for many years. He does not do anything for me. He did not even finish paying my dower of 17 shillings. At the Imam's house, we divorced and he gave me £4.

The qadi asked them to reconcile, but the woman chose divorce, electing to pay her husband eighteen pounds, three shillings for the bridewealth.[38]

Also, on August 2, 1955, Haddy Loum came before the qadi of Bathurst and claimed: "I found my husband Muhammad Njie with another woman behind the market. When he came home in the evening, he beat me. In the morning, he said he divorced me." The husband, in his response, stated that he paid two pounds and nine shillings as part of the bridewealth and eight pounds remained to be paid. One witness also confirmed that Muhammad only paid two pounds and nine shillings. Then the qadi ordered divorce and asked Muhammad to pay ten pounds to Haddy in monthly installments of one pound and ten shillings. However, the wife came back to court and said that she forgave Muhammad the remainder of the bridewealth.[39]

The examples above represent the types of issues relating to jealousy in conjugal relationships. In the first case, Haddijatou and her husband's claims fell on the opposite end of the spectrum. Haddijatou alleged ill-treatment and extortion as well as the husband's denial of having impregnated her. However the husband denied what Haddijatou said and implicitly accused her of jealousy because of the second wife. What is particularly interesting about this case is that Haddijatou was granted a divorce without witnesses. Was the qadi convinced of her statement despite the lack of witnesses? In general, producing witnesses may create a burden of proof for a woman that is unfeasible in most cases, certainly a hundred years ago but also today. In this way, the law, even as "applied equally," may be inherently discriminatory toward women.

The second, third, and fourth cases are also typical of conflicts in matrimonial relationships, especially when one of the spouses is not comfortable or confident of her or his position in the relationship. In this frame of reference, male conceptions of society and perceptions of women can be seen as factors controlling women's sexuality and freedom. One of the difficult problems for women is how to continue

to live in a polygamous marriage. Kathryn F. Mason shows that relations between cowives, especially when a first wife had no role in selecting a second wife, are characterized by jealousy, hostility, and efforts to escape the polygamous arrangement.[40] It is worth asking why and how men failed to support their wives at the time. Were men deliberately not supporting their wives because of lack of job opportunities as a result of changes in the labor regime? Also, were both men and women alike struggling to reconcile competing interests in the face of the new dynamics of African-European relations? From these cases, it can be seen that both men and women were basically struggling to support themselves and their families by doing menial jobs or selling food, actions that did not sit well with their partners. Colonial rule introduced wage labor that forced men and women to find ways to make ends meet, matters that forced people to make uncomfortable decisions.

Property Rights in Marriage and Divorce

Struggles over property rights in Bathurst included men and women quarrelling over estates, household goods, and even body ornaments. As always, the patriarchal nature of Gambian society, whereby men tend to be the breadwinners and own the means of production (land, labor, and capital) and the house, complicated matters further. Of relevance here is the case of Mariama Koita against her mother, Binta Ann.

On July 18, 1906, Mariama came before the qadi and informed the court that she and her husband, Momodou Jobe, had given her father, Dooa Jabi, $52, two bulls, and a cow for safekeeping. While they were away, Mariama's father died. According to Mariama, she asked her mother about the things she and her husband had given to Dooa Jabi to keep. Her mother said that she had only seen the two bulls and the cow; a calf had been born to the cow while Mariama and her husband were away, and the cow had then been stolen. Mariama's mother denied any knowledge of the $52. Mariama also informed the court that her mother had prevented her from taking ownership of the house that her father had bequeathed to her.

In her defense, Binta Ann told the qadi that when her husband died, all she saw were two bulls, a calf, a cow, and ten dollars. She further said that the cow had been stolen, and that she had sold the calf and bought another cow. She also stated that she informed the police at the time the cow had been stolen. The qadi then asked her for the money that Momodou Jobe and his wife had given to Dooa Jabi. Binta

replied that Momodou had not given her fifty-two dollars. The qadi then asked Binta Ann whether Dooa Jabi, before his death, had given any instructions with regard to his affairs after his death. She replied in the negative.

While one witness for Mariama Koita said under oath that Dooa Jabi had with him the cow and two bulls and money up to the time he died, although he did not tell anyone about them before his death, two other witnesses said under oath that they knew that Dooa Jabi had given Mariama a piece of property as a mark of gratitude for her obedience and for the fact that she had mastered the Quran by heart and had even learned a bit of English. Witnesses for Binta Ann testified under oath that they had seen the livestock but knew nothing about the money. When the qadi had heard these statements, he called on Binta Ann to pay for the two cows, relying on the guidance of the Mukhtasar of Sheikh Khalil regarding situations in which "one [dies] without making a will and none of his property is seen to."[41]

This case shows the importance not only of property rights issues but of marriage itself. Was it possible that the father recognized the marriage between Mariama Koita and Momodou Jobe, but the mother did not approve of it? Did this case involve religious issues important for marriage? Why did the father leave a compound for Mariama to inherit as a result of her "knowing the Quran and English"? Perhaps this case also illustrates the complexities of marriage regarding who could be married to whom, based on traditional marital rules and regulations.

Another relevant case involves Ibrima Cole and his wife, Isha Cole. On May 7, 1914, Ibrima brought Isha before the qadi of Bathurst and claimed that he and his wife had returned from Sierra Leone to Kaolack, Senegal. He reported that his wife had left him in Kaolack and returned to Sierra Leone, refusing to stay in her marriage. In her defense, Isha refuted her husband's claims and reported that he had stolen silver worth thirty shillings from her. When she confronted him about it, he threatened her with a knife. When the qadi heard the disputants, he ordered divorce but left the custody of the couple's sons to the father.[42] Isha effectively used the courtroom as a platform to inform the qadi of her husband's violent character. This case shows that during the early twentieth century, communities in the Gambia Colony and Protectorate were dealing with a range of property rights conflicts over jewelry, animals, land, clothing, and other material goods. These property rights cases, in Gambia as elsewhere in colonial Africa, frequently found their way into courtrooms.[43] Codification made it possible for Europeans to keep their gaze on the activities of the court.

A substantial number of divorce cases in early twentieth-century Bathurst grappled with the issue of disappearing husbands and lack of maintenance for wives. Men who abandoned their families were so common in the Gambia that J. K. McCallum, traveling commissioner for MacCarthy Island District, reported that

> As regards the marriages, it is not to be taken that they are satisfactory, for it is a common occurrence for the husband to go away for months without leaving any support for his family. I have known cases of this kind where the husband has been away for two years, and more, and whereabouts unknown.[44]

It was the responsibility of marrying men to pay bridewealth to the bride's parents, a practice that by the early twentieth century had become monetized. Men sometimes found it economically necessary to leave their families for periods of time to seek paying work, wherever they could find an opportunity. One such avenue to find income was the cultivation of groundnuts, beginning in 1843. The colonial regime introduced taxes around this time, which could only be paid in cash, forcing hundreds if not thousands of young men to migrate to the Gambia River valley to grow the cash crop. Hence, the need to pay taxes in cash catalyzed rural-urban migration while colonial capitalism created a growing demand for labor for porterage, building infrastructure, and producing food for the burgeoning administrative centers.[45] Known as "strange farmers," some of these laborers would stay in the city for years, depending on how quickly they could accumulate money, before returning to their families in the rural areas.[46] Philip Curtin also describes these migrants as the "first of the free 'strange or migrant farmers,' who as far back as the 1780s and probably earlier still, . . . from countries like Bondu would go down to the Gambia for a period of farming near salt water markets."[47]

The disruption of African families in the early twentieth century, scholars have argued, was due largely to the imposition of colonial rule.[48] The erosion of kin groups and extended family networks accelerated as family members migrated to colonial cities and towns to look for paid work and to avail themselves of the social amenities, health facilities, and schools available in urban areas. As seen in the court transcripts, the disappearance of husbands can be attributed to changes in identity, individuation, the weakening of marriage bonds, and new demands for labor. In the Gambia as elsewhere in Africa, women bore the burden of family upkeep, and they would sometimes go to the courts to sue for maintenance or divorce from vanishing husbands.[49] In light of some unprecedented economic and

social changes, women whose husbands disappeared for long periods of time, or whose husbands failed to maintain them, often went to the qadi court to ask for divorce or settlement.

The records also indicate cases of child custody and show how they were resolved in court. One case involved Sasoon Cham and his wife, Sainey Bojang. The couple's daughter, Mam Sainey Cham, married and begot a child named Jatton Bojang. After the daughter divorced her husband, the child lived with her grandmother for fifteen years, who during that time fed and clothed her. One day, Jatton visited the child's father (Sainey) in a village outside of Bathurst, and he allegedly refused to allow Jatton to go back to her grandmother.

The grandmother went to the qadi to have her granddaughter returned. The qadi ordered the defendant to return Jatton Bojang to her grandmother. The qadi relied on the authority of four steps in Muslim jurisprudence: "A woman repudiated by her husband is entitled to the custody of her child until it attains puberty in the case of a boy or in the case of a girl till her marriage by consummation."[50] However, the Supreme Court of Bathurst heard the case on appeal, and the judgment of the qadi was reversed.[51] This case is important because it shows the possibilities of appeal and the complexity of resolving such issues.

Some factors that complicated child custody in courts were labor rights and cultural or customary claims to children. In many parts of Africa, minors form an important part of the labor pool, especially in agricultural communities. For example, in Kabba, Nigeria, "the concept 'ties of blood' served as a focal point for reinterpreting the respective claims of Bunu Yoruba women and men to children after divorce," writes Elisha Renne. "Beliefs about how these blood ties were constituted not only differed between the British and Nigerians, they were reinterpreted differently over time by Nigerian women and men. . . . With the introduction of divorce and the child custody rule, men could claim children on the basis of a single bride wealth payment."[52] Elsewhere in West Africa, such as central Ghana, a father has the right of use over his children, but the true ownership is vested in their maternal grandmother.[53] With most ethnic groups in Gambia the father retains the right of custody to the child because of consanguinity. This is also in line with Islamic practice, in which the child remains with the father until s/he reaches the age of eighteen. Among the Mandinka, sometimes a male child can go to live with his mother's brother—*bariŋlaa*—during which time the uncle would benefit from the child's labor. However, in all custodial issues, the father's decision is paramount; he wields ultimate authority over his child.

One of the ways to enhance understanding of these court records and women's voices in the proceedings is to look further at how women's positions within the patriarchal household were negotiated and resolved. Indeed, the records demonstrate that issues of marriage, divorce, and remarriage (reconciliation) were considered and analyzed as strategies that both women and men used in the court to empower themselves within the household. It is clear that women bargained and negotiated their positions in different ways. Certainly, the practice of *fay* or *bori* is one way in which women usually contested male power from a position of relative strength. When women ran away from their marriages to their parents, they were questioning men's love and desire for them. In a sense, what the women were essentially saying to the men was: "If you still love me, come for me and we will negotiate our household problems together."

In that vein, I turn to a few more cases to illustrate more explicitly how women bargained and disputed their way out of marriage in court, or worked to make the marriage tenable for themselves. One pertinent incident was the case of Fatoumata Kombo and Mbai Kombo. On July 7, 1934, Fatoumata brought her husband, Mbai, in front of the qadi of Bathurst. In her testimony, the wife claimed:

> My husband has not been giving me maintenance for five years, no food, and did not buy any gold chain for me. He said that he divorced me. However, he brought another woman into the house for three months. I asked him to let the woman leave the house and he refused. We fought at night and he threw me and my daughter out of the house.

The husband in his defense stated:

> My wife never lacked food or clothing. She never reported me to anybody about her conditions. No woman stayed with me in our house. We lived with a lady called Touma in the same compound. One day I told Touma's sister that I want to marry Touma and my wife heard about it and she began to create problems between us.

When the qadi had heard the disputants, he asked the husband to give ten shillings for the two months during which he had failed to support his wife, and asked the wife to return to her marriage house; he told them both to stop quarreling about Touma. The qadi then asked the husband to either marry Touma or not bring her to the house.[54]

In other cases, qadis encourage litigants to reconcile when they don't find justifiable reasons to order a divorce. On October 20, 1927, Tuti Bah brought claims against her husband, Abdoulie Manneh. Tuti claimed that

> My husband refused to speak with me for three days. I reported him to my parents and they asked me to be patient. I asked him to give me fish money but he refused. He said to me, "I don't have it, I will give it to you when I have it."

In his defense, Abdoulie said:

> I sent my wife to Kuntaur to look for food but instead she went to Bunkiling without my permission and we quarreled over the issue. She also asked me whether we can move out from where we were living but I said no. She left for Kaolack. I asked her to stay for ten days but she stayed for twenty days. I wrote to her and told her that she is out of my control.

When the qadi heard the disputants, he ordered them to reconcile and try to make each other happy in their marriage.[55]

In another case, on April 29, 1952, Muhammad Camara brought a case against his wife Fatou Jallow and complained that his wife used to go out every night. Muhammad narrated that he made several complaints to Fatou's parents but to no avail. Fatou in her defense recounted how the husband threw all her belongings out of the house, which led to a passerby stealing £5 from the things. She further stated that her belongings were then moved to her sister's house. Muhammad acknowledged responsibility for mistreating Fatou and asked her to return. The qadi then advised them to go and live with each other peacefully, but asked the husband to refund his wife the £5 that was stolen.[56]

Similarly, on May 27, 1952, Fatoumata Sawo brought her husband, Ekeri Njie, before the qadi of Bathurst and complained that Ekeri failed to maintain her well. Fatoumata also complained that at the time of their marriage, Ekeri promised to give her £16 and 17s. in order to pay a loan. Ekeri made a payment of £2. Also, Ekeri promised to give her £5 daily. At the time of the discussion, Fatoumata forced Ekeri to make a written undertaking that she produced in court as evidence. The husband accepted all that the wife said, but he reported that he gave one Modou Sise £8 to give the wife. Modou told the court that he paid the money as part of the bridewealth. The husband further said that he also gave £10 to one Muhammad

to give to the wife. In addition, he housed the wife at a monthly rent of £2. The husband said that the wife had nothing to complain about. When the qadi heard the disputants, he ordered Ekeri to give to Fatoumata fifteen pounds and that their marriage should continue. The qadi ordered the money to be paid on May 28, 1952.[57]

Certainly, women bargained and mediated their positions within the patriarchal household. Perhaps, as shown in the first case, the wife's motive for going to the court was to get rid of the other woman and to reassert her rights in a polygamous household. The reconciliation case is also interesting because it relates to the tradition of *fay* or *bori musoo* (runaway) in which the woman's intention in going to court or to her parents is to seek support in order to make the marriage tenable. Scholars have used several approaches to describe and situate women's struggle in polygamy and in patriarchal societies. In her work in Niger, Barbara Cooper illustrates that both men and women find the negotiation of marriage to be simultaneously one of the primary means by which they can mediate change, and the locus of tremendous instability in their own lives. She further notes, "Because marriage is negotiable, it becomes the ground upon which change is encountered by both men and women, sometimes quite unpleasantly."[58] Deniz Kandiyoti employs the term "patriarchal bargaining":

> Patriarchal bargains influence both the potential for and specific forms of women's active or passive resistance in the face of their oppression. Moreover, patriarchal bargains are not timeless or immutable entities, but are susceptible to historical transformations that open up new areas of struggle and renegotiation of the relations between genders.[59]

Nwando Achebe's use of the "female principle," a factor that embodies all aspects of female involvement in society, could also be used to understand women's struggle within the household.[60] Elizabeth Schmidt sees the household as a terrain of struggle, manifested in disputes over the division of labor, control over female reproduction, and the redistribution of resources, which in turn help to shape the broader society.[61] In one way or another, these examples from different parts of colonial Africa point to ways in which certain cultural traditions favored women. By leaving their marriage households, Gambian women could rely on the traditional practices of reconciliation through the custom of *bori* or *fay*. Also, the cases show that women could sometimes take leading roles in mediating changes in their lives. In court cases where the outcome is reconciliation, especially when the woman

initiates the litigation, the man is always concerned about treating his wife better. If not, when the woman goes to the court again, the man could lose her or be blamed by the qadi. Perhaps it should be noted that, as in most societies, Gambians in general take a complementary and contradictory stand on gender relationships. While some men unfairly treat their wives, no man wants his mother to be badly treated. Moreover, society frowns on men who are in the habit of maltreating their wives. In general, a man who habitually divorces ends up having no wife, because his demand for a wife is always rejected. In traditional Mandinka communities, such a person is referred to as *sonto*.[62] Thus, by taking these cases to the qadi courts, women in colonial Bathurst were seeking to use the new legal avenues open to them to shore up their position within customary marriage structures.

Conclusion

Undeniably, the establishment of the Muslim court in 1905 had a significant effect on the position of women not only within the household but also in colonial society in general, as women played a role in shaping legal debates and judicial outcomes. Women took advantage of the opportunities provided in the Muslim court to challenge their husbands in order to get some form of redress such as divorce or compensation. Part of the reason for these changes was the court being situated at the intersection of cultural tradition, Islam, colonial rule, and gender dynamics.

As illustrated in many of the cases above, marital disputes and their resolution were complex and often disruptive, especially for women. The examples indicate not only the level of abuse against women but also the opportunities for women to contest their positions within the household. Apart from the court, a number of other factors made it possible for women to secure positive outcomes. First, British administrators usually observed Muslim court sessions with interpreters, and sometimes the court's decisions were overturned by the higher court of appeals, where "Islam had no place." Second, the legal basis for women's position within Islam was confirmed by numerous references to widely cited Islamic legal texts. The status of the qadi himself as an influential member of the Muslim community, and the tight-knit nature of Bathurst society, also helped establish women's legal position. In fact, one qadi is renowned for advising litigants to withdraw their cases from the court so he could treat them at his home, in "the traditional way or according to custom."[63] Third, and most importantly, the court occasioned debates

among women across households about women's rights in marriage. This begs the question: were Gambian women who frequented the courts fully aware of the intricacies of court procedures and precedents, and did they thus prepare their discourse accordingly?

The imposition of colonial rule compelled European officials to work with African chiefs and rulers, including Muslim clerics who had been acting as judges before the arrival of the colonizers.[64] In order to ensure that the qadi courts would be legitimized and trusted by Muslims, the British colonial administration chose qadis from among Muslims based on their Islamic education and connections. Qadis enjoyed respect and recognition from society due to their intellectual and cultural contributions, and they were also esteemed for their esoteric knowledge. Qadis were socially honorable people with whom colonial rulers sought to cooperate in order to better control Muslim subjects and peacefully administer the colony and the protectorate. The relationship between the British and the qadis also shows that colonial rule was made possible partly because of Muslim leaders' involvement in the colonial machinery. Finally, this analysis can serve as a reminder that, in regard to marriage and property rights, societies in Africa and in Europe, despite significant differences, continue to marginalize women or extract from them a heavy penalty for seeking their freedom from destructive relationships.

Conclusion

By building upon the recent historiographical trend of using judicial records to better understand African social history, this book has addressed some of the important issues that have been neglected in the historiography of the Gambia and, more generally, of West Africa. I have documented how women and men in Bathurst contested, challenged, and negotiated divorce, child custody, inheritance, and other issues relating to the general support of a family household, thus changing the nature of societal relations in Bathurst and within larger Gambian society. I have explored how the Muslim court transformed the terrain of marriage discourse, as it provided women with both a forum for the articulation of their rights and a new measure of protection from abusive husbands. It is clear that the court provided women with a means to settle disputes between and within families. Furthermore, the evidence is abundant that a cross-section of Gambian women went to court because the court responded to their queries about what a husband's duties to his wife really were.

All the cases referenced in this book highlight not only the type of abuse directed towards women but also the important role of the qadis in the formation of women's awareness about their rights and privileges in marriage. To reiterate, on February 26, 1907, just two years after the court was established, Haddijatou Njie

appeared before the qadi of Bathurst claiming that her husband denied making her pregnant and therefore refused to give her support. She also reported that her husband had been abusive to her by seizing her pair of gold bangles. The husband denied maltreating her and wanted her to return, but she chose divorce, which the qadi granted to her. The qadi relied on the statement of Sheikh Khalil, "release is lawful."[1] By relying on such codes in Islamic law, women like Haddijatou were able to separate themselves from abusive husbands.

From the records, it can be concluded that the prevalence of divorce and women's reaction towards it seemed to arise from a number of different issues and factors such as negligence, maltreatment, and jealousy. By taking their cases to the qadi, women sought to legitimize their positions in marriage households in ways congruent with Islamic and customary laws and also favored by the new colonial edicts. As shown in many of the cases in this book, a cross-section of women in colonial Bathurst and its environs understood their place in their marriage households and in Islam, and as such, they took advantage of the qadi court to release themselves from abusive husbands and to a limited extent from patriarchy. By concentrating on individual court cases, I have endeavored—as Fernand Braudel would like us to do—to understand the structures of everyday life for a better appreciation of wider issues of women's contestations in colonial Bathurst and its surroundings.[2]

I have also made it clear that certain traditional and customary practices were disadvantageous to women and kept them in untenable marriages. The examples of wife inheritance and sister marriages obligated women to enter marriages without an opportunity to express their positions because of fear of being castigated. Added to these were general patriarchal dynamics that undercut women's ability to release themselves from abusive husbands. Often, the way in which women manipulated these webs of traditional male power was to go before the qadi, who used Islamic texts to release women or to warn men to treat their women with dignity and respect. In addition, some local traditions provided a framework for women to gain control of their lives and also to shame men who were habitual wife abusers.

I have shown that the institution of marriage was shaped by broader social and economic change causing tensions between husbands and wives and within families. The high cost of bridewealth at the time, coupled with cash-crop production and the monetization of the colonial economy were factors that induced so many men to leave their wives and children to go in search of money to make

bridewealth payments. The high cost of bridewealth also compelled many women to stay in abusive marriages because they were required to return it when they asked for divorce. Considering that this money had usually been previously spent by a woman's male parents and relatives, its payment could be burdensome and problematic.

In many ways, the cases represented in this book point to not only a number of critical social and cultural issues but also, and most importantly, to questions of power and representation. First, the way in which women opted to change their lives through the court interrogates deep social and patriarchal issues within the household and marriage. It is reasonable to suggest that women's actions were in effect a claim for their place within the marriage household and especially their resolve to secure their rights. In this way, women's social and legal actions changed, ameliorated, and/or negotiated their lives in marriage by confronting their husbands in the court's public space.

Second, the manner in which men tended to resist or unilaterally divorce their wives brings to the fore the problem of power within the household. By refusing to accept divorce, or refusing to tolerate social space for their wives, men appeared to contest the questioning of their power and authority within the household. In Gambia, it is common to find men as decision makers in society and in a large number of marriage households. In this way, seeing men's power being eroded in court equaled defiance and loss of certain privileges structured in patriarchy.

In addition, to appreciate the dynamics of relationships between husbands and wives or complainants, I draw on the work of Adeline Masquelier, who suggests that "power needs to be traced in mundane practices and everyday representations."[3] Hence, there is need to interpret everyday quarrels in married households and how these disputes got settled in court. This is to say that men as power holders in a traditional marriage could claim a position of relative privilege in relation to their wives. Indeed, a man had the privilege to drive his wife to frustration knowing full well that if the wife went to court, she would have to refund him the bridewealth money. Furthermore, the man also had the dispensation to refuse or delay granting divorce to his wife so that it would be the wife who asked for divorce to enable the husband to get back his bridewealth—a factor that was disadvantageous to the woman.

In order to understand how traditional practices evolved, it is important to remember that reform in the Gambia implied greater fealty to the traditions of Islam: In Islam, a man has a moral and legal responsibility to support his family.

The remedy for nonsupport for a woman is divorce, which is granted by an Islamic court and generally is not difficult to get.[4] The changes in colonial Gambian society cannot be attributed to any one decisive factor; rather, there was a proliferation of alternatives for resolving disputes.[5] In essence, as Allan Christelow notes, "the choices and strategies of litigants and the existence of potential alternative sources of judicial authority in the form of the qadi's court, the British administration, and the British courts all had influences in shaping legal realities."[6] Women like Haddijatou were able to take advantage of the creation of the court and the presence of Europeans to find new and effective ways of confronting abusive husbands.

Central to my argument is an appreciation for the interconnectedness between gender and identity, traditional marriage practices, custom, Islamic teaching and theology, and marriage laws promulgated by the British colonial authorities. I recognize that court records alone are not sufficient for understanding the complex nature of social relationships in the Gambia at this time; the records also need to be analyzed through the larger cultural contexts in which they were created.

Hence, I have stressed the need to appreciate the complex and evolving nature of certain traditions and customs and why some persist today. Furthermore, I have argued that the study of the court provides insight into the ways in which residents of Bathurst and the Gambia struggled to reconcile competing interests, broader Anglo-Gambian relations, the establishment and maintenance of multiple and often competing legal terrains and judicial traditions, and internal cultural differences. An examination of the everyday lives of women and men in colonial Bathurst brings into sharp relief many of the complications and contradictions of British colonialism in the Gambia.

Unquestionably, colonialism and colonial rule negatively affected Africa and Africans in many ways. However, European colonizers also waged war via legal compulsion on what they deemed to be outdated forms of bondage—slavery, concubinage, child marriage, and abuse of women. Their new legal enactments and contexts, according to Ismail Rashid, gave opportunities to women to find new means of self-realization.[7] In colonial Gambia, some of these laws include the Muhammadan Law Recognition Ordinance (1905), the Muhammadan Court Rules (1917), and the Muhammadan Marriage and Divorce Act (1941). This legislation's unintended consequences included strengthening women's position in society, particularly through the Muslim court. Not only would the British review a qadi's decision, or even search for a precedent from another Muslim country, when they were doubtful about a judge's ruling, but Gambian women, like women in other

African colonial settings, shrewdly took advantage of these new laws and used them to undercut male authority.

To some extent, these statutes also marked a shift from traditional or customary forms of marriage practices and dispensation of justice, whereby a Muslim judge or judges could declare divorce solely on the husband's account without consulting his wife. Some scholars see this traditional male-centered understanding of sharia as resulting in discriminatory treatment that negatively impacts women.[8] This conclusion also resonates with what Qadi Omar Secka sees as the major difference between the present-day and former qadis in Gambia; present-day qadis tend to go abroad for their training at modern universities, whereas qadis of earlier generations tended to be "traditionalist" and oriented toward sharia. For Secka, this difference might determine the outcome of a case; a traditional legal approach would likely have a more negative effect on a woman's rights than a more modern approach.[9]

I have examined the relationships between husbands and wives, different Muslim groups, and between European officials and Africans to focus attention on the changes that took place in Bathurst. The Bathurst qadi was instrumental in shaping popular perceptions in the colonial city and rural hinterland. Clearly, fights to control the qadi court and other Islamic institutions further fractured and divided Bathurst Muslims, who already struggled to forge a cohesive identity due to their efforts to work within the colonial system in an attempt to exploit the social, political, and economic opportunities that came with it.

This book illustrates the complicated nature of European law, and the difficulties Africans had to endure in traversing the contours of the new legal terrain. What made this passage difficult was the multiplicity of the legal landscape—the British, Islamic, and African customary laws. We now should have a clearer understanding of the magnitude of the changes ushered in with the complex legal systems introduced in colonial Bathurst over the first half of the twentieth century. The 1928 qadi crisis that erupted between Muslim elders provides a context in which to understand the social history of Bathurst and colonial Gambia at large. The incident brought together seemingly disparate social, political, and economic constituents, as well as people from different social and cultural backgrounds, and demonstrated the role of the Muslim court in the adjudication of justice in the Gambia Colony and Protectorate.

The crisis pointed out the Muslim elders' role not only in the development of Bathurst as a colonial city but also in the creation of legal institutions there. Africans in Bathurst demanded the establishment of a Muslim court because they wanted

their cases to be heard by a qadi rather than a European-trained judge, whom they saw as Christian. Their demand for the Muslim court has implications for our understanding of colonial rule in general; much of the scholarship tends to characterize the colonial period as one in which Europeans imposed new administrative structures on reluctant and passive Africans.[10] In the Gambia colony, by demanding an alternative judicial system, the Africans were instrumental in shaping their legal terrain. The British responded by accommodating Muslim demands because they sought to maintain a peaceful and smoothly running colonial state, free from Muslim reprisals. Two key concerns of the Muslims were the establishment of a Muslim court and the opening of a secular school where Muslim children could be educated. In other words, Muslims wanted a spiritual space, but they also wanted to seize some of the social and economic benefits ushered in by colonial rule.[11] Bathurst Muslim elders wanted equal standing with their Christian cousins, who were benefiting from British education and rule by becoming part of the colonial machinery.

The 1928 crisis underlined the importance not only of the post of the qadi but also of control over other Muslim institutions in the urban colony. As Allan Christelow's work on colonial Senegal demonstrated: "The qadi represents a unified polity embracing different classes and interest groups. This is based on the Muslim conception of the Madina as a protected physical space shared by autonomous communities, each internally articulated by its religious courts and schools. Because it helped give the Muslim urban community a sense of autonomy and identity, especially as long as that community was barred from effective participation in municipal politics."[12] Bathurst Muslim elders, however, remained divided over issues of qadiship, caste, and place of origin.

In the Gambia, although Muslims were not officially barred from politics, they were not able to present a united candidate during the political campaigns of the late 1950s or during the 1960s and 1970s, despite a shared Wolof ethnicity.[13] Early settlers had come to Bathurst in waves, but as fragmented groups. Some groups came with European settlers from Senegal as slaves or servants, and others came as technicians to build the new British colonial city. Others came as a result of the Muslim wars that ravaged the region for more than half a century. Still others came as individual migrants in search of work, education in the colonial system, and other opportunities provided by the city. The new city had very little to offer in terms of ethnic and kinship security, and the migrants found it necessary to form new alliances or groupings to survive changing conditions in the urban space.[14] These social networks were based on several factors such as ethnicity, place of

origin and caste, and economic and political interests. All the qadis profiled here were of the Wolof ethnic group, although one of the most controversial disputes over the qadiship centered on place of origin, alongside disagreement about caste and political representation. A common Islamic background among Bathurst Muslims did not always help cement ties between them or help suppress their disagreements, and instead, it was often economic and political issues that more significantly shaped relations in the city.

Finally, although it is difficult to measure the court's impact on fostering peace and order, or to determine the extent to which divorce bettered the lives of some Bathurst women, it is safe to conclude that these examples are suggestive of positive changes within the marriage household. Divorce protected women from chronic abuse and maltreatment. It seems that there was an attempt to encourage discourse about marriage within the court, and the positive outcomes were important for women dealing with abusive husbands. As the book demonstrated, there is another, more important reason for the popularity of the Muslim court: recourse to this court ensured that those men who habitually abused their wives or failed to provide for them would have their fate decided by the culturally legitimate and socially accepted qadi.

In the future, the court may have to address some questions to keep pace with the changing realities of marriage and other social relationships. For example, what are the consequences for men who are found guilty of abusing their wives? In other words, what happens to the man if and when the qadi declares divorce as a result of abuse? Does the woman's right to justice simply end with being granted divorce? Nevertheless, in spite of its long history in influencing multiple aspects of quotidian life, the qadi court has been largely overlooked in critical analyses of the historical development of Gambian society, especially in respect to women's lives. It is my hope that the arguments and evidence in this book will help us move beyond a shallow and narrowly sectarian understanding of social change in the Gambia. It is no longer enough to say that the colonized, too, have a history—this must be demonstrated in empirical detail. Appreciating the rich substance of social transformation requires moving beyond a reliance on simplistic dualities such as Muslim versus Christian; urban versus rural; traditional versus modern. I have put forward a more complete and complex interpretation of the past that sharpens our understanding of the history still being made today in a country where 95 percent of the population considers itself Muslim. Beneath and within that impressive statistic is a continuing multiplicity of both Islamic and traditional ideas.

Notes

Introduction

1. Fish money is daily money given to wives by their husbands to buy food for the family.

2. Muslim Court Record Year Book, 1927–1930, Qadi Court, Banjul, Gambia, 414–17.

3. I am aware of the problems surrounding the meaning of "tradition" and "custom." In this book, I use the terms to mean a set of practices and belief systems that exist in the present but were inherited from the past. See David Gross, *The Past in Ruins: Tradition and the Critique of Modernity* (Amherst: University of Massachusetts Press, 1992). I give more attention to tradition and custom in chapters 2 and 5. I also use dowry and bridewealth interchangeably.

4. Elke Stockreiter, *Islamic Law, Gender and Social Change in Colonial Zanzibar* (New York: Cambridge University Press, 2015); Emily S. Burrill, *States of Marriage: Gender, Justice, and Rights in Colonial Mali* (Athens: Ohio University Press, 2015); Erin E. Stiles and Katrina Daly Thompson, *Gendered Lives in the Western Indian Ocean: Islam, Marriage, and Sexuality on the Swahili Coast* (Athens: Ohio University Press, 2015); Sean Hanretta, *Islam and Social Change in French West Africa: History of an Emancipatory Community* (Cambridge: Cambridge University Press, 2009); Hassan Mwakimako, "Kadhi Court and Appointment of Kadhi in Kenya Colony," *Religion Compass* 2, no. 4 (2008): 424–43; Laura Fair, *Pastimes and Politics: Culture, Politics, and Identity in Post-Abolition*

Zanzibar, 1890–1945 (Athens: Ohio University Press, 2001); Richard Roberts, *Litigants and Households: African Disputes and Colonial Courts in the French Soudan, 1895–1912* (Portsmouth, NH: Heinemann, 2005); Richard Roberts, "Representation, Structure, and Agency: Divorce in the French Soudan during the Early Twentieth Century," *Journal of African History* 40 (1999): 389–410; Susan F. Hirsch, *Pronouncing and Persevering: Gender and the Discourses of Disputing in an African Court* (Chicago: University of Chicago Press, 1998); Thomas V. McClendon, "Tradition and Domestic Struggle in the Courtroom: Customary Law and the Control of Women in Segregation-Era Natal," *International Journal of African Historical Studies* 28, no. 3 (1995): 527–61; Allan Christelow, ed., *Thus Ruled Emir Abbas: Selected Cases from the Records of the Emir of Kano's Judicial Council* (East Lansing: Michigan State University Press, 1994); Carol Dickerman, "African Courts under the Colonial Regime: Usumbura, Rwanda-Urundi, 1938–62," *Canadian Journal of African Studies* 26, no. 1 (1992): 55–69.

5. For more detailed analysis of "public sphere," see Jürgen Habermas, *The Structural Transformation of the Public Sphere: An Inquiry into a Category of Bourgeois Society* (Cambridge, MA: MIT Press, 1989), 24. Habermas notes that official intervention in the privatized household finally came to constitute the target of a developing critical public sphere. The private sphere coexists with the public sphere, which includes public authority, such as the court.

6. In fact, until quite recently, throughout the protectorate, courts were held only on Wednesdays, days marked as rest days. This enabled not only litigants to come to the courts but also spectators. In this way, courtrooms were always crowded. In Bathurst, courts were held daily from Monday to Friday.

7. Toby Green, "Baculamento or Encomienda? Legal Pluralisms, Subjectivities, and Contestation of Power in the 17th Century Pan-Atlantic World," *Journal of Global Slavery* (forthcoming). See also Lauren Benton, *Law and Colonial Cultures: Legal Regimes in World History, 1400–1900* (New York: Cambridge University Press, 2002).

8. Edward Said, *Orientalism* (New York: Vintage Books, 1979); Mahmood Mamdani, *Citizen and Subject: Contemporary Africa and the Legacy of Late Colonialism* (Princeton, NJ: Princeton University Press, 1996); Mohamed Adhikari, *Not White Enough, Not Black Enough: Racial Identity in the South African Colored Community* (Athens: Ohio University Press, 2005); K. Mann and R. Roberts, eds., *Law in Colonial Africa* (Portsmouth, NH: Heinemann, 1991).

9. George H. Karekwaivanane, "Legal Encounters: Law, State and Society in Zimbabwe, c.1950–2008" (PhD diss., University of Oxford, 2012).

10. Murray Last, "The Colonial Caliphate of Northern Nigeria," in *Le temps des marabouts:*

Itinéraires et stratégies islamiques en Afrique Occidentale Francaise, v.1880–1960, ed. David Robinson and Jean-Louis Triaud (Paris: Karthala, 1997), 67–82; David Robinson, "France as Muslim Power in West Africa," *Africa Today* 46, no. 3/4 (1999): 105–27; and Roberts, *Litigants and Households*.

11. National Records Service [NRS], Colonial Secretary's Office [CSO] 2/942, April 6, 1948, Report on the Working of the Muhammadan Court, Memo from E. R. Ward to Lord Hailey. When the courts were set up in northern Nigeria, British administrators decided that the courts were to administer the native law and customs prevailing in the area of jurisdiction, and might award any type of punishment recognized thereby except mutilation, torture, or any other that might be deemed "repugnant" to natural justice and humanity.

12. See Charlotte A. Quinn, *Mandingo Kingdoms of the Senegambia: Traditionalism, Islam, and European Expansion* (Evanston, IL: Northwestern University Press, 1972); and Donald Wright, *The World and a Small Place in Africa: A History of Globalization in Niumi, the Gambia* (New York: M. E. Sharpe, 2010). Both Quinn and Wright have extensively shown how Gambians were affected by Islam mainly through wars but not through the Muslim courts.

13. Paolo Sartori and Ido Shahar, "Legal Pluralism in Muslim-Majority Colonies: Mapping the Terrain," *Journal of the Economic and Social History of the Orient* 55, no. 4/5 (2012): 637–63; Abdul-Fatah 'Kola Makinde and Philip Ostien, "Legal Pluralism in Colonial Lagos: The 1894 Petition of the Lagos Muslims to Their British Colonial Masters," *Die Welt des Islams* 52, no. 1 (2012): 51–68; Allan Christelow, "Islamic Law and Judicial Practice in Nigeria: An Historical Perspective," *Journal of Muslim Minority Affairs* 22, no. 1 (2002): 185–204; Sally Engle Merry, "Legal Pluralism," *Law and Society Review* 22 (1988): 869–96; David Killingray, "The Maintenance of Law and Order in British Colonial Africa," *African Affairs* 85, no. 340 (1986): 411–37; Allan Christelow, *Muslim Law Courts and the French Colonial State in Algeria* (Princeton, NJ: Princeton University Press, 1985).

14. Terence Ranger, "The Invention of Tradition in Colonial Africa," in *Perspectives on Africa: A Reader in Culture, History, and Representation*, ed. Roy Richard Grinker, Stephen C. Lubkemann, and Christopher B. Steiner (Malden, MA: Wiley-Blackwell, 2010); and Kristin Mann and Richard Roberts, eds., *Law in Colonial Africa* (Portsmouth, NH: Heinemann, 1991).

15. For more on colonial systems of administration, see Michael Crowder, *West Africa under Colonial Rule* (Evanston, IL: Northwestern University Press, 1968).

16. Last, "The Colonial Caliphate of Northern Nigeria."

17. For more on how colonial officials attempted to work with Muslim societies, see Robinson,

"France as Muslim Power in West Africa." For how colonial administrators codified African "traditions" and created "new" ways of administration, see Martin Chanock, *Law, Custom and Social Order: The Colonial Experience in Malawi and Zambia* (Cambridge: Cambridge University Press, 1985); and Mann and Roberts, *Law in Colonial Africa*.

18. In Islam, believers subject themselves to Islamic law, that is the sharia (way or path), which is divine revelations in the Holy Quran and the example set forth by the Prophet Muhammad in the Hadith or Sunnah (words and deeds of the Prophet). In addition, Muslims rely on the consensus of religious leaders, examples from the Quran or Hadith (Sunnah), or reasoning to mitigate or render justice. Sharia cannot be changed. For notes on sharia, see Tijani Muhammad Naniya, "History of the Shari'a in Some States of Northern Nigeria to Circa 2000," *Journal of Islamic Studies* 13, no. 1 (2002): 15. Tijani notes that for Muslims, the sharia represents the "way of religion" that "the Quran (45:18) enjoins for the whole of life, collective and individual. It defines crimes and punishments, regulates contractual relationships, and provides guidance and a legal framework for relations with non-Muslims within its jurisdiction, and relations with societies and states beyond its jurisdiction." The sharia also comments on how morals and ethics should be conducted in an Islamic society, including moderation, contentment, and sincere belief in the will of God and the Sunna of the Prophet Muhammad. The sharia also "accommodates the diversity of local cultures and conditions on the basis of the Quranic verse (5:48), which affirms that God has appointed to every people 'a law and a way of life,' and he has not willed to make 'you a single community.'"

19. For example, see the works of Harry Gailey, *A History of the Gambia* (London: Routledge and Kegan Paul, 1964); John M. Gray, *A History of the Gambia* (London: Frank Cass, 1966); Quinn, *Mandingo Kingdoms of the Senegambia*; Wright, *The World and a Small Place in Africa*; Alice Bellagamba, "Slavery and Emancipation in the Colonial Archives: British Officials, Slave Owners, and Slaves in the Protectorate of the Gambia (1890–1936)," *Canadian Journal of African Studies* 39, no. 1 (2005): 5–40; and Lamin Sanneh, *The Jakhanke Muslim Clerics: A Religious and Historical Study of Islam in Senegambia* (Lanham, MD: University Press of America, 1989).

20. Gray, *A History of the Gambia*.

21. Quinn, *Mandingo Kingdoms of the Senegambia*.

22. Wright, *The World and a Small Place in Africa*. Another good study of Senegambia is Philip Curtin's *Economic Change in Precolonial Africa: Senegambia in the Era of the Slave Trade* (Madison: University of Wisconsin Press, 1975). Curtin's study, focusing on the economic changes in the Senegambia region during the era of the slave trade, shows centuries of economic and commercial connections between North Africa and other

parts of Africa, particularly Senegambia, and how these connections have been fostered by the spread of Islam and by Arab migrants.

23. Judith Carney and Michael Watts, "Disciplining Women? Rice, Mechanization, and the Evolution of Mandinka Gender Relations in Senegambia," *Signs: Journal of Women in Culture and Society* 16, no. 4 (1991): 651–81. See also Richard A. Schroeder, "'Gone to Their Second Husbands': Marital Metaphors and Conjugal Contracts in The Gambia's Female Garden Sector," *Canadian Journal of African Studies* 30, no. 1 (1996): 69–87.

24. Roberts, "Representation, Structure, and Agency." There is also a growing body of legal anthropology in Muslim societies. For example, see Rubya Mehdi, ed., *Law and Religion in Multicultural Societies* (Copenhagen: Djøf Forlag, 2008); John R. Bowen, *Islam, Law, and Equality in Indonesia: An Anthropology of Public Reasoning* (Cambridge: Cambridge University Press, 2003); Lawrence Rosen, *Bargaining for Reality: The Construction of Social Relations in a Muslim Community* (Chicago: University of Chicago Press, 1984); Allan Christelow, "The Muslim Judge and Municipal Politics in Colonial Algeria and Senegal," *Comparative Studies in Society and History* 24, no. 1 (January 1982): 3–24; Christelow, *Muslim Law Courts and the French Colonial State*; Max Gluckman, *The Judicial Process among the Barotse of Northern Rhodesia* (Manchester: University of Manchester Press, 1955); Chanock, *Law, Custom and Social Order*; and Elliot Alexander Keay and Sam Scruton Richardson, *The Native and Customary Courts of Nigeria* (London: African Universities Press, 1966).

25. Hirsch, *Pronouncing and Persevering*.

26. Dickerman, "African Courts under the Colonial Regime." See also the work of McClendon, "Tradition and Domestic Struggle in the Courtroom"; Sally Falk Moore, *Social Facts and Fabrications: "Customary" Law on Kilimanjaro, 1880–1980* (Cambridge: Cambridge University Press, 1986); Margaret Jean Hay and Marcia Wright, eds., *African Women and the Law: Historical Perspectives* (Boston: Boston University, African Studies Center, 1982); and J. N. D. Anderson, "Muslim Marriages and the Courts in East Africa," *Journal of Law* 1, no. 1 (1957): 14–22. Allan Christelow's *Thus Ruled Emir Abbas*, a portrayal of Emir Abbas's court in northern Nigeria, also demonstrates how the newly created court under the purview of the British became a site for contestation and mediation.

27. See Josephine Beoku-Betts, "Western Perceptions of African Women in the 19th and Early 20th Centuries," in *Readings in Gender in Africa*, ed. Andrea Cornwall (Bloomington: Indiana University Press, 2005), 20–31; Gertrude Mianda, "Colonialism, Education, and Gender Relations in the Belgian Congo: The Évolué Case," in *Women in African Colonial Histories*, ed. Jean Allman, Nakanyike Musisi, and Susan Geiger (Bloomington: Indiana University Press, 2002), 144–63; Dorothy Hodgson and Sheryl McCurdy, *"Wicked" Women*

and the Reconfiguration of Gender in Africa (Portsmouth, NH: Heinemann, 2001); Iris Berger and E. Frances White, *Women in Sub-Saharan Africa: Restoring Women to History* (Bloomington: Indiana University Press, 1999).

28. Emily Lynn Osborn, *Our New Husbands Are Here: Households, Gender, and Politics in a West African State from the Slave Trade to Colonial Rule* (Athens: Ohio University Press, 2011), 146–47.

29. Roberts, "Representation, Structure, and Agency," 389–410; see also McClendon, "Tradition and Domestic Struggle in the Courtroom," 527–61.

30. Osborn, *Our New Husbands Are Here*, 148.

31. McClendon, "Tradition and Domestic Struggle in the Courtroom," 527.

32. Jean Allman, Nakanyike Musisi, and Susan Geiger, eds., *Women in African Colonial Histories* (Bloomington: Indiana University Press, 2002), 1.

33. See Beth Buggenhagen, *Muslim Families in Global Senegal: Money Takes Care of Shame* (Bloomington: Indiana University Press, 2012); Dorothea E. Schulz, *Muslims and New Media in West Africa: Pathways to God* (Bloomington: Indiana University Press, 2012); Adeline Masquelier, *Women and Islamic Revival in a West African Town* (Bloomington: Indiana University Press, 2009); Barbara Cooper, *Marriage in Maradi: Gender and Culture in a Hausa Society in Niger, 1900–1989* (Portsmouth, NH: Heinemann, 1997); Lucy Creevey, "Islam, Women, and the Role of the State in Senegal," *Journal of Religion in Africa* 26, no. 3 (1996): 268–307; Hodgson and McCurdy, *"Wicked" Women and the Reconfiguration of Gender in Africa*; and Barbara Callaway, *The Heritage of Islam: Women, Religion, and Politics in West Africa* (Boulder, CO: Lynne Rienner, 1994).

34. Peter Ntephe, "Does Africa Need Another Kind of Law? Alterity and the Rule of Law in Subsaharan Africa" (PhD diss., SOAS, University of London, 2012); George H. Karekwaivanane, "'It Shall Be the Duty of Every African to Obey and Comply Promptly': Negotiating State Authority in the Legal Arena, Rhodesia 1965–1980," *Journal of Southern African Studies* 37, no. 2 (2011): 333–49; A. E. Afigbo, *The Warrant Chiefs: Indirect Rule in Southeastern Nigeria, 1891–1929* (New York: Humanities Press, 1972); T. O. Elias, *The Nature of African Customary Law* (Manchester: Manchester University Press, 1956).

35. Andrea Stuart, *Sugar in the Blood: A Family's Story of Slavery and Empire* (New York: Alfred A. Knopf, 2013); Rebecca J. Scott and Jean M. Hébrard, *Freedom Papers: An Atlantic Odyssey in the Age of Emancipation* (Cambridge, MA: Harvard University Press, 2012); James H. Sweet, *Domingos Alvares, African Healing, and the Intellectual History of the Atlantic World* (Chapel Hill: University of North Carolina Press, 2011); Roquinaldo Ferreira, "Atlantic Microhistories: Mobility, Personal Ties, and Slaving in the Black Atlantic World (Angola and Brazil)," in *Cultures of the Lusophone Black Atlantic*, ed. Nancy

Priscilla Naro, Roger Sansi-Roca, and David H. Treece (New York: Palgrave Macmillan, 2007), 96–128; Randy J. Sparks, *The Two Princes of Calabar: An Eighteenth-Century Atlantic Odyssey* (Cambridge, MA: Harvard University Press, 2004); José da Silva Horta, "Evidence for a Luso-African Identity in 'Portuguese' Accounts on 'Guinea of Cape Verde' (Sixteenth–Seventeenth Centuries)," *History in Africa* 27 (2000): 99–130.

36. Thomas Spear, "Approaches to Documentary Sources," in *Sources and Methods in African History: Spoken, Written, Unearthed*, ed. Toyin Falola and Christian Jennings (Rochester, NY: University of Rochester Press, 2003), 169–70. For more on limitations of documentary sources, see John Edward Philips, *Writing African History* (Rochester, NY: University of Rochester Press, 2005); Toyin Falola and Christian Jennings, eds., *Sources and Methods in African History: Spoken, Written, Unearthed* (Rochester, NY: University of Rochester Press, 2003); and Donald A. Ritchie, *Doing Oral History: A Practical Guide* (Oxford: Oxford University Press, 2003), 26. Ritchie points out that "although archival documents have the advantage of not being influenced by later events or otherwise changing over time, as an interviewee might, documents are sometimes incomplete, inaccurate, and deceiving."

37. Thomas V. McClendon, *Genders and Generations Apart: Labour Tenants and Customary Law in Segregation-Era South Africa, 1920s–1940s* (Oxford: James Currey, 2002), 14.

38. I worked with Shaykh Adi Jobe in the translation of all the cases in Arabic. Mr. Jobe studied the Quran at his home village in Kerr Jarga, Niumi, North Bank Region, and went on to study in Egypt and Saudi Arabia. He now works at the King Fahad Mosque in Serrekunda, Gambia, where he gives sermons before Friday prayers.

39. Stockreiter, *Islamic Law, Gender, and Social Change in Post-Abolition Zanzibar*, 11–12. In the Zanzibari court studied by Stockreiter, she finds the records incomplete and fragmented.

40. Joseph C. Miller, "History and Africa/Africa and History," *American Historical Review* 104, no. 1 (February 1999): 8. See also, for example, Luise White, Stephan E. Miescher, and David William Cohen, *African Words, African Voices: Critical Practices in Oral History* (Bloomington: Indiana University Press, 2001); Falola and Jennings, *Sources and Methods in African History*; and Philips, *Writing African History*.

41. Jan Vansina, *Oral Tradition as History* (Madison: University of Wisconsin Press, 1985), 3. Vansina distinguishes oral history from oral tradition, noting that while the former gets its sources from reminiscences, hearsay, or eyewitness accounts, the latter is information passed from mouth to mouth (memorized messages, memorized traditions, and everyday language) for a period beyond the lifetime of the informant. Correspondence with Toby Green.

42. Walter Hawthorne, *Planting Rice and Harvesting Slaves: Transformations along the Guinea-Bissau Coast, 1400–1900* (Portsmouth, NH: Heinemann, 2003). See also Robert M. Baum, *Shrines of the Slave Trade: Diola Religion and Society in Precolonial Senegambia* (Oxford: Oxford University Press, 1999); and Vansina, *Oral Tradition as History*.

43. Toby Green, "From Essentialism to Pluralisms: New Directions in West African History from the Oral History Archive at Fajara, The Gambia (Brill, forthcoming).

44. Sarah Mirza and Margaret Strobel, eds., *Three Swahili Women: Life Histories from Mombasa, Kenya* (Bloomington: Indiana University Press, 1989).

45. Louise A. Tilly, "People's History and Social Science History," *Social Science History* 7, no. 4 (1983): 457–74.

46. Michael G. Peletz, *Religious Courts and Cultural Politics in Malaysia* (Princeton, NJ: Princeton University Press, 2002).

47. Susan C. Weller, "Structured Interviewing and Questionnaire Construction," in *Handbook of Methods in Cultural Anthropology*, ed. Bernard H. Russell (Walnut Creek, CA: AltaMira Press, 2000), 365–409.

48. Kathleen M. Dewalt and Billie Dewalt, *Participant Observation: A Guide for Field Workers* (New York: AltaMira Press, 2002). Dewalt and Dewalt recommend a type of participant interview method that is passive—that is more focused on observation while keeping note of the happenings at the interview scene.

49. During two of these court sittings, I participated in the solemnization of marriages, which the court also arranges.

50. Daphne Patai, "US Academics and Third World Women: Is Ethical Research Possible?," in *Women's Words: The Feminist Practice of Doing Oral History*, ed. Sherna Berger Gluck and Daphne Patai (New York: Routledge, 1991), 137–53.

51. For example, in an interview with village elders in Medina Seedia, they were able to accurately tell us the tale of the founder of the village, his educational background, and the lifespan of all the village heads and imams since the establishment of the village.

52. For example, in 1900, two British traveling commissioners, six Gambian constables, and a large number of innocent people lost their lives in a land dispute that involved the villages of Sankandi and Batteling and the British colonial administration. This crisis has gained currency in colonial British historiography on the Gambia and popular memory in the country as the Battle of Sankandi. The local leaders of this conflict were brought to trial at the Supreme Court in Bathurst, where they were eventually convicted and sentenced to death. For the full story, see Gray, *A History of the Gambia*, 472.

Chapter One. Advent of Colonial Rule: Shaping the Legal Landscape

1. For the rise of militant Islam in the West African region, see David Robinson, *The Holy War of Umar Tal: The Western Sudan in the Mid-Nineteenth Century* (Oxford: Clarendon Press, 1985); Donald R. Wright, *The World and a Small Place in Africa: A History of Globalization in Niumi, the Gambia* (New York: M. E. Sharpe, 2010); and Spencer J. Trimingham, *A History of Islam in West Africa* (London: Oxford University Press, 1962).

2. The British administration of the Gambia evolved around Bathurst as the colony, and the rest of the country as the protectorate. The governor sat in the colony, and traveling commissioners served in the protectorate, one for each bank of the Gambia River— south and north bank. The role of the traveling commissioner was as an assessor to the "native" courts and the administration of the area under his jurisdiction. In Gambia, the Alkali (Alikalo, Alkaides) is the village head or chief. He is usually the founder of the village, and he acts in matters of land distribution and judges other issues. "Alkaide" is a corruption of the Arabic word for Muslim judge.

3. In most parts of Gambia, especially Muslim areas, kola nuts sanctify marriages and also bless many social occasions. "Traditionally," before husbands take their wives, they will help the intended in-law with work on his farm and also sometimes with small presents. Also, material things such as cloth, household utensils, and jewelry constitute marriage items or presents. *Coos* here means millet.

4. The Almami is the religious leader of the community, and he usually presides over cases relating to marriage and divorce and solemnizes births and marriages. The Almami also leads the community in prayers.

5. National Records Service [NRS], Annual Reports [ARP] 32/1, 1891, North Bank, Traveling Commissioner's Reports.

6. For a full story of this case, see NRS, ARP 32/1.

7. Based on several arguments made by scholars on colonial rule, one can make the case that the system of administration imposed by colonial rulers presupposed three issues: Europeans demeaned traditional authorities, respected the values of traditional rule, and/or did not have tangible ideas of how Africans should be ruled and therefore were forced to work with them. For instance, see Michael Crowder, *West Africa under Colonial Rule* (Evanston, IL: Northwestern University Press, 1968); Peter K. Tibenderana, "The Irony of Indirect Rule in Sokoto Emirate, Nigeria, 1903–1944," *African Studies Review* 31, no. 1 (April 1988): 67–92; and Sara Berry, "Hegemony on a Shoestring: Indirect Rule and Access to Agricultural Land," *Africa: Journal of the International African Institute* 62, no. 3 (1992): 327–55.

8. The Holy Quran is central to the dispensation of Islamic justice, the sharia (way or path),

which is divine revelation. Its presence in a judicial matter signifies that all or one of the litigants is Muslim.

9. George H. Karekwaivanane, "'It Shall Be the Duty of Every African to Obey and Comply Promptly': Negotiating State Authority in the Legal Arena, Rhodesia 1965–1980," *Journal of Southern African Studies* 37, no. 2 (2011): 333–49; Kristin Mann and Richard Roberts, eds., *Law in Colonial Africa* (Portsmouth, NH: Heinemann, 1991).

10. Richard Roberts, *Litigants and Households: African Disputes and Colonial Courts in the French Soudan, 1895–1912* (Portsmouth, NH: Heinemann, 2005). Roberts says that landscapes of power thus contain physical institutions such as the chieftaincy, heads of households, and courts, as well as social and cultural practices such as kinship, marriage, slavery, labor, religion, leisure, wealth, and authority. In fact, many scholars have contended that for colonial rule to be functional, African "traditions" and customs had to be incorporated into European legal practices. For example, see Frederick Lugard, *The Political Memoranda: Revision of Instructions to Political Officers on Subjects Chiefly Political and Administrative* (London: Frank Cass, 1970); Terence Ranger and Eric Hobsbawm, eds., *The Invention of Tradition* (Cambridge: Cambridge University Press, 1983); Mann and Roberts, *Law in Colonial Africa*; and Martin Chanock, *Law, Custom and Social Order: The Colonial Experience in Malawi and Zambia* (Cambridge: Cambridge University Press, 1985). A good example of European interference in African "traditional" rule was the case of northern Nigeria, when, at the time of conquest, some "traditional" rulers were co-opted into the new British administrative system. See, for example, Murray Last, "The Colonial Caliphate of Northern Nigeria," in *Le temps des marabouts: Itinéraires et stratégies islamiques en Afrique Occidentale Francaise, v.1880–1960*, ed. David Robinson and Jean-Louis Triaud (Paris: Karthala, 1997), 67–82; and Peter K. Tibenderana, *Sokoto Province under British Rule, 1903–1939: A Study in Institutional Adaptation and Culturalization of a Colonial Society in Northern Nigeria* (Zaria, Nigeria: Ahmadu Bello University Press, 1988). French colonial officials had similar dealings with Africans. See David Robinson, "France as Muslim Power in West Africa," *Africa Today* 46, no. 3/4 (1999): 105–27; and David Robinson, "French 'Islamic' Policy and Practice in Late Nineteenth-Century Senegal," *Journal of African History* 29, no. 3 (1988): 415–35.

11. Roberts, *Litigants and Households*, 30.

12. The Gambia, The People 2016, http://www.theodora.com/wfbcurrent/gambia_the/gambia_the_people.html.

13. Charlotte A. Quinn, *Mandingo Kingdoms of the Senegambia: Traditionalism, Islam, and European Expansion* (Evanston, IL: Northwestern University Press, 1972), 6.

14. For more on the rivalry among Europeans to control the trade in the Gambia, see Philip

Curtin, *Economic Change in Precolonial Africa: Senegambia in the Era of the Slave Trade* (Madison: University of Wisconsin Press, 1975), 102. Curtin describes the activities of the Europeans as a play: "The style of warfare among Europeans of Senegambia posts involved a dominant defender and an aggressive challenger at each stage. In the first half of the seventeenth century, the Portuguese defended against the Dutch, France and England watched, more or less inactive on the sidelines. Then as the Dutch became supreme in the 1600's and the 1700's, the English and French acted together to dislodge them, just as Holland or England were to act together against France from the 1600's to the 1710's."

15. See, for example, Peter Mark, "Fetishers, 'Marybuckes,' and the Christian Norm: European Images of Senegambians and Their Religions, 1550–1760," *African Studies Review* 23, no. 2 (1980): 91–99; George E. Brooks, *Landlords and Strangers: Ecology, Society, and Trade in Western Africa, 1000–1630* (Boulder, CO: Westview Press, 1993); Peter Mark, "The Evolution of 'Portuguese' Identity: Luso-Africans on the Upper Guinea Coast from the Sixteenth to the Early Nineteenth Century," *Journal of African History* 40, no. 2 (1999): 173–91.

16. See John M. Gray, *A History of the Gambia* (London: Frank Cass, 1966).

17. See Winifred Galloway, *James Island: A Background with Historical Notes on Juffure, Albreda, San Domingo and Dog Island* (Banjul: Oral History and Antiquities Division, 1978). For more on the early Europeans in the Gambia, see Peter Mark, *"Portuguese" Style and Luso-African Identity: Precolonial Senegambia, Sixteenth–Nineteenth Centuries* (Bloomington: Indiana University Press, 2002); George E. Brooks, *Eurafricans in Western Africa: Commerce, Social Status, Gender, and Religious Observance from the Sixteenth to the Eighteenth Century* (Athens: Ohio University Press, 2003), and NRS, Colonial Reports, Gambia, 1960–1961, Quadrangle, Banjul, Gambia.

18. For trade and trading activities, see Mungo Park, *Travels in the Interior of Africa, in the Years 1795, 1796, & 1797*, abridged ed. (London: J. W. Myers, 1799); and Richard Jobson, *A Discovery of the River Gambra and the Golden Trade of the Aethiopians* (London: Dawsons of Pall Mall, 1623).

19. See Wright, *The World and a Small Place in Africa*; Martin A. Klein, *Islam and Imperialism in Senegal: Sine-Saloum, 1847–1914* (Stanford, CA: Stanford University Press, 1968); and Gray, *A History of the Gambia*.

20. NRS, ARP 28/1, 1893, South Bank, Traveling Commissioner's Reports.

21. NRS, ARP 28/1, vol. 2, 1893–1899, South Bank, Traveling Commissioner's Reports.

22. The *ulama* generally refers to a group of Islamic scholars knowledgeable in Muslim affairs and law.

23. See Lamin Sanneh, *The Crown and the Turban: Muslims and West African Pluralism* (Boulder, CO: Westview Press, 1997).

24. Jobson, *A Discovery of the River Gambra*, 99.

25. See Toby Green, *Meeting the Invisible Man: Secrets and Magic in West Africa* (London: Faber and Faber, 2009).

26. Quinn, *Mandingo Kingdoms of the Senegambia*, 54–55.

27. For example, see Curtin, *Economic Change in Precolonial Africa*; Wright, *The World and a Small Place in Africa*; and Thomas C. Hunter, "The Development of an Islamic Tradition of Learning among the Jakhanke of West Africa" (PhD diss., University of Chicago, 1977).

28. For more discussion on marabouts (clerics) and their wealth, see Benjamin F. Soares, *Islam and the Prayer Economy: History and Authority in a Malian Town* (Ann Arbor: University of Michigan Press, 2005); and D. B. Cruise O'Brien, *The Mourides of Senegal: The Political and Economic Organization of an Islamic Brotherhood* (Oxford: Clarendon Press, 1971). It should be mentioned that today, the position of the Almamis is not much different, as they continue to be teachers and guardians of esoteric knowledge.

29. See Lamin Sanneh, *The Jakhanke Muslim Clerics: A Religious and Historical Study of Islam in Senegambia* (Lanham, MD: University Press of America, 1989); Lamin Sanneh, "The Origins of Clericalism in West African Islam," *Journal of African History* 17, no. 1 (1976): 49–72; and Thomas C. Hunter, "The Jabi Tarikhs: Their Significance in West African Islam," *International Journal of African Historical Studies* 9, no. 3 (1976): 435–57. See also Rebecca Turner, "Gambian Religious Leaders Teach about Islam and Family Planning," *International Family Planning Perspectives* 18, no. 4 (1992): 150–51.

30. Wright, *The World and a Small Place in Africa*, 197; see also Quinn, *Mandingo Kingdoms of the Senegambia*. Quinn's work is undoubtedly one of the most comprehensive accounts of the Soninke-Marabout Wars in the Gambia.

31. See Gray, *A History of the Gambia*. Maba was killed in 1867 during a raid in Sine Saloum. His death did not end the fighting between the Muslims and non-Muslims. Gray documents the rise of Muslims against their non-Muslim overlords up and down the Gambia River after the death of Maba.

32. Gray, *A History of the Gambia*, 448; see also Gordon Innes, ed. and tr., *Kaabu and Fuladu: Historical Narratives of the Gambian Mandinka* (London: School of Oriental and African Studies, 1976); and Charlotte A. Quinn, "A Nineteenth Century Fulbe State," *Journal of African History* 12, no. 3 (1971): 427–40.

33. David Robinson, *Paths of Accommodation: Muslim Societies and French Colonial Authorities in Senegal and Mauritania, 1880–1920* (Athens: Ohio University Press, 2000).

34. See Nehemia Levtzion and Randall L. Pouwels, eds., *The History of Islam in Africa*

(Athens: Ohio University Press, 2000).

35. See Crowder, *West Africa under Colonial Rule*.

36. NRS, Colonial Secretary's Office [CSO] 3/87, Sheik Omar Faye.

37. Ibid.

38. Ibid.

39. NRS, CSO 3/144, Muhammadan School.

40. NRS, CSO 3/144, Letter from Jahumpa to Governor Denham, March 26, 1929.

41. NRS, CSO 3/144, Colonial Secretary to Ousman Jeng, October 7, 1929.

42. *Gambia Echo*, June 3, 1940, 5.

43. Jean-Louis Triaud, "Islam in Africa under French Colonial Rule," in *The History of Islam in Africa*, ed. Nehemia Levtzion and Randall L. Pouwels (Athens: Ohio University Press, 2000), 171.

44. For discussions on *Islam noire* and French Islamic policy toward Africa, see Robinson, *Paths of Accommodation*; Robinson, "French 'Islamic' Policy and Practice"; Levtzion and Pouwels, *The History of Islam in Africa*; Muhammad Sani Umar, "The Tijaniyya and British Colonial Authorities in Northern Nigeria," in *La Tijâniyya: Une confrérie musulmane à la conquête de l'Afrique*, ed. Jean-Louis Triaud and David Robinson (Paris: Karthala, 2000), 327–55; Robert Launay and Benjamin F. Soares, "The Formation of an 'Islamic Sphere' in French Colonial West Africa," *Economy and Society* 28 (1999): 497–519; D. B. Cruise O'Brien, "Towards an 'Islamic Policy' in French West Africa, 1854–1914," *Journal of African History* 8, no. 2 (1967): 303–16.

45. Paul Lovejoy and Jan S. Hogendorn, "Revolutionary Mahdism and Resistance to Colonial Rule in the Sokoto Caliphate, 1905–1906," *Journal of African History* 31, no. 2 (1990): 217–44.

46. NRS, ARP 28/2, 1903–1923, South Bank, Traveling Commissioner's Report.

47. Ibid.

48. French territory is present-day Senegal, a country that surrounds Gambia on all sides except the Atlantic Ocean. The delimitation of formal boundaries between the Gambia and Senegal in the 1890s did little to curb the flow of people from one region to another.

49. NRS, CSO 2/391, Abdoulie Janneh.

50. Thora Williamson, *Gold Coast Diaries: Chronicles of Political Officers in West Africa, 1900–1919*, ed. Anthony Kirk-Greene (London: Radcliffe Press, 2000), 13.

51. NRS, CSO 3/76, 1924, Trials by Assessors.

52. For a full version of this case, see the *Gambia Echo*, March 2, 1936, 3.

53. Judicial Committee of the Privy Council (Great Britain), "Abdoulie Drammeh vs. Joyce Drammeh," *Journal of African Law* 14, no. 2 (Summer 1970): 115–20.

54. *Gambia Echo*, August 7, 1967, 2.

55. Harry A. Gailey, *A History of the Gambia* (London: Routledge and Kegan Paul, 1964), 104.

56. The word "native" carries a pejorative meaning, and I am using it here only to refer to the protectorate's legal institutions established by the British.

57. Mann and Roberts, *Law in Colonial Africa*, 13.

58. NRS, ARP 28/1, June 1899, "An Attempt to Make the Tribunal Efficient," from Traveling Commissioner Waine Wright to Administrator, Bathurst (M.I. Report).

59. NRS, ARP 28/2, 1903–1923, South Bank, Traveling Commissioner's Report.

60. NRS, ARP 28/1, from Traveling Commissioner to Administrator, South Bank.

61. NRS, ARP 28/1, from Waine Wright to Governor Rib Llewelyn.

62. For translation of religious scripts, see Lamin Sanneh, *Translating the Message: The Missionary Impact on Culture* (Maryknoll, NY: Orbis Books, 1989). Sanneh discusses the translatability of the Bible as well as problems associated with the Quran *not* being translatable.

63. NRS, ARP 28/1, MacCarthy Island Report, 1898–1899, from Percy Waine Wright to the Administrator, Bathurst.

64. NRS, CSO 2/531, April 13, 1922, Monthly Diary, North Bank Province.

65. See Mann and Roberts, *Law in Colonial Africa*.

66. NRS, CSO 2/1375, 1933, Native Tribunals Ordinance.

67. Ibid.

68. NRS, CSO 2/1375, Native Tribunals Ordinance.

69. Ibid.

70. NRS, CSO 2/941, March 31, 1932, The View and Opinion of Colonial Civil Servants of the Native Courts, Quarterly Report, G. Nuun to Colonial Secretary.

71. Ibid.

72. Ibid.

73. Ibid.

74. NRS, CSO 3/321, October 15, 1937, Protectorate Subordinate Provincial Courts.

75. Ibid.

76. NRS, CSO 2/1589, 1936, North Bank Province Report.

77. NRS, CSO 3/280, August 14, 1935, Acting Colonial Secretary to Commissioners.

78. NRS, CSO 2/941, Regarding Native Tribunals, Financial.

79. See, for example, Berry, "Hegemony on a Shoestring," 327–55; Mahmood Mamdani, *Citizen and Subject: Contemporary Africa and the Legacy of Late Colonialism* (Princeton, NJ: Princeton University Press, 1996); Karen E. Fields, *Revival and Rebellion in Colonial Central Africa* (Princeton, NJ: Princeton University Press, 1985).

80. For example, see Sally Falk Moore, "Treating Law as Knowledge: Telling Colonial Officers What to Say to Africans about Running 'Their Own' Native Courts," *Law and Society Review* 26 (1992): 11–46, 12; and Sally Falk Moore, *Social Facts and Fabrications: "Customary" Law on Kilimanjaro, 1880–1980* (Cambridge: Cambridge University Press, 1986), 88. Moore earlier suggested that the introduction of colonial law promoted cultural transformations among colonized peoples, yet also established limits to these transformations and provided opportunities to resist and negotiate colonial power. See also Thomas Spear, "Neo-Traditionalism and the Limits of Invention in British Colonial Africa," *Journal of African History* 44, no. 1 (2003), 3. Spear's analyses of the "making of customary law" have similarly shown how colonial authorities, missionaries, and African elders cobbled together local customs, colonial law, Christian morality, and administrative regulations; codified them; gave them penal and corporal sanctions; and made them enforceable by authoritarian chiefs, contrary to negotiated precolonial practices.

Chapter Two. Marriage Laws in the Gambia: Traditions and Customs

1. In Gambia, according to some traditions and customs, when a husband dies, one of his brothers can marry the wife; the practice is known in Mandinka as *nimoosaatoo* and in Wolof as *dona*.

2. Muslim Court Record Year Book, 1933–1937, Qadi Court, Banjul, Gambia, 62.

3. Muslim Court Record Year Book, 1952–1957, Qadi Court, Banjul, 399. It is important to note that fines in the record book are recorded in dollars and pounds for most of the period under study. I am not sure why the scribe got "dollars" and "pounds" confused. However, it is understandable because the Maria Theresa dollar was popular currency in Senegambia a long time ago.

4. Julia Sloth-Nielsen and Lea Mwambene, "Talking the Talk and Walking the Walk: How Can the Development of African Customary Law Be Understood?," *Law in Context* 28, no. 2 (2010); Marie-Antoinette Sossou, "Widowhood Practices in West Africa: The Silent Victims," *International Journal of Social Welfare* 11 (2002): 201–9; Patricia G. Kameri-Mbote, "Gender Dimensions of Law, Colonialism and Inheritance in East Africa: Kenyan Women's Experiences," *Law and Politics in Africa, Asia and Latin America* 35, no. 3 (2002): 373–98; E. R. Leach, "Polyandry, Inheritance and the Definition of Marriage," *Man* 55 (1955): 182–86; Fitnat Naa-Adjeley, "Reclaiming the African Woman's Individuality: The Struggle between Women's Reproductive Autonomy and African Society and Culture," *American University Law Review* 44, no. 4 (1995): 1351–82.

5. Interview with Alh. Sunkare Marakong, Central River Division, Wassu, July 5, 2013;

Principal Qadi, Alhagi Masamba Jagne, Banjul Qadi Court, Banjul, Gambia, July 23, 2013; Alhagi Kantong Suwareh, Ndanka Village, North Bank Region, August 3, 2013.

6. Terence Ranger, "The Invention of Tradition in Colonial Africa," in *Perspectives on Africa: A Reader in Culture, History, and Representation,* ed. Roy Richard Grinker, Stephen C. Lubkemann, and Christopher B. Steiner (Malden, MA: Wiley-Blackwell, 2010. See also Jan Vansina, for whom traditions embody continuity and shape the future for those who hold them, and as such they can be continually renewed; Jan Vansina, *Paths in the Rainforest: Toward a History of Political Tradition in Equatorial Africa* (Madison: University of Wisconsin Press, 1990), 257–58.

7. Martin Chanock, *Law, Custom and Social Order: The Colonial Experience in Malawi and Zambia* (Cambridge: Cambridge University Press, 1985).

8. Thomas Spear, "Neo-Traditionalism and the Limits of Invention in British Colonial Africa," *Journal of African History* 44, no. 1 (2003): 3–27.

9. For information on marriage practices, see Luigi M. Solivetti, "Family, Marriage and Divorce in a Hausa Community: A Sociological Model," *Africa: Journal of the International African Institute* 64, no. 2 (1994): 252–71; and Alma Gottlieb, "Cousin Marriage, Birth Order and Gender: Alliance Models among the Beng of Ivory Coast," *Man,* n.s., 21, no. 4 (December 1986): 697–722.

10. Abdullah Yusuf Ali, *The Meaning of the Holy Quran* (Beltsville, MD: Amana Publications, 2004), Suratul Nisa, chapter 4, verse 11, 186–87.

11. Ibid., Suratul Nisa, chapter 4, verse 5, 183.

12. Barbara Callaway, *Muslim Hausa Women in Nigeria: Tradition and Change* (Syracuse, NY: Syracuse University Press, 1987), 39.

13. Elke Stockreiter, *Islamic Law, Gender and Social Change in Colonial Zanzibar* (New York: Cambridge University Press, 2015), 19.

14. Ali, *The Meaning of the Holy Quran,* Suratul Al Talaq, chapter 65, verses 1–6, 1483–85.

15. On tradition and custom, I had several discussions with Alhagi Kantong Suwareh, Ndanka village, North Bank Region, August 3, 2013. Kantong runs a clerical school with a number of students.

16. Muslim Court Record Year Book, 1933–1937, Qadi Court, Banjul, 53.

17. Muslim Court Record Year Book, 1952–1957, Qadi Court, Banjul, 393. The children were presumably from the wife's earlier marriage.

18. Ibid., 349.

19. On aspects of traditional marriage, I interviewed Alh. Sunkare Marakong, Central River Division, Wassu, July 5, 2013. I also interviewed Nfamara Jatta, Georgetown, Janjanbureh, July 6, 2013, and Ajaratou Maimouna Savage, Kanifing, July 25, 2013.

20. Bala Saho, "Challenges and Constraints: Forced Marriage as a Form of 'Traditional' Practice in the Gambia," in *Marriage by Force? Contestation over Consent and Coercion in Africa*, ed. Annie Buntung, Benjamin N. Lawrence, and Richard Roberts (Athens: Ohio University Press, 2016), 178–98.

21. In many cases, poor parents tend to keep their daughters in difficult marriages.

22. Discussions with Alhagi Kantong Suwareh, Ndanka Village, North Bank Division, August 3, 2013; Shaykh Adi Jobe, Serrekunda, July 1–August 4, 2014.

23. Interviews with Alh. Sunkare Marakong, Central River Division, Wassu, July 5, 2013; Nfamara Jatta, Georgetown, Janjanbureh, Gambia, July 6, 2013; Alhagi Kantong Suwareh, Ndanka Village, North Bank Division, August 3, 2013.

24. Muslim Court Record Year Book, 1952–1957, Qadi Court, Banjul, 342.

25. These examples refer to hardworking and respectable women; women who engage in extramarital dalliances have an even harder time currying favor in court. In fact, recently, a court in Gambia ordered a woman to be hanged for infanticide. In her testimony, the woman complained that the reason why she dumped her baby into a well was that she was afraid her father would kill her if he learned that she had gotten pregnant out of wedlock. For this story, see the *Daily Observer* (Banjul), October 25, 2011.

26. Michelle Zimbalist Rosaldo and Louise Lamphere, eds., *Woman, Culture, and Society* (Stanford, CA: Stanford University Press, 1974), 3.

27. Mineke Schipper, *Source of All Evil: African Proverbs and Sayings on Women* (London: Allison and Busby, 1991), 142.

28. It should be mentioned that "native" laws and "customs" have become increasingly Muslim laws due to the Islamization in the region for several centuries. In fact, Islam is so ingrained with "tradition" that "traditional" conflict resolution often relies on the Hadith to attempt to resolve conflicts. For example, the Islamic term *sabarr* has been reinterpreted in the Gambian context, with the local meaning connoting forbearance and forgiveness: "Inna Allah ma es-sabarriin" (God is with the patient/forgiving ones) and "Es-sabr miftahul farajj" (patience/forbearance is the key to success). Interviews with Sheikh Seediya Dabo, the grand marabout, and Yusuf Dabo at Medina Seedia; with Seringe Mamamt Saho and Bubakar Saho at Fass Sakho; and with Alhaji Badou Sallah, Imam Mbye Kah, Kebba Njie, and Oustass Cherno Kah at Medina Seringe Mass, November 23, 2010.

29. For a detailed description and meaning of some of these ordinances, see John M. Gray, *A History of the Gambia* (London: Frank Cass, 1966).

30. See Elizabeth Schmidt, *Peasants, Traders, and Wives: Shona Women in the History of Zimbabwe, 1870–1939* (London: James Currey, 1992); Elizabeth Schmidt, "Negotiated

Spaces and Contested Terrain: Men, Women, and the Law in Colonial Zimbabwe, 1890–1939," *Journal of Southern African Studies* 16, no. 4 (1990): 622–48; Richard Roberts, "Representation, Structure, and Agency: Divorce in the French Soudan during the Early Twentieth Century," *Journal of African History* 40 (1999): 389–410; Richard Roberts, *Litigants and Households: African Disputes and Colonial Courts in the French Soudan, 1895–1912* (Portsmouth, NH: Heinemann, 2005).

31. Emily Burrill, Richard Roberts, and Elizabeth Thornberry, eds., *Domestic Violence and the Law in Colonial and Postcolonial Africa* (Athens: Ohio University Press, 2010), 9.

32. Kenneth Swindell, *The Strange Farmers of the Gambia: A Study in the Redistribution of African Population* (Norwich, England: Geo Books, 1981).

33. Chanock, *Law, Custom and Social Order.*

34. Roberts, "Representation, Structure, and Agency," 389–410. See also Thomas V. McClendon, "Tradition and Domestic Struggle in the Courtroom: Customary Law and the Control of Women in Segregation-Era Natal," *International Journal of African Historical Studies* 28, no. 3 (1995): 527–61; and Jean Allman, Nakanyike Musisi, and Susan Geiger, eds., *Women in African Colonial Histories* (Bloomington: Indiana University Press, 2002), 1.

35. Saho, "Challenges and Constraints."

36. Alice Bellagamba, Sandra E. Greene, and Martin Klein, eds., *The Bitter Legacy: African Slavery Past and Present* (Princeton, NJ: Markus Wiener, 2013).

37. Alice Bellagamba, "Slavery and Emancipation in the Colonial Archives: British Officials, Slave Owners, and Slaves in the Protectorate of the Gambia (1890–1936)," *Canadian Journal of African Studies* 39, no. 1 (2005): 5–41.

38. For the predicament of women and children during slavery and colonial rule in Africa, see Richard Roberts and Suzanne Miers, *The End of Slavery in Africa* (Madison: University of Wisconsin Press, 1988); Elizabeth A. Eldredge, *Power in Colonial Africa: Conflict and Discourse in Lesotho, 1870–1960* (Madison: University of Wisconsin Press, 2007); Paul E. Lovejoy and David Richardson, "The Business of Slaving: Pawnship in West Africa, c.1600–1800," *Journal of African History* 42, no. 1 (2001): 67–89. The issue of child marriage even today is common in many African societies, in particular Muslim societies. For example, a recent study by UNICEF in six West African countries showed that 44 percent of twenty- to twenty-four-year-old women in Niger were married by the age of fifteen. See UNICEF, "Early Marriage: Child Spouses," *Innocenti Digest* (Florence) 7 (March 2001): 2; and Burrill, Roberts, and Thornberry, *Domestic Violence and the Law.*

39. See National Records Service [NRS], Colonial Secretary's Office [CSO] 2/1395, Minimum Age of Marriage of Consent (Inside Outside Marriage in the Gambia, Memorandum); and NRS, CSO 3/304, Forced Marriage of African Girls, Banjul, Gambia. See also Brett

L. Shadle, "Bridewealth and Female Consent: Marriage Disputes in African Courts, Gusiiland, Kenya," *Journal of African History* 44, no. 2 (2003): 241–62.

40. Nana Grey-Johnson, *The Story of the Newspaper in the Gambia* (Banjul: Book Production and Material Resources Unit, 2004), 50.

41. Hassoum Ceesay, *Gambian Women: An Introductory History* (Banjul: Fulladu Publishers, 2007), 64.

42. NRS, CSO 3/133.

43. Ceesay, *Gambian Women: An Introductory History*. Infanticide remains a major issue in contemporary Gambia. The *Point* newspaper, in a recent editorial, noted that "The issue of baby dumping in the country, especially among young girls, is no doubt, a cause for concern, and a national problem. Almost on a daily basis, one reads newspapers or sees on television people arraigned for dumping their new-born babies in pit latrines or even at dump sites." *Point*, February 8, 2011.

44. For the effects of and reactions to the Dissolution of Marriages Act of 1967, see Hassoum Ceesay, *A Brief Historical Insight into Gender-Based Violence in the Gambia, 1886–2005* (Banjul: African Centre for Democracy and Human Rights Studies, 2005). It is not unusual in Gambia for people to change their religion in order to marry.

45. Kristin Mann and Richard Roberts, *Law in Colonial Africa* (Portsmouth, NH: Heinemann, 1991), 4.

46. Mahmood Mamdani, *Citizen and Subject: Contemporary Africa and the Legacy of Late Colonialism* (Princeton, NJ: Princeton University Press, 1996).

47. See Barbara Cooper, *Marriage in Maradi: Gender and Culture in a Hausa Society in Niger, 1900–1989* (Portsmouth, NH: Heinemann, 1997), xlv. This ambivalence could be what Cooper characterized as Niger's colonial and postcolonial state's gingerly attempts to legislate marriage reforms for fear of provoking large-scale social and economic disruption. Despite the legal structures put in place, French legislation and the formal court system never effectively supplanted indigenous courts for arbitrating disputes in Maradi.

48. NRS, Native Authority [NA] 26, Bathurst, 1951, Letter from Commissioner, Upper River Division, to Senior Commissioner.

49. Ibid.

50. NRS, NA/26, Letter from Commissioner, Bathurst, to the Amir of Ahmadiyya Movement, Sierra Leone. The Ahmadiyya Movement was a nineteenth-century Islamic movement founded in India.

51. NRS, NA/26, May 15, 1952, Letter from Sergeant G. Humphrey Smith to E. F. Small.

52. NRS, NA/26, September 25, 1952, Letter, A. C. Spurling to Senior Commissioner,

Humphrey Smith.

53. Ibid.

54. I have discussed the issue of traditional marriage in detail elsewhere. See Saho, "Challenges and Constraints."

Chapter Three. Making the City: The Gambia Colony and Protectorate

1. In many colonial cities of West Africa, especially Bathurst, young people, usually immigrants, made money by using carts to ferry goods around the city. In local parlance, this practice became known as *bara* ñini (originating from the Malinke for "looking for work"). Nowadays, most people use a wheelbarrow instead of a cart for the same purpose.

2. The Aku spoke English with a mixture of local languages. In other African, American, and Caribbean countries they are known as Creoles. For more on ideas and processes of creolization, see Charles Stewart, ed., *Creolization: History, Ethnography, and Theory* (Walnut Creek, CA: Left Coast Press, 2007); James Sweet, *Recreating Africa: Culture, Kinship, and Religion in the African-Portuguese World, 1441–1770* (Chapel Hill: University of North Carolina Press, 2003); and Toby Green, *The Rise of the Trans-Atlantic Slave Trade in Western Africa, 1300–1589* (Cambridge: Cambridge University Press, 2012). For information on the Aku and Bathurst, see Florence K. C. Mahoney, "Government and Opinion in the Gambia, 1816–1901" (PhD diss., School of Oriental and African Studies, London, 1963).

3. During this period, Bathurst was the seat of all the main pillars of the law; the Supreme Court, the Qadi Court, and the Police Court. Therefore, in the realm of the law, all legal issues which could not be resolved in the protectorate found their way in Bathurst.

4. See Gray, *A History of the Gambia.*

5. In 1826, the British obtained permission from the king of Barra for the cession to the crown colony of a strip of a mile of coastal land on the north bank of the Gambia River from Jinak to the Jokadu Creek. In 1832, the area was extended to the sea. The area is still known as the Ceded Mile.

6. See Harry A. Gailey, *Historical Dictionary of the Gambia*, 2nd ed. (Metuchen, NJ: Scarecrow Press, 1987), 36–38; and Arnold Hughes and Harry A. Gailey, *Historical Dictionary of the Gambia*, 3rd ed. (Lanham, MD: Scarecrow Press, 1999), 37–38.

7. For the city's demography, see Arnold Hughes and David Perfect, *A Political History of the Gambia, 1816–1994* (Rochester, NY: University of Rochester Press, 2006), 16; and Gray, *A History of the Gambia*, 315.

8. The population increase was perhaps due to the intensity of the Soninke-Marabout Wars

between non-Muslims and Muslims, 1850–1901.

9. Hughes and Perfect, *A Political History of the Gambia*, 16; Charlotte A. Quinn, *Mandingo Kingdoms of the Senegambia: Traditionalism, Islam, and European Expansion* (Evanston, IL: Northwestern University Press, 1972), 23–25; and Gray, *A History of the Gambia*, 325–27. On the Serere, see Green, *The Rise of the Trans-Atlantic Slave Trade*.

10. For a detailed description of Wolof social and political culture, see David Gamble, Linda K. Salmon, and Alhaji Hassan Njie, eds., *Peoples of The Gambia: The Wolof*, Gambian Studies no. 17 (San Francisco: San Francisco State University, Department of Anthropology, 1985); Abdoulaye-Bara Diop, *La société wolof, tradition et changement: Les systèmes d'inégalité et de domination* (Paris: Karthala, 1981); Martin A. Klein, "Servitude among the Wolof and Sereer of Senegambia," in *Slavery in Africa: Historical and Anthropological Perspectives*, ed. Suzanne Miers and Igor Kopytoff (Madison: University of Wisconsin Press, 1977); Martin A. Klein, *Islam and Imperialism in Senegal: Sine-Saloum, 1847–1914* (Stanford, CA: Stanford University Press, 1968); and Green, *The Rise of the Trans-Atlantic Slave Trade*.

11. Eric S. Charry, *Mande Music: Traditional and Modern Music of the Maninka and Mandinka of West Africa* (Chicago: University of Chicago Press, 2000); Donald R. Wright, "Niumi: The History of a Western Mandinka State through the Eighteenth Century" (PhD diss., Indiana University, 1976); Winifred Galloway, "A History of Wuli from the Thirteenth to the Nineteenth Century" (PhD diss., Indiana University, 1975); Thomas C. Hunter, "The Development of an Islamic Tradition of Learning among the Jakhanke of West Africa" (PhD diss., University of Chicago, 1977); and Harry A. Gailey, *A History of the Gambia* (London: Routledge and Kegan Paul, 1964), 12.

12. Hughes and Perfect, *A Political History of the Gambia*, 13.

13. Richard Jobson, *A Discovery of the River Gambra and the Golden Trade of the Aethiopians* (London: Dawsons of Pall Mall, 1623), 47.

14. See, for example, Green, *The Rise of the Trans-Atlantic Slave Trade*; and Steven K. Thompson, "Revisiting 'Mandingization' in Coastal Gambia and Casamance (Senegal): Four Approaches to Ethnic Change," *African Studies Review* 54, no. 2 (2011): 95–121.

15. For more on Mandingo social and political organization, see George E. Brooks, *Landlords and Strangers: Ecology, Society, and Trade in Western Africa, 1000–1630* (Boulder, CO: Westview Press, 1993); Quinn, *Mandingo Kingdoms of the Senegambia*; Lamin Sanneh, *The Jakhanke Muslim Clerics: A Religious and Historical Study of Islam in Senegambia* (Lanham, MD: University Press of America, 1989); Donald R. Wright, *The World and a Small Place in Africa: A History of Globalization in Niumi, the Gambia* (New York: M. E. Sharpe, 2010); Donald R. Wright, "Darbo Jula: The Role of a Mandinka Jula Clan in

the Long-Distance Trade of the Gambia River and Its Hinterland," *African Economic History*, no. 3 (Spring 1977): 33–45; and Peter Weil, "Mandinka Mansaya: The Role of the Mandinka in the Political System of the Gambia" (PhD diss., University of Oregon, 1968).

16. For more on the Jola, see Robert Baum, *Shrines of the Slave Trade: Diola Religion and Society in Precolonial Senegambia* (Oxford: Oxford University Press, 1999); Paul Pélissier, *Les Diola:* Étude *sur l'habitat des rizicultures de Basse-Casamance* (Dakar: University of Dakar, Department of Geography, 1958); Peter Mark, "Economic and Religious Change among the Diola of Boulouf (Casamance), 1890–1940: Trade, Cash Cropping, and Islam in Southwestern Senegal" (PhD diss., Yale University, 1976); Olga Linares, *Power, Prayer, and Production: The Jola of Casamance, Senegal* (Cambridge: Cambridge University Press, 1992); Olga Linares, "From Tidal Swamp to Inland Valley: On the Social Organization of Wet Rice Cultivation among the Diola of Senegal," *Africa: Journal of the International African Institute* 51, no. 2 (1981): 557–95; and Frances Anne Leary, "Islam, Politics, and Colonialism: A Political History of Islam in the Casamance Region of Senegal (1850–1919)" (PhD diss., Northwestern University, 1970).

17. Hughes and Perfect, *A Political History of the Gambia*.

18. Quinn, *Mandingo Kingdoms of the Senegambia*, 8. See also Charlotte Quinn, "A Nineteenth Century Fulbe State," *Journal of African History* 12, no. 3 (1971): 427–40.

19. Spencer J. Trimingham, *A History of Islam in West Africa* (London: Oxford University Press, 1962), 160–61.

20. See David Robinson, *Paths of Accommodation: Muslim Societies and French Colonial Authorities in Senegal and Mauritania, 1880–1920* (Athens: Ohio University Press, 2000). See also David Robinson, *The Holy War of Umar Tal: The Western Sudan in the Mid-Nineteenth Century* (Oxford: Clarendon Press, 1985); and Andrew F. Clark, "The Fulbe of Bundu (Senegambia): From Theocracy to Secularization," *International Journal of African Historical Studies* 29, no. 1 (1996): 1–23.

21. Hughes and Perfect, *A Political History of the Gambia*, 15–16.

22. For a detailed description of population movements, see ibid., 8–9.

23. Gailey, *A History of the Gambia*; see also Gray, *A History of the Gambia*.

24. Qadi Court Proceedings, 1933–1937, Qadi Court, Banjul, Gambia. Dower (dowry) refers to the money the husband pays to the wife's parents at the time of marriage. It is commonly known as bridewealth. In this book, dowry and bridewealth are used interchangeably.

25. Abdullah Yusuf Ali, *The Meaning of the Holy Quran* (Beltsville, MD: Amana Publications, 2004), Suratul Al Maidah, chapter 5, verse 5, 246. Muslim women are not supposed to marry non-Muslim men because such a marriage can affect their Muslim status.

26. Muslim Court Record Book, 1952–1957, Qadi Court, Banjul, Gambia.

27. Muslim Court Record Book, 1952–1957, Qadi Court, Banjul, 37/1954.

28. Muslim Court Record Book, 1927–1930, Qadi Court, Banjul, 193/1953.

29. For discussion on conversion, see Nathan Nunn, "Religious Conversion in Colonial Africa," *American Economic Review* 100, no. 2 (May 2010): 147–52; Nehemia Levtzion, ed., *Conversion to Islam* (New York: Holmes and Meier, 1979); Humphrey J. Fisher, "Conversion Reconsidered: Some Historical Aspects of Religious Conversion in Black Africa," *Journal of the International African Institute* 43, no. 1 (1973): 27–40.

30. It is contradictory, however, that the primary reason for the establishment of the Muslim court was that Muslims wanted little to do with the European courts, which they saw as Christian.

31. Interview with Alhaji Sering A. M. Secka, Banjul, Gambia, June 29, 2016.

32. Elizabeth Schmidt, *Peasants, Traders, and Wives: Shona Women in the History of Zimbabwe, 1870–1939* (London: James Currey, 1992), 1.

33. In the early 1900s, slavery cases filtered through the Muslim court in Bathurst, where wives and their children escaped to avoid being sold into slavery. See also Gray, *A History of the Gambia*, 319, on slaves who sought refuge in Bathurst. In fact, it can be noted that although the European powers in West Africa passed laws against slave dealing, the crucial dilemma of colonial rule was how to manage the transition from a slave to a nonslave economy. As Richard Roberts and Suzanne Miers note, the end of slavery in West Africa often pitted slaves against owners as well as the colonial state in a struggle to control labor. They further note that colonial rule created a growing demand for labor for porterage, for building infrastructure, and for producing food for the burgeoning administrative centers. Hence, freed slaves had three broad options: they could leave their former owners and move away; they could remain near them but sever ties to the extent that this was possible and desirable; or they could remain in their owners' households or villages but on different terms. See Richard Roberts and Suzanne Miers, *The End of Slavery in Africa* (Madison: University of Wisconsin Press, 1988); and Paul E. Lovejoy and Jan S. Hogendorn, *Slow Death for Slavery: The Course of Abolition in Northern Nigeria, 1897–1936* (Cambridge: Cambridge University Press, 1993).

34. Note the frequent use of pounds, shillings, and dollars in the record books. See chapter 5.

35. Muslim Court Record Book, 1906–1916, Qadi Court, Banjul, 56.

36. The Mukhtasar, or legal treatises, of Sheikh Khalil (fourteenth century) is often regarded as the most advanced text in Maliki law. Much of the Mukhtasar was translated into English in 1916, by order of Frederick Lugard, governor-general of Nigeria, for the use of colonial officials in northern Nigeria. Perhaps a copy of this book found its way to the Gambia after the establishment of the Muslim court. See Philip Ostien, *Sharia*

Implementation in Northern Nigeria, 1999–2006: A Sourcebook, 5 vols. (Ibadan, Nigeria: Spectrum Books, 2007). It was likely that Gambian Islamic scholars who studied abroad had knowledge of the Mukhtasar of Sheik Khalil and many other legal treatises. For many centuries, Senegambian scholars studied abroad in renowned Islamic centers in North Africa and the Middle East. See, for example, John Hunwick, "Sub-Saharan Africa and the Wider World of Islam: Historical and Contemporary Perspectives," *Journal of Religion in Africa* 26, no. 3 (1966): 232; Sanneh, *The Jakhanke Muslim Clerics*; Wright, *The World and a Small Place in Africa*; Trimingham, *A History of Islam in West Africa*; and Spencer J. Trimingham, *The Influence of Islam upon Africa* (New York: Frederick A. Praeger, 1968).

37. For more on this case, see Muslim Court Record Book, 1906–1913, Qadi Court, Banjul.
38. National Records Service [NRS], Colonial Secretary's Office [CSO] 2/6, Notes for Guidance of Traveling Commissioners.
39. Elisabeth Mary McMahon, "Becoming Pemban: Identity, Social Welfare and Community during the Protectorate Period" (PhD diss., Indiana University, 2005); Trevor Getz, *Slavery and Reform in West Africa: Toward Emancipation in Nineteenth-Century Senegal and the Gold Coast* (Athens: Ohio University Press, 2004); Martin Klein, *Slavery and Colonial Rule in French West Africa* (Cambridge: Cambridge University Press, 1998).
40. Alice Bellagamba, "Slavery and Emancipation in the Colonial Archives: British Officials, Slave-Owners, and Slaves in the Protectorate of the Gambia (1890–1936)," *Canadian Journal of African Studies* 39, no. 1 (2005): 5–41, 13.
41. Klein, *Slavery and Colonial Rule in French West Africa*, 241.
42. Lovejoy and Hogendorn, *Slow Death for Slavery*; Roberts and Miers, *The End of Slavery in Africa*; Robin Law, ed., *From Slave Trade to "Legitimate" Commerce: The Commercial Transition in Nineteenth-Century West Africa* (Cambridge: Cambridge University Press, 1995); Boubacar Barry, *Senegambia and the Atlantic Slave Trade* (Cambridge: Cambridge University Press, 1998); Walter Rodney, *A History of the Upper Guinea Coast, 1545–1800* (New York: Monthly Review Press, 1970); and Walter Rodney, "Slavery and Other Forms of Social Oppression on the Upper Guinea Coast in the Context of the Atlantic Slave Trade," *Journal of African History* 7, no. 3 (1966): 431–47.
43. Traveling Commissioner Reports, 1893–1899, ARP/28/1, National Archives, Banjul, Gambia.
44. Lovejoy and Hogendorn, *Slow Death for Slavery*, 4.
45. Ibid., 37, 40.
46. For more on the disruption of African families and the question of freed slaves, see Roberts and Miers, *The End of Slavery in Africa*, 6; James F. Searing, "No Kings, No Lords, No Slaves: Ethnicity and Religion among the Sereer-Safèn of Western Bawol, 1700–1914,"

Journal of African History 43, no. 3 (2002): 407–29; James F. Searing, "Aristocrats, Slaves, and Peasants: Power and Dependency in the Wolof States, 1700–1850," *International Journal of African Historical Studies* 21, no. 3 (1988): 475–503; Klein, *Slavery and Colonial Rule in French West Africa*; Myron Echenberg, *Colonial Conscripts: The Tirailleurs Sénégalais in French West Africa, 1857–1960* (Portsmouth, NH: Heinemann, 1991); and Bellagamba, "Slavery and Emancipation in the Colonial Archives," 5–41, 7.

47. Emily S. Burrill, *States of Marriage: Gender, Justice, and Rights in Colonial Mali* (Athens: Ohio University Press, 2015), 71.

48. Wright, *The World and a Small Place in Africa*.

49. Bellagamba, "Slavery and Emancipation in the Colonial Archives."

50. See Gray, *A History of the Gambia*.

51. NRS, CSO 2/114, Traveling Commissioner Not to Accept Any Present from the Natives.

52. For a description of the vegetation of early Bathurst, see Gray, *A History of the Gambia*.

53. Bill Freund, *The African City: A History* (Cambridge: Cambridge University Press, 2007), 56.

54. Garth Andrew Myers, *Verandahs of Power: Colonialism and Space in Urban Africa* (Syracuse, NY: Syracuse University Press, 2003), 7–8.

55. Gray, *A History of the Gambia*, 463.

56. NRS, CSO 3/144, Muhammadan Court.

57. Bala Saho, "Appropriation of Islam in a Gambian Village: Life and Times of Shaykh Mass Kah, 1827–1936," *African Studies Quarterly* 12, no. 4 (Fall 2011): 1–21.

58. Iris Berger, *Women in Twentieth-Century Africa* (Cambridge: Cambridge University Press, 2016); Emmanuel Akyeampong, "'Wo Pe Tam Won Pe Ba' ('You like cloth but you don't want children'): Urbanization, Individualism, and Gender Relations in Colonial Ghana, 1900–1939," in *Africa's Urban Past*, ed. David M. Anderson and Richard Rathbone (Portsmouth, NH: Heinemann, 2000), 222–34; Freund, *The African City*.

59. Maria Curtrifelli, *Women in Africa: Roots of Oppression* (London: Zed Books, 1984).

60. *Gambia Echo*, July 26, 1937, 3–6.

61. *Gambia Echo*, January 18, 1937, 3.

62. *Tarikh* here refers to Muslim religious order. It could also mean "history" or "chronicle." The two main *tarikhs* in the Senegambia are the Tijaniyyaa and Qadiriyya (including Murridiyya), which gained currency among the Wolof during the nineteenth and eighteenth centuries, respectively. Most local clerics embraced either one or the other.

63. Interview with Qadi Momodou Lamin Ceesay of Brikam Qadi Court, West Coast Region, at New Yundum, Kombo North District, West Coast Region, December 14, 2010, assisted by Lamin Yarbo.

64. Interview with Qadi Momodou Lamin Ceesay of Brikam Qadi Court, West Coast Region, at New Yundum, Kombo North District, West Coast Region, December 14, 2010, assisted by Lamin Yarbo; interview with Qadi Momodou Lamin Khan, Banjul Magistrate Court, Buckle Street, August 30, 2010, assisted by Lamin Nyangado and Alieu Jawara; interview with Qadi A. L. H. Muhammad Abdoulie Jaiteh, Serrekunda, London Corner, June 10, 2010, assisted by Alieu Jawara; and interview with Senior Qadi Alhagie Masamba Jagne, Kanifing Magistrate Court (Qadi Court), Kanifing, December 12, 2010, assisted by Bakary Sanyang, Alieu Jawara, and Lamin Nyangado.

65. Interview with Justice Qadi Omar Secka, Qadi's Appeal Court Chambers, November 23, 2010, High Court, Banjul, assisted by Bakary Sanyang and Lamin Nyangado. Qadi Secka began his studies at the Muslim High School in Banjul and then moved to the Islamic Institute in Latri Kunda. From there, he went to Sudan for two years and also spent one year in Mauritania. He also studied in Saudi Arabia at Medina Munawara University. Nowadays there is a qadi appeals court at the Banjul High Court. It is chaired by Qadi Omar Secka; the other members are Alhagie Ensa Darbo, Alhagie Ousman Jah, and Serigne Modou Kah.

66. See Kristin Mann and Richard Roberts, eds., *Law in Colonial Africa* (Portsmouth, NH: Heinemann, 1991).

67. Although elders and clerics were conversant with sharia, it is not strictly practiced in the region. This allows traditional leaders to consider relationships and use other forms of traditional conflict resolution (described in chapter 2).

68. In present-day Senegal, the situation is not much different; the absence of support from extended kin groups could increase the chance of domestic violence. See Codou Bop, "I Killed Her Because She Disobeyed Me in Wearing This New Hairstyle: Gender-Based Violence, Laws, and Impunity in Senegal," in *Domestic Violence and the Law in Colonial and Postcolonial Africa*, ed. Emily Burrill, Richard Roberts, and Elizabeth Thornberry (Athens: Ohio University Press, 2010), 203–19.

69. See Mark Davidheiser, "Special Affinities and Conflict Resolution: West African Social Institutions and Mediation," Beyond Intractability: The Conflict Information Consortium, University of Colorado, December 2005.

70. See Richard Roberts, "Representation, Structure, and Agency: Divorce in the French Soudan during the Early Twentieth Century," *Journal of African History* 40 (1999): 389–410.

71. Allan Christelow, ed. *Thus Ruled Emir Abbas: Selected Cases from the Records of the Emir of Kano's Judicial Council* (East Lansing: Michigan State University Press, 1994), 10.

72. Muslim Court Record Year Book, 1905–1916, Qadi Court, Banjul.

73. In colonial days, many women fell afoul of the city's administrators for sweeping dirt onto the streets; they were subsequently punished by paying fines.

74. For example, during my interviews with village elders, most informants indicated that, whether in colonial days or nowadays, they hardly ever take their quarrels to the British-instituted courts, especially matrimonial issues. They always strove to manage and resolve these quarrels at the village level. Interviews with Sheikh Seediya Dabo, the grand marabout, and Yusuf Dabo at Medina Seedia; with Seringe Mamamt Saho and Bubakar Saho at Fass Sakho; and with Alhaji Badou Sallah, Imam Mbye Kah, Kebba Njie, and Oustass Cherno Kah at Medina Seringe Mass, November 23, 2010.

75. In present-day Senegal, the situation is not much different, in which the absence of support from extended kin groups could increase the chances of domestic violence. See Bop, "I Killed Her Because She Disobeyed Me," 203–19.

76. For population movements in the region, see Andrew F. Clark, "Internal Migrations and Population Movements in the Upper Senegal Valley (West Africa), 1890–1920," *Canadian Journal of African Studies* 28, no. 3 (1994): 399–420.

77. For example, see Sally Falk Moore, "Treating Law as Knowledge: Telling Colonial Officers What to Say to Africans about Running 'Their Own' Native Courts," *Law and Society Review* 26 (1992): 11–46; and Sally Falk Moore, *Social Facts and Fabrications: "Customary" Law on Kilimanjaro, 1880–1980* (Cambridge: Cambridge University Press, 1986), 88.

78. Lovejoy and Hogendorn, *Slow Death for Slavery*, 4.

Chapter Four. Qadi Court: Crisis of Legitimization

1. Ironic in the "fair judgment" argument is that Ousman Jeng was a member of British Gambia's Legislative Council, the only Gambian member representing Bathurst's Muslim community. As such, he was closely associated with the colonial government, a fact that would render Gambia's governor not in a position to make an unbiased decision about the case. Also notable about this case was that it remained wholly an accusation, meaning that no evidence was ever produced in court according to the records.

2. National Records Service [NRS], Colonial Secretary's Office [CSO] 3/133, 1928, Bathurst Mosque, Quadrangle, Banjul, Gambia.

3. NRS, CSO 3/133.

4. The Royal West African Frontier Force was a multi-battalion field force formed by the British Colonial Office in 1900 to garrison the West African colonies of Nigeria, Gold Coast, Sierra Leone, and the Gambia.

5. NRS, CSO 3/133.

6. Carol Dickerman, "African Courts under the Colonial Regime: Usumbura,

Rwanda-Urundi, 1938–62," *Canadian Journal of African Studies* 26, no. 1 (1992): 55–69.

7. Brett L. Shadle, "Changing Traditions to Meet Current Altering Conditions: Customary Law, African Courts, and the Rejection of Codification in Kenya, 1930–1960," *Journal of African History* 40, no. 3 (1999): 412.

8. Kristin Mann and Richard Roberts, eds., *Law in Colonial Africa* (Portsmouth, NH: Heinemann, 1991), 4.

9. Ibid.

10. See A. A. Oba, "Islamic Law as Customary Law: The Changing Perspective in Nigeria," *International and Comparative Law Quarterly* 51, no. 4 (October 2002): 817–50.

11. Allan Christelow, "Islamic Law in Africa," in *The History of Islam in Africa*, ed. Nehemia Levtzion and Randall L. Pouwels (Athens: Ohio University Press, 2000), 373.

12. See, for example, Frederick Lugard, *The Political Memoranda: Revision of Instructions to Political Officers on Subjects Chiefly Political and Administrative* (London: Frank Cass, 1970), 281; Paul E. Lovejoy and Jan S. Hogendorn, *Slow Death for Slavery: The Course of Abolition in Northern Nigeria, 1897–1936* (Cambridge: Cambridge University Press, 1993); Richard Roberts, "Representation, Structure, and Agency: Divorce in the French Soudan during the Early Twentieth Century," *Journal of African History* 40 (1999): 389–410; and Rebecca Shereikis, "From Law to Custom: The Shifting Legal Status of Muslim Originaires in Kayes and Medine, 1903–1913," *Journal of African History* 42 (2001): 261–83.

13. David Robinson, "French 'Islamic' Policy and Practice in Late Nineteenth-Century Senegal," *Journal of African History* 29, no. 3 (1988): 415–35.

14. Prior to independence in 1965, law in the Gambia was composed of the received law, native law, and "custom." The received law was established by the Law of England Application Ordinance, which provided that the common law, the doctrines of equity, and statutes of general application in force in England on November 1, 1880, should apply in the colony of the Gambia. The law, which was administered by tribunals in "native" law and "custom," as well as in Muslim law, related to civil status, marriage, succession, divorce, dowry, the rights and authorities of partners, and guardianship whenever the parties were Muslims. See Arnold Hughes, ed., *The Gambia: Studies in Society and Politics*, African Studies Series no. 3 (Birmingham: University of Birmingham, Centre of West African Studies, 1991), 55.

15. Arnold Hughes and David Perfect, *A Political History of the Gambia, 1816–1994* (Rochester, NY: University of Rochester Press, 2006), 8–9. The figure of 4,993 excludes the Aku, Manjago, Ibo, and other Africans living in Bathurst at the time.

16. NRS, CSO 2/942. When the courts were set up in northern Nigeria, British administrators decided that the courts were to administer the native law and customs prevailing in the

area of jurisdiction, and might award any type of punishment recognized thereby except mutilation, torture, or any other that might be deemed "repugnant" to natural justice and humanity.

17. NRS, CSO 2/942.

18. Ibid.

19. Mann and Roberts, *Law in Colonial Africa*, 14.

20. Muslim Court Year Book, 1906–1916, Qadi Court, Banjul, Gambia, 391.

21. Muslim Court Record Year Book, 1927–1930, Qadi Court, Banjul, 387.

22. Muslim Court Record Year Book, 1927–1930, Qadi Court, Banjul, 377.

23. The reliance of the colonial government on these Muslim leaders was also conditioned by years of conflict and wars waged from 1850 to 1901, when the region was plunged into a series of religious wars instigated by militant Islamic leaders who wished to build theocratic states, purify Islam, and convert non-Muslims. These wars involved Europeans, who were trying to control the region and the local populations. The wars are referred to in Senegambian historiography as the Soninke-Marabout Wars—wars between believers and nonbelievers.

24. Abdulkadir Hashim, "Servants of Sharīʿa: Qāḍīs and the Politics of Accommodation in East Africa," *Sudanic Africa* 16 (2005): 27–51. Whether to continue the existing legal structures was among the dilemmas that faced the postcolonial states. Native institutions, including qadi courts, were maintained to strengthen the indirect rule policy observed by the British.

25. For a discussion of colonial rule, see, for example, ibid., 27–51. See also J. N. D. Anderson, "Return Visit to Nigeria: Judicial and Legal Developments in the Northern Region," *International and Comparative Law Quarterly* 12, no. 1 (January 1963): 282–94; David Robinson, "Ethnographie et droit coutumier au Sénégal," *Cahiers d'Études Africaines* 32, no. 126 (1992): 221–37; H. O. Danmole, "The Alkali Court in Ilorin Emirate during Colonial Rule," *Transafrican Journal of History* 18 (1989): 173–86; A. E. Afigbo, *The Warrant Chiefs: Indirect Rule in Southeastern Nigeria, 1891–1929* (New York: Humanities Press, 1972); Michael Crowder and Obaro Ikime, eds., *West African Chiefs: Their Changing Status under Colonial Rule and Independence* (Ife, Nigeria: University Press of Ife, 1970); Mann and Roberts, *Law in Colonial Africa*; Michael Crowder, *West Africa under Colonial Rule* (Evanston, IL: Northwestern University Press, 1968); Michael Crowder, "Indirect Rule—French and British Style," *Africa: Journal of the International African Institute* 34 (1964): 197–205.

26. NRS, CSO 3/144, The Muhammadan Court. See also the Muhammadan Court Record Book, 1906–1916, Banjul Muslim Court.

27. Qadi Court Banjul, Court Proceedings Book, 1933–1937.

28. Interview with Saihou Bah, Kanifing South, Gambia, August 10, 2011, assisted by Alieu Jawara.

29. NRS, CSO 3/144.

30. NRS, CSO 3/133.

31. Interview with Qadi Alieu Saho, Bakoteh, Gambia, August and December 2010. At an early age, Qadi Jobe studied the Quran in a local *dara* in Bathurst while attending secular school. He furthered his education in the village of Medina Seringe Mass and also in Ndar and Pir in Senegal. Upon his return, Qadi Jobe taught in a local *dara* and became prominent among Islamic scholars in Bathurst through his work with the courts, public sermons, and other religious works. Qadi Jobe was fluent in both Arabic and English, which worked to his advantage. About the Islamic school in the village of Medina Seringe Mass, see Bala Saho, "Appropriation of Islam in a Gambian Village: Life and Times of Shaykh Mass Kah, 1827–1936," *African Studies Quarterly* 12, no. 4 (Fall 2011): 1–21.

32. NRS, CSO 2/1638, Marriage License Issued by Native Tribunals.

33. NRS, CSO 3/144, Commissioner South Bagley to Colonial Secretary, Bathurst, September 16, 1938.

34. Arnold Hughes and Harry A. Gailey, *Historical Dictionary of the Gambia*, 3rd ed. (Lanham, MD: Scarecrow Press, 1999), 83.

35. NRS, ARP 30/1, Governor Blackhall [*sic*] to Arafang Jorbateh of MacCarthy Island, March 3, 1867.

36. NRS, ARP 30/1.

37. Lamin Sanneh, *The Crown and the Turban: Muslims and West African Pluralism* (Boulder, CO: Westview Press, 1997), 150–51. Madrassas are public Arabic-language schools run privately and monitored by the government. Sanneh notes that by 1900, the British had responded to similar demands for Islamic schools with secular education elsewhere in West Africa. In Freetown colony in Sierra Leone, a madrassa system of Islamic education was launched with government support.

38. John M. Gray, *A History of the Gambia* (London: Frank Cass, 1966), 311–14.

39. Sanneh, *The Crown and the Turban*, 167.

40. The head of the Muhammadan School and the qadi of the Muslim court were well-paid positions, and they continued to be vigorously contested for almost four decades.

41. NRS, CSO 3/144.

42. NRS, CSO 3/133, Momodou Jahumpa and Others to SOS for the Colonies, September 2, 1929.

43. NRS, CSO 3/133, Workman to Lord Passfield, April 20, 1930.

44. NRS, CSO 3/133.

45. Ibid.

46. NRS, CSO 3/133, Memo from Judge of the Supreme Court of the Gambia to Honorable Acting Colonial Secretary, Bathurst, March 29, 1929.

47. Bill Freund, *The African City: A History* (Cambridge: Cambridge University Press, 2007), 87.

48. Allan Christelow, "The Muslim Judge and Municipal Politics in Colonial Algeria and Senegal," *Comparative Studies in Society and History* 24, no. 1 (January 1982): 6.

49. Interview with Alhaji A. M. Sering Secka, June 29, 2016, Banjul, Gambia. For more information on castes and social differentiation, see Cornelia Panzacchi, "The Livelihoods of Traditional Griots in Modern Senegal," *Africa: Journal of the International African Institute* 64, no. 2 (1994): 190–210; Tamari Tal, "The Development of Caste System in West Africa," *Journal of African History* 32, no. 2 (1991): 221–50; D. M. Todd, "Caste in Africa?," *Africa: Journal of the International African Institute* 47, no. 4 (1977): 435–40.

50. For controversies surrounding imamship in Banjul and other localities in Gambia, see *Gambia Daily News*, Friday, October 21, 2011; *Point News Paper*, Wednesday, September 23, 2009; *Point News Paper*, Tuesday, November 25, 2008.

51. NRS, CS02/1610, 1936: Rules of the Muhammadan Society.

52. Ousman Kobo, 'We Are Citizens Too': The Politics of Citizenship in Independent Ghana," *Journal of Modern African Studies* 48, no. 1 (2010): 67–94, 71. See also Patrick J. Ryan, "Ariadne auf Naxos: Islam and Politics in a Religiously Pluralistic African Society," *Journal of Religion in Africa* 26, no. 3 (1996): 308–29.

53. See Shereikis, "From Law to Custom."

54. J. Ayo Dele Langley, "The Gambia Section of the NCBWA," *Africa: Journal of the International African Institute* 39, no. 4 (1969): 382–95, 388.

55. NRS, CSO 3/144, Committee of Management of Muhammadan School.

56. NRS, CSO 3/144, Almami of Bathurst to Governor Southorn, June 20, 1939.

57. Langley, "The Gambia Section of the NCBWA."

58. NRS, CSO 3/133, Letter to Governor, Sir Edward Brandle Denham, March 26, 1926.

59. NRS, CSO 3/133, Letter Signed by Jahumpa and Drammeh, September 2, 1929.

60. NRS, CSO 3/133, Commissioner of Police to the Hon. Acting Colonial Secretary, April 8, 1929.

61. NRS, CSO 3/133.

62. Deborah Pellow, "Muslim Segmentation: Cohesion and Divisiveness in Accra," *Journal of Modern African Studies* 23, no. 3 (September 1985): 419–20. See also Jonathon Glassman, "Sorting Out the Tribes: The Creation of Racial Identities in Colonial Zanzibar's

Newspaper Wars," *Journal of African History* 41, no. 3 (2000): 395–428.

63. Alhagie A. E. cham Joof, March 3, 2011, Bakau, Gambia.

Chapter Five. Qadis, Complainants, and Settlements: Case Studies

1. Muslim Court Record Book, 1906–1916, Muslim Court, Banjul, Gambia, 72.

2. In Muslim marriages, only the bridewealth can be returned/refunded to the husband. Material things given at the time of marriage, unless specified, cannot be returned.

3. For a detailed description of this case, see the Muhammadan Court Records Book, 1906–1916, at the Muslim Court, Police Court grounds, Banjul, Gambia. This book is not cataloged and therefore has no accession number. It can be found in the chief qadi's office in Banjul. All the cases in the book are dated and signed by the qadi and his assessors.

4. No women were detained, sent to prison, or otherwise penalized for not being able to return the bridewealth in full; no matter how high the amount, divorce could still take place.

5. The issue of slavery continued to affect settlement and marriage patterns in most parts of Senegambia. It is an issue that needs to be studied. See Martin A. Klein, "La notion d'honneur et la persistance de la servitude au Soudan occidental," *Cahiers d'Études Africaines* 45 (2005): 831–51; Andrew F. Clark, "The Challenges of Cross-Cultural Oral History: Collecting and Presenting Pulaar Traditions on Slavery from Bundu, Senegambia (West Africa)," *Oral History Review* 20, no. 1/2 (April 1992): 1–21; and Albert Aldo Benini, *Community Development in a Multi-Ethnic Society: The Upper River Division of the Gambia, West Africa; With Minor Comparative Studies from Upper Volta and Benin* (Saarbrucken, Germany: Verlagbreitenbach, 1980).

6. In Gambia, goldsmiths, blacksmiths, and silversmiths are characterized as a caste group together with griots. See chapter 1. For more information on caste, see Tamari Tal, "The Development of Caste System in West Africa," *Journal of African History* 32, no. 2 (1991): 221–50; D. M. Todd, "Caste in Africa?," *Africa: Journal of the International African Institute* 47, no. 4 (1977): 435–40; and Cornelia Panzacchi, "The Livelihoods of Traditional Griots in Modern Senegal," *Africa: Journal of the International African Institute* 64, no. 2 (1994): 190–210.

7. The court cases show that men were paying high bridewealth at the time, amounts that would be considered high even in present times. The case between Sainabou Amah and her husband indicates a bridewealth of $403, an astronomical sum for 1907. At present, the daily wage of an average Gambian is less than a dollar.

8. Jane Guyer, *Women and the State in Africa: Marriage Law, Inheritance, and Resettlement*

(Boston: African Studies Center, Boston University, 1987), 4–5. See also Thomas Håkansson, *Bridewealth, Women, and Land: Social Change among the Gusii of Kenya* (Uppsala, Sweden: Almqvist and Wiksell, 1988).

9. Abdullah Yusuf Ali, *The Meaning of the Holy Quran* (Beltsville, MD: Amana Publications, 2004), Suratul Al Talaq, chapter 65, verse 1–6, 1483–85.

10. See Ali, *The Meaning of the Holy Quran*, Suratul Al Talaq and Suratul Nisa (2004). Discussions with Shaykh Adi Jobe, Serrekunda, July 1–August 4, 2014.

11. Allan Christelow, "The Muslim Judge and Municipal Politics in Colonial Algeria and Senegal," *Comparative Studies in Society and History* 24, no. 1 (January 1982): 6.

12. For example, as described in chapter 3, a Bathurst Muslim elder, J. C. Faye, was once asked by the colonial governor to travel to the protectorate to explain to the Muslims the readiness of the British government to work with everybody.

13. Susan F. Hirsch, *Pronouncing and Persevering: Gender and the Discourses of Disputing in an African Islamic Court* (Chicago: University of Chicago Press, 1998).

14. See John Ralph Willis, "Jihad fi Sabil Allah: Its Doctrinal Basis in Islam and Some Aspects of Its Evolution in Nineteenth-Century West Africa," *Journal of African History* 8, no. 3 (1967): 395–415. Willis's comment refers to the way in which sheikhs or Muslim clerics spread their ideas by means of traveling with their followers. Through such travels, clerics seek more personal contacts, thereby increasing their following.

15. See Lamin Sanneh, "Futa Jallon and the Jakhanke Clerical Tradition: Historical Setting," *Journal of Religion in Africa* 12, no. 1 (1981): 40. Sanneh stated that after the breakup of Diakha-Bambuhku in the fifteenth century, major clerical dispersions developed toward Dentilia, Khasso, Bundu, and the Upper Senegambia. See also David E. Skinner, "Islam and Education in the Colony and Hinterland of Sierra Leone (1750–1914)," *Canadian Journal of African Studies* 10, no. 3 (1976).

16. Willis, "Jihad fi Sabil Allah," 399. The hajj (the pilgrimage Muslims make to the holy city of Mecca), one of the five obligatory requirements of Islam, was one way that Muslim clerics in the Gambia visited the Arabian Peninsula. See also Arnold Hughes and Harry A. Gailey, *Historical Dictionary of the Gambia*, 3rd ed. (Lanham, MD: Scarecrow Press, 1999). According to Hughes and Gailey, Senegambians were among the first West Africans to travel to Mecca, some as early as the eleventh century. Four routes across the Sahara were used by the pilgrims on this long, dangerous journey, each converging on Cairo. A good number of these believers stayed in Mecca to study, while those who did not stay still interacted with Muslims from all over the world.

17. Richard Jobson, *A Discovery of the River Gambra and the Golden Trade of the Aethiopians* (London: Dawsons of Pall Mall, 1623), 94–97.

18. See John Ralph Willis, *In the Path of Allah: The Passion of Al-Hajj-Umar; An Essay into the Nature of Charisma in Islam* (London: Frank Cass, 1989).

19. For more on the spread of Islamic knowledge in the region, see Charlotte A. Quinn, *Mandingo Kingdoms of the Senegambia: Traditionalism, Islam, and European Expansion* (Evanston, IL: Northwestern University Press, 1972), 54–55; Skinner, "Islam and Education in the Colony and Hinterland of Sierra Leone," 503; and Martin A. Klein, "Social and Economic Factors in the Muslim Revolution in Senegambia," *Journal of African History* 13, no. 3 (1972): 426. For specific examples of how clerics do their work, see Toby Green, *Meeting the Invisible Man: Secrets and Magic in West Africa* (London: Faber and Faber, 2009).

20. Skinner, "Islam and Education in the Colony and Hinterland of Sierra Leone," 507.

21. It should be noted that it was generally male children who populated the *daras* or Quranic schools, and this is still the case today. *Talibe* is the Wolof term for these students; among the Fula ethnic group, Islamic students are called *almudo*.

22. For more on Islamic education and the teacher-student relationship, see Jobson, *A Discovery of the River Gambra*; David Gamble, Linda K. Salmon, and Alhaji Hassan Njie, eds., *Peoples of The Gambia: The Wolof*, Gambian Studies no. 17 (San Francisco: San Francisco State University, Department of Anthropology, 1985); James F. Searing, "Aristocrats, Slaves, and Peasants: Power and Dependency in the Wolof States, 1700–1850," *International Journal of African Historical Studies* 21, no. 3 (1988): 475–503; Lamin Sanneh, *The Crown and the Turban: Muslims and West African Pluralism* (Boulder, CO: Westview Press, 1997); Louis Brenner, *Controlling Knowledge: Religion, Power, and Schooling in a West African Muslim Society* (Bloomington: Indiana University Press, 2001); Rudolph T. Ware III, "'Njangaan': The Daily Regime of Quranic Students in Twentieth Century Senegal," *International Journal of African Historical Studies* 37, no. 3 (2004): 515–38; and Donna L. Perry, "Muslim Child Disciples, Global Civil Society, and Children's Rights in Senegal: The Discourses of Strategic Structuralism," *Anthropological Quarterly* 77, no. 1 (2004): 47–84.

23. Gamble, Salmon, and Njie, *Peoples of the Gambia*.

24. Ibid., 38.

25. For more on the Africanization of Islam, see David Robinson, *Muslim Societies in Africa: New Approaches in African History* (Cambridge: Cambridge University Press, 2004). Robinson expresses how Africans appropriated Islam and made it their own.

26. The Department of State for Education negotiated with the relevant authorities within and outside the Gambia to have a madrassa's certificate endorsed based on whether the school had fulfilled the criteria of the Education Department. The government set up the

Islamic Advisory Committee, which was charged to look into certificates coming from madrassas, including those in the Middle East, because of the increase in numbers of Gambians studying at madrassas in Arab and other Middle Eastern countries.

27. In June 1959, Gambian students at Al-Azhar University in Cairo wrote back to the Ministry of Education to explain the nature of their courses. The students indicated Arabic language and Islamic studies covering subject areas such as Muhammadan law, exegesis, tradition of the Prophet inclusive of the study of texts and terminology, morphology, rhetoric, Arabic literature, prosody and rhyme, logics and polemics, physics, chemistry, biology, history, geography, and English or French language. The Gambian students in Cairo at the time were Arifan Mallam Sawane, Kambourama Karamba, Mohamed Al-Amin, Abu Bakr Fatajo, Saja Fati, Mohamed Mustapha Kanji, and Omar Jah.

28. Interview with Qadi Momodou Lamin Khan, August 9, 2010, qadi's office, Banjul. I have had several meetings with Qadi Khan and attended some of his court sittings. He was born at Medina Seringe Mass and studied in local *daras* at Fass Sakho and Kerr Makumba Njie villages in Gambia and Kerr Saa Rohki and Ndar in Senegal. He also received extensive training in Fez (Morocco), Libya, and Algeria from 1977 to 1984, where he studied sharia law. He holds a bachelor's degree in general law. Upon his return to Gambia, he worked briefly as a Quranic teacher, a qadi's scribe, and now as a principal qadi in Banjul.

29. For an example of sons inheriting the position of their fathers, see D. B. Cruise O'Brien, *The Mourides of Senegal: The Political and Economic Organization of an Islamic Brotherhood* (Oxford: Clarendon Press, 1971); and Cheikh Anta Babou, *Fighting the Greater Jihad: Amadu Bamba and the Founding of the Muridiyya of Senegal, 1853–1913* (Athens: Ohio University Press, 2007).

30. Bala Saho, "Appropriation of Islam in a Gambian Village: Life and Times of Shaykh Mass Kah, 1827–1936," *African Studies Quarterly* 12, no. 4 (Fall 2011): 1–21.

31. Muhammadan Court Record Book, 1906–1916, Qadi Court, Banjul, Gambia, 122/1908.

32. See Ghislaine Lydon, "Obtaining Freedom at the Muslims' Tribunal: Colonial Kadijustiz and Women's Divorce Litigation in Ndar (Senegal)," in *Muslim Family Law in Sub-Saharan Africa: Colonial Legacies and Post-Colonial Challenges*, ed. Shamil Jeppie, Ebrahim Moosa, and Richard Roberts (Amsterdam: Amsterdam University Press, 2010), 135–64.

33. Interview with Sheikh Seediya Dabo, the grand marabout, and Yusuf Dabo, elders at Medina Seedia; interview with Seringe Mamamt Saho, Bubakar Saho, and Fass Sakho; and interview with Alhaji Badou Sallah, Imam Mbye Kah, Kebba Njie, and Oustass Cherno Kah, Medina Seringe Mass, November 23, 2010.

34. The CFA franc is the most widely used currency in most French-speaking West and Central African countries; it is also used in some Portuguese-speaking countries.

35. Muslim Court Record Year Book, 1952–1957, Qadi Court, Banjul, 208.

36. Ibid., 403.

37. Muslim Court Record Book, 1906–1916, Banjul, 52/1907.

38. Muslim Court Record Year Book, 1933–1937, Qadi Court, Banjul, 42/1934.

39. Muslim Court Record Year Book, 1952–1957, Qadi Court, Banjul, 56.

40. For relations and problems between cowives, see Kathryn F. Mason, "Co-Wife Relationships Can Be Amicable as Well as Conflictual: The Case of the Moose of Burkina Faso," *Canadian Journal of African Studies* 22, no. 3 (1988): 615–24; Sangeetha Madhavan and Caroline H. Bledsoe, "The Compound as a Locus of Fertility Management: The Case of the Gambia," *Culture, Health, and Sexuality* 3, no. 4 (October–December 2001): 451–68; David W. Ames, "The Economic Base of Wolof Polygyny," *Southwestern Journal of Anthropology* 11, no. 4 (Winter 1955): 391–403; and Michel Garenne and Etienne van de Walle, "Polygyny and Fertility among the Sereer of Senegal," *Population Studies* 43, no. 2 (July 1989): 267–83.

41. Muslim Court Record Year Book, 1905–1916, Qadi Court, Banjul, 10.

42. Ibid.

43. Richard Roberts and William Worger, "Law, Colonialism, and Conflicts over Property in Sub-Saharan Africa," *African Economic History* 25 (1997): 1–7; and Richard Roberts, "Conflicts over Property in the Middle Niger Valley at the Beginning of the Twentieth Century," *African Economic History* 25 (1997): 79–96.

44. National Records Service [NRS], ARP 30/4, 1914, MacCarthy Island District, Traveling Commissioner's Report. It is important to mention that, through migrations to the Gambia River valley, some of these migrants ended up in Bathurst.

45. Richard Roberts and Suzanne Miers, eds., *The End of Slavery in Africa* (Madison: University of Wisconsin Press, 1988), 20.

46. Among Muslims in the Gambia, marriage could be consummated even if the bridewealth were not paid in full. For more on migrant workers and groundnut production, see Kenneth Swindell, *The Strange Farmers of the Gambia: A Study in the Redistribution of African Population* (Norwich, England: Geo Books, 1981). See also Assan Sarr, "Land and Historical Changes in a River Valley: Property, Power, and Dependency in the Lower Gambia Basin, Nineteenth and Early Twentieth Centuries" (PhD diss., Michigan State University, 2010).

47. Philip Curtin, *Economic Change in Precolonial Africa: Senegambia in the Era of the Slave Trade* (Madison: University of Wisconsin Press, 1975), 231.

48. See Martin Chanock, *Law, Custom and Social Order: The Colonial Experience in Malawi and Zambia* (Cambridge: Cambridge University Press, 1985); and Richard Roberts,

Litigants and Households: African Disputes and Colonial Courts in the French Soudan, 1895–1912 (Portsmouth, NH: Heinemann, 2005).

49. In many parts of colonial Africa, migrant labor was instrumental in the disintegration of African families, especially in southern Africa, where men went to work in the mines and women were left at home to take care of the children. Some scholars have written extensively on how South African families were fragmented and emotionally distressed by male members of families staying away for the majority of the year. See Peter Magubane, *Women of South Africa: Their Fight for Freedom* (Boston: Little, Brown, 1993); Fatima Meer, *Women in the Apartheid Society* (New York: United Nations Centre against Apartheid, 1985); Nomboniso Gasa, ed., *Women in South African History* (Cape Town: Human Sciences Research Council Press, 2007); Helen Scanlon, *Representation and Reality: Portraits of Women's Lives in the Western Cape, 1948–1976* (Cape Town: Human Sciences Research Council Press, 2007); Julia C. Wells, *We Now Demand! The History of Women's Resistance to Pass Laws in South Africa* (Johannesburg: Wits University Press, 1993); T. Dunbar Moodie, *Going for Gold: Men, Mines, and Migration* (Berkeley: University of California Press, 1994); Patrick Harries, *Work, Culture, and Identity: Migrant Laborers in Mozambique and South Africa, c. 1860–1910* (Portsmouth, NH: Heinemann, 1994); and Belinda Bozzoli, *Women of Phokeng: Consciousness, Life Strategy, and Migrancy in South Africa, 1900–1983* (Portsmouth, NH: Heinemann, 1991).

50. Muslim Court Record Book, 1906–1916, Banjul Muslim Court.

51. It would be interesting to know why the Supreme Court of Bathurst overturned the decision of the Muslim court, which seemed to give a more favorable ruling to the woman.

52. Elisha P. Renne, "Polyphony in the Courts: Child Custody Cases in Kabba District Court, 1925–1979," *Ethnology* 31, no. 3 (July 1992): 219–20.

53. Jean Allman, "Fathering, Mothering and Making Sense of 'Ntamoba': Reflections on the Economy of Child-Rearing in Colonial Asante," *Africa: Journal of the International African Institute* 67, no. 2 (1997): 296–321.

54. Muslim Court Record Year Book, 1933–1937, Qadi Court, Banjul, 67.

55. Muslim Court Record Year Book, 1927–1930, Qadi Court, Banjul, 343.

56. Muslim Court Record Year Book, 1952–1957, Qadi Court, Banjul, 78/1952.

57. Ibid., 419.

58. Cooper, *Marriage in Maradi*, xxvii.

59. Deniz Kandiyoti, "Bargaining with Patriarchy," *Gender and Society* 2 (1988): 274–90. See also Alaine S. Hutson, "Women, Men, and Patriarchal Bargaining in an Islamic Sufi Order: The Tijaniyya in Kano, Nigeria, 1937 to the Present," *Gender and Society* 15, no. 5 (October

2001): 734–53.

60. Nwando Achebe, *Farmers, Traders, Warriors, and Kings: Female Power and Authority in Northern Igboland, 1900–1960* (Portsmouth, NH: Heinemann, 2005), 27.

61. Elizabeth Schmidt, *Peasants, Traders, and Wives: Shona Women in the History of Zimbabwe, 1870–1939* (London: James Currey, 1992), 1.

62. *Sonto* is a person who cannot find a partner because of his abusive or violent character.

63. Qadi Momodou Lamin Khan, August 30, 2010, and August 11, 2011, Banjul Muslim Court, Banjul, Gambia.

64. Abdulkadir Hashim, "Servants of Sharīʿa: Qāḍīs and the Politics of Accommodation in East Africa," *Sudanic Africa* 16 (2005): 27–51.

Conclusion

1. Muslim Court Records Year Book, 1905–1916, Qadi's Office, Banjul, 52/1907.

2. See Fernand Braudel, *The Structures of Everyday Life: Civilization and Capitalism, 15th–18th Century* (Berkeley: University of California Press, 1992). For interest in micro- and megahistories, see Kenneth Pomeranz, *The Great Divergence: China, Europe and the Making of the Modern World Economy* (Princeton, NJ: Princeton University Press, 2000).

3. Adeline Masquelier, *Prayer Has Spoiled Everything: Possession, Power, and Identity in an Islamic Town of Niger* (Durham, NC: Duke University Press, 2001), 22.

4. Barbara Callaway, *Muslim Hausa Women in Nigeria: Tradition and Change* (Syracuse, NY: Syracuse University Press, 1987), 39. See also Suratul Nisa, chapter 4.

5. Allan Christelow, *Thus Ruled Emir Abbas: Selected Cases from the Records of the Emir of Kano's Judicial Council* (East Lansing: Michigan State University Press, 1994).

6. Ibid., 10.

7. Ismail Rashid, "Class, Caste, and Social Inequality in West African History," in *Themes in West Africa's History*, ed. Emmanuel Kwaku Akyeampong (Athens: Ohio University Press, 2006), 118–40.

8. For example, see Amien Waheeda, "Overcoming the Conflict between the Right to Freedom of Religion and Women's Rights to Equality: A South African Case Study of Muslim Marriages," *Human Rights Quarterly* 28, no. 3 (August 2006): 729–54; Anwar Hekmat, *Women and the Koran: The Status of Women in Islam* (Amherst, MA: Prometheus Books, 1997); Fatima Mernissi, *Women and Islam: An Historical and Theological Enquiry* (Oxford: Blackwell Publishers, 1987); Codou Bop, "Roles and the Position of Women in Sufi Brotherhoods in Senegal," *Journal of the American Academy of Religion* 73, no. 4 (2005): 1099–119; and Penda Mbow, "Les femmes, l'Islam et les associations religieuses au Sénégal: Le dynamisme des femmes en milieu urbain," in *Transforming Female Identities:*

Women's Organizational Forms in West Africa, ed. Eva Evers Rosander (Uppsala, Sweden: Nordic Africa Institute, 1997), 48–159.

9. Interview with Justice Qadi Omar Secka, Qadi's Appeal Court Chambers, November 23, 2010.

10. For further discussions on colonial rule in Africa, see Michael Crowder, *West Africa under Colonial Rule* (Evanston, IL: Northwestern University Press, 1968); and Peter K. Tibenderana, "The Irony of Indirect Rule in Sokoto Emirate, Nigeria, 1903–1944," *African Studies Review* 31, no. 1 (April 1988): 67–92.

11. David Robinson, *Paths of Accommodation: Muslim Societies and French Colonial Authorities in Senegal and Mauritania, 1880–1920* (Athens: Ohio University Press, 2000), 76, 204. The process of engagement is well illustrated in David Robinson's notion of accommodation, which uses the example of Islamic leaders and colonial agents. Robinson examines the ways in which Muslim leaders in Mauritania and Senegal negotiated relations with the colonial authorities of French West Africa in order to preserve their autonomy in the religious, social, and economic realms while abandoning the political sphere to their non-Muslim rulers, thus allowing themselves to be subjected to French rule. A significant way in which "the alliance between these Muslim leaders and French colonial agents was negotiated was for French agents to secure decrees (*fatwa*) from the leading authorities of Mecca saying that submission to European rule was acceptable for Muslims." For example, Alhagi Malick Sy (1854–1922), who by 1902 had established himself at Tivaouane, the heart of the groundnut basin in Senegal, showed his allegiance to the French and endorsed French power: "Support the French government totally. God has given special victory, grace and favour to the French. He has chosen them to protect our persons and property. This is why it is necessary to live in perfect rapport with them."

12. Allan Christelow, "The Muslim Judge and Municipal Politics in Colonial Algeria and Senegal," *Comparative Studies in Society and History* 24, no. 1 (January 1982): 4.

13. During party politics of the 1960s and 1970s, three Wolof Muslim political aspirants were active in Bathurst: Momodou Jahumpa of the Muslim Party, John C. Faye of the Democratic Party, and Pierre Sarr Njie of the United Party.

14. See Deborah Pellow, "Muslim Segmentation: Cohesion and Divisiveness in Accra," *Journal of Modern African Studies* 23, no. 3 (September 1985): 419–44. For example, Pellow echoes that the differentiation among some Muslims in Ghana centered on the argument of legitimacy—they sought to build a new mosque and to choose a new leader. For her, this contestation is fueled by the dyadic concept of ethnic group and ethnicity, and regional identity.

Bibliography

Primary Sources: Gambian Archives, Banjul and Fajara, The Gambia

Banjul Muslim Court, 1906–1916, Muhammadan Court Record Book.

Banjul Muslim Court, 1916–1919, Muhammadan Court Record Book.

Colonial Secretary's Office, CSO 2/391, Abdoulie Janneh.

Colonial Secretary's Office, CSO 2/460, 1921, Monthly Diary, Hopkinson.

Colonial Secretary's Office, CSO 2/531, 1922, Monthly Diary, North Bank Province.

Colonial Secretary's Office, CSO 2/941, March 1932. Quarterly Report. G. Nuun to Colonial Secretary.

Colonial Secretary's Office, CSO 2/941, Regarding Native Tribunals, Financial.

Colonial Secretary's Office, CSO 2/942, April 1948, Report on the Working of the Muhammadan Court, Memo from E. R. Ward to Lord Hailey.

Colonial Secretary's Office, CSO 2/1182, Amendment of Muhammadan Law Recognition Ordinance.

Colonial Secretary's Office, CSO 2/1375, 1933, Native Tribunal Ordinance.

Colonial Secretary's Office, CSO 2/1458, 1933, Provincial Courts Ordinance.

Colonial Secretary's Office, CSO 2/1589, 1936, North Bank Province Report.

Colonial Secretary's Office, CSO 2/1610, 1936, Rules of the Muhammadan Society.

Colonial Secretary's Office, CSO 2/1638, Marriage License Issued by Native Tribunals.

Colonial Secretary's Office, CSO 2/1652, Civil and Christian Marriage Ordinance.

Colonial Secretary's Office, CSO 3/76, 1924, Trials by Assessors.

Colonial Secretary's Office, CSO 3/144, Muhammadan Court.

Colonial Secretary's Office, CSO 3/280, August 1935, Acting Colonial Secretary to Commissioners.

Colonial Secretary's Office, CSO 3/321, 1937, Protectorate, Subordinate Provincial Courts.

Muslim Court Record Year Book, 1927–1930, Qadi Court, Banjul.

Muslim Court Record Year Book, 1933–1937, Qadi Court, Banjul.

Muslim Court Record Year Book, 1952–1957, Qadi Court, Banjul.

National Records Service, Annual Reports, ARP 28/1, 1893, Traveling Commissioner's Reports, South Bank.

National Records Service, Annual Reports, ARP 28/1, Bathurst, June 1899. Traveling Commissioner's Report, MacCarthy Island.

National Records Service, Annual Reports, ARP 28/1, 1903–1923, South Bank.

National Records Service, Annual Reports, ARP 30/1, March 1867, MacCarthy Island.

National Records Service, Annual Reports, ARP 30/1, 1907, MacCarthy Island Division.

National Records Service, Annual Reports, ARP 30/3, 1898–1899, Traveling Commissioner's Report, MacCarthy Island Province, vol. 3.

National Records Service, Annual Reports, ARP 30/4, 1914, Traveling Commissioner's Report, MacCarthy Island Province.

National Records Service, Annual Reports, ARP 32/1, 1891, Traveling Commissioner's Reports, North Bank.

National Records Service, Annual Reports, ARP 32/1, 1891, Traveling Commissioner's Reports, North Bank.

National Records Service, Annual Reports, ARP 34/1, 1943, Divisional Report.

National Records Service, Annual Reports, ARP 34/4, 1946, Divisional Report.

National Records Service, District Local Court, DLC1/1, 1965–1971, Niamina West Court Proceedings.

Interviews

Bah, Late Muhammad Lamin Medina, 2010, North Bank Region.

Bah, Saihou, August 10, 2011, Kanifing South.

Ceesay, Momodou Lamin, December 14, 2010, Brikama Qadi Court, West Coast Region, New Yundum, Kombo North District.

Dabo, Sheikh Seediya, November 23, 2010, Medina Seedia.

Dabo, Yusuf, November 23, 2010, Medina Seedia.

Jagne, Qadi Alhagie Masamba, December 12, 2010, Kanifing Magistrate Court (Qadi Court), Kanifing.

Jaiteh, Qadi A. L. H. Muhammad Abdoulie, June 10, 2010, Serrekunda, London Corner.

Jatta, Nfamara, July 6, 2013, Janjanbureh, Georgetown.

Jobe, Adi, Serrekunda, July 1–August 4, 2014.

Joof, Cham A. E., March 3, 2011, Bakau.

Kah, Imam Mbye, November 22, 2010, Medina Seringe Mass.

Kah, Oustass Cherno, November 22, 2010, Medina Seringe Mass.

Khan, Qadi Muhammad Lamin, August 30, 2010, and August 11, 2011, Banjul Muslim Court, Banjul.

Njie, Kebba, November 22, 2010, Medina Seringe Mass.

Saho, Bubakar, November 22, 2010, Fass Sakho.

Saho, Qadi Alieu, August and December 2010, Bakoteh.

Saho, Seringe Mamamt, November 22, 2010, Fass Sakho.

Sallah, Aji Fatou, August 10, 2011, Banjul.

Sallah, Alhaji Badou, November 22, 2010, Medina Seringe Mass.

Sambang, Kebba, November 25, 2010, Salikenye.

Savage, Ajaratou Maimouna, July 25, 2013, Kanifing.

Secka, Alhaji Sering A. M., June 29, 2016, Banjul.

Secka, Qadi Omar, November 23, 2010, Qadi's Appeal Court Chambers, High Court, Banjul.

Suso, Shaikou, November 18, 2010, Banjul.

Suwareh, Alhagi Kantong, August 3, 2013, Ndanka Village, North Bank Province.

Published Works

Achebe, Nwando. *Farmers, Traders, Warriors, and Kings: Female Power and Authority in Northern Igboland, 1900–1960*. Portsmouth, NH: Heinemann, 2005.

Adhikari, Mohamed. *Not White Enough, Not Black Enough: Racial Identity in the South African Colored Community*. Athens: Ohio University Press, 2005.

Afigbo, A. E. *The Warrant Chiefs: Indirect Rule in Southeastern Nigeria, 1891–1929*. New York: Humanities Press, 1972.

Akyeampong, Emmanuel. "'Wo Pe Tam Won Pe Ba' ('You like cloth but you don't want children'): Urbanization, Individualism, and Gender Relations in Colonial Ghana, 1900–1939." In *Africa's Urban Past*, edited by David M. Anderson and Richard Rathbone, 222–34. Portsmouth, NH: Heinemann, 2000.

Ali, Abdullah Yusuf. *The Meaning of the Holy Quran*. Beltsville, MD: Amana Publications, 2004.

Allman, Jean. "Fathering, Mothering and Making Sense of 'Ntamoba': Reflections on the

Economy of Child-Rearing in Colonial Asante." *Africa: Journal of the International African Institute* 67, no. 2 (1997): 296–321.

Allman, Jean, Nakanyike Musisi, and Susan Geiger, eds. *Women in African Colonial Histories.* Bloomington: Indiana University Press, 2002.

Ames, David W. "The Economic Base of Wolof Polygyny." *Southwestern Journal of Anthropology* 11, no. 4 (Winter 1955): 391–403.

Anderson, David M. "Master and Servant in Colonial Kenya." *Journal of African History* 41, no. 3 (2000): 459–85.

Anderson, J. N. D. "Muslim Marriages and the Courts in East Africa." *Journal of Law* 1, no. 1 (1957): 14–22.

———. "Return Visit to Nigeria: Judicial and Legal Developments in the Northern Region." *International and Comparative Law Quarterly* 12, no. 1 (January 1963): 282–94.

Anderson, Mary B. *Do No Harm: How Aid Can Support Peace—or War.* Boulder, CO: Lynne Rienner, 1999.

Babou, Cheikh Anta. *Fighting the Greater Jihad: Amadu Bamba and the Founding of the Muridiyya of Senegal, 1853–1913.* Athens: Ohio University Press, 2007.

Barry, Boubacar. *Senegambia and the Atlantic Slave Trade.* Cambridge: Cambridge University Press, 1998.

Baum, Robert M. *Shrines of the Slave Trade: Diola Religion and Society in Precolonial Senegambia.* Oxford: Oxford University Press, 1999.

Bellagamba, Alice. "Slavery and Emancipation in the Colonial Archives: British Officials, Slave Owners, and Slaves in the Protectorate of the Gambia (1890–1936)." *Canadian Journal of African Studies* 39, no. 1 (2005): 5–41.

Bellagamba, Alice, Sandra E. Greene, and Martin Klein, eds. *The Bitter Legacy: African Slavery Past and Present.* Princeton, NJ: Markus Wiener, 2013.

Benini, Albert Aldo. *Community Development in a Multi-Ethnic Society: The Upper River Division of the Gambia, West Africa; With Minor Comparative Studies from Upper Volta and Benin.* Saarbrucken, Germany: Verlagbreitenbach, 1980.

Benton, Lauren. *Law and Colonial Cultures: Legal Regimes in World History, 1400–1900.* New York: Cambridge University Press, 2002.

Beoku-Betts, Josephine. "Western Perceptions of African Women in the 19th and Early 20th Centuries." In *Readings in Gender in Africa*, edited by Andrea Cornwall, 20–31. Bloomington: Indiana University Press, 2005.

Berger, Iris. *Women in Twentieth-Century Africa.* Cambridge: Cambridge University Press, 2016.

Berger, Iris, and E. Frances White. *Women in Sub-Saharan Africa: Restoring Women to History.* Bloomington: Indiana University Press, 1999.

Berry, Sara. "Hegemony on a Shoestring: Indirect Rule and Access to Agricultural Land." *Africa: Journal of the International African Institute* 62, no. 3 (1992): 327–55.

Bop, Codou. "I Killed Her Because She Disobeyed Me in Wearing This New Hairstyle: Gender-Based Violence, Laws, and Impunity in Senegal." In *Domestic Violence and the Law in Colonial and Postcolonial Africa*, edited by Emily Burrill, Richard Roberts, and Elizabeth Thornberry, 203–19. Athens: Ohio University Press, 2010.

———. "Roles and the Position of Women in Sufi Brotherhoods in Senegal." *Journal of the American Academy of Religion* 73, no. 4 (2005): 1099–119.

Bowen, John R. *Islam, Law, and Equality in Indonesia: An Anthropology of Public Reasoning.* Cambridge: Cambridge University Press, 2003.

Boyden, Jo, and Sara Gibbs. *Children and War: Understanding Psychological Distress in Cambodia.* Geneva: United Nations Research Institute for Social Development, 1997.

Bozzoli, Belinda. *Women of Phokeng: Consciousness, Life Strategy, and Migrancy in South Africa, 1900–1983.* Portsmouth, NH: Heinemann, 1991.

Burrill, Emily S. *States of Marriage: Gender, Justice, and Rights in Colonial Mali.* Athens: Ohio University Press, 2015.

Braudel, Fernand. *The Structures of Everyday Life: Civilization and Capitalism, 15th–18th Century.* Berkeley: University of California Press, 1992.

Brenner, Louis. *Controlling Knowledge: Religion, Power, and Schooling in a West African Muslim Society.* Bloomington: Indiana University Press, 2001.

Brooks, George E. *Eurafricans in Western Africa: Commerce, Social Status, Gender, and Religious Observance from the Sixteenth to the Eighteenth Century.* Athens: Ohio University Press, 2003.

———. *Landlords and Strangers: Ecology, Society, and Trade in Western Africa, 1000–1630.* Boulder, CO: Westview Press, 1993.

Buggenhagen, Beth. *Muslim Families in Global Senegal: Money Takes Care of Shame.* Bloomington: Indiana University Press, 2012.

Burrill, Emily, Richard Roberts, and Elizabeth Thornberry, eds. *Domestic Violence and the Law in Colonial and Postcolonial Africa.* Athens: Ohio University Press, 2010.

Callaway, Barbara. *The Heritage of Islam: Women, Religion, and Politics in West Africa.* Boulder, CO: Lynne Rienner, 1994.

———. *Muslim Hausa Women in Nigeria: Tradition and Change.* Syracuse, NY: Syracuse University Press, 1987.

Carney, Judith, and Michael Watts. "Disciplining Women? Rice, Mechanization, and the Evolution of Mandinka Gender Relations in Senegambia." *Signs: Journal of Women in Culture and Society* 16, no. 4 (1991): 651–81.

Ceesay, Hassoum. *A Brief Historical Insight into Gender-Based Violence in the Gambia, 1886–2005.* Banjul: African Centre for Democracy and Human Rights Studies, 2005.

———. *Gambian Women: An Introductory History.* Banjul: Fulladu Publishers, 2007.

Chanock, Martin. *Law, Custom and Social Order: The Colonial Experience in Malawi and Zambia.* Cambridge: Cambridge University Press, 1985.

Charry, Eric S. *Mande Music: Traditional and Modern Music of the Maninka and Mandinka of West Africa.* Chicago: University of Chicago Press, 2000.

Christelow, Allan. "Islamic Law and Judicial Practice in Nigeria: An Historical Perspective." *Journal of Muslim Minority Affairs* 22, no. 1 (2002): 185–204.

———. "Islamic Law in Africa." In *The History of Islam in Africa,* edited by Nehemia Levtzion and Randall L. Pouwels, 373–96. Athens: Ohio University Press, 2000.

———. "The Muslim Judge and Municipal Politics in Colonial Algeria and Senegal." *Comparative Studies in Society and History* 24, no. 1 (January 1982): 3–24.

———. *Muslim Law Courts and the French Colonial State in Algeria.* Princeton, NJ: Princeton University Press, 1985.

———, ed. *Thus Ruled Emir Abbas: Selected Cases from the Records of the Emir of Kano's Judicial Council.* East Lansing: Michigan State University Press, 1994.

Clark, Andrew F. "The Challenges of Cross-Cultural Oral History: Collecting and Presenting Pulaar Traditions on Slavery from Bundu, Senegambia (West Africa)." *Oral History Review* 20, no. 1/2 (April 1992): 1–21.

———. "The Fulbe of Bundu (Senegambia): From Theocracy to Secularization." *International Journal of African Historical Studies* 29, no. 1 (1996): 1–23.

———. "Internal Migrations and Population Movements in the Upper Senegal Valley (West Africa), 1890–1920." *Canadian Journal of African Studies* 28, no. 3 (1994): 399–420.

Cooper, Barbara. *Marriage in Maradi: Gender and Culture in a Hausa Society in Niger, 1900–1989.* Portsmouth, NH: Heinemann, 1997.

Creevey, Lucy. "Islam, Women, and the Role of the State in Senegal." *Journal of Religion in Africa* 26, no. 3 (1996): 268–307.

Crowder, Michael. "Indirect Rule—French and British Style." *Africa: Journal of the International African Institute* 34 (1964): 197–205.

———. *West Africa under Colonial Rule.* Evanston, IL: Northwestern University Press, 1968.

Crowder, Michael, and Obaro Ikime, eds. *West African Chiefs: Their Changing Status under Colonial Rule and Independence.* Ife, Nigeria: University Press of Ife, 1970.

Curtin, Philip. *Economic Change in Precolonial Africa: Senegambia in the Era of the Slave Trade.* Madison: University of Wisconsin Press, 1975.

Curtrifelli, Maria. *Women in Africa: Roots of Oppression.* London: Zed Books, 1984.

Danmole, H. O. "The Alkali Court in Ilorin Emirate during Colonial Rule." *Transafrican Journal of History* 18 (1989): 173–86.

Davidheiser, Mark. "Special Affinities and Conflict Resolution: West African Social Institutions and Mediation." Beyond Intractability: The Conflict Information Consortium, University of Colorado, December 2005.

Dewalt, Kathleen M., and Billie Dewalt. *Participant Observation: A Guide for Field Workers*. New York: AltaMira Press, 2002.

Dickerman, Carol. "African Courts under the Colonial Regime: Usumbura, Rwanda-Urundi, 1938–62." *Canadian Journal of African Studies* 26, no. 1 (1992): 55–69.

Diop, Abdoulaye-Bara. *La société wolof, tradition et changement: Les systèmes d'inégalité et de domination*. Paris: Karthala, 1981.

Echenberg, Myron. *Colonial Conscripts: The Tirailleurs Sénégalais in French West Africa, 1857–1960*. Portsmouth, NH: Heinemann, 1991.

Eldredge, Elizabeth A. *Power in Colonial Africa: Conflict and Discourse in Lesotho, 1870–1960*. Madison: University of Wisconsin Press, 2007.

Elias, T. O. *The Nature of African Customary Law*. Manchester: Manchester University Press, 1956.

Fair, Laura. *Pastimes and Politics: Culture, Politics, and Identity in Post-Abolition Zanzibar, 1890–1945*. Athens: Ohio University Press, 2001.

Falola, Toyin, and Christian Jennings, eds. *Sources and Methods in African History: Spoken, Written, Unearthed*. Rochester, NY: University of Rochester Press, 2003.

Ferreira, Roquinaldo. "Atlantic Microhistories: Mobility, Personal Ties, and Slaving in the Black Atlantic World (Angola and Brazil)." In *Cultures of the Lusophone Black Atlantic*, edited by Nancy Priscilla Naro, Roger Sansi-Roca, and David H. Treece, 96–128. New York: Palgrave Macmillan, 2007.

Fields, Karen E. *Revival and Rebellion in Colonial Central Africa*. Princeton, NJ: Princeton University Press, 1985.

Fisher, Humphrey J. "Conversion Reconsidered: Some Historical Aspects of Religious Conversion in Black Africa." *Journal of the International African Institute* 43, no. 1 (1973): 27–40.

Fitnat, Naa-Adjeley. "Reclaiming the African Woman's Individuality: The Struggle between Women's Reproductive Autonomy and African Society and Culture." *American University Law Review* 44, no. 4 (1995): 1351–82.

Freund, Bill. *The African City: A History*. Cambridge: Cambridge University Press, 2007.

Gailey, Harry A. *Historical Dictionary of the Gambia*. 2nd ed. Metuchen, NJ: Scarecrow Press, 1987.

———. *A History of the Gambia*. London: Routledge and Kegan Paul, 1964.

Galloway, Winifred. "A History of Wuli from the Thirteenth to the Nineteenth Century." PhD diss., Indiana University, 1975.

———. *James Island: A Background with Historical Notes on Juffure, Albreda, San Domingo and Dog Island*. Banjul: Oral History and Antiquities Division, 1978.

Gambia, The. People 2016. Http://www.theodora.com/wfbcurrent/gambia_the/gambia_the_people.html.

Gamble, David, Linda K. Salmon, and Alhaji Hassan Njie, eds. *Peoples of The Gambia: The Wolof*. Gambian Studies no. 17. San Francisco: San Francisco State University, Department of Anthropology, 1985.

Garenne, Michel, and Etienne van de Walle. "Polygyny and Fertility among the Sereer of Senegal." *Population Studies* 43, no. 2 (July 1989): 267–83.

Gasa, Nomboniso, ed. *Women in South African History*. Cape Town: Human Sciences Research Council Press, 2007.

Getz, Trevor. *Slavery and Reform in West Africa: Toward Emancipation in Nineteenth-Century Senegal and the Gold Coast*. Athens: Ohio University Press, 2004.

Glassman, Jonathon. "Sorting Out the Tribes: The Creation of Racial Identities in Colonial Zanzibar's Newspaper Wars." *Journal of African History* 41, no. 3 (2000): 395–428.

Gluckman, Max. *The Judicial Process among the Barotse of Northern Rhodesia*. Manchester: University of Manchester Press, 1955.

Gottlieb, Alma. "Cousin Marriage, Birth Order and Gender: Alliance Models among the Beng of Ivory Coast." *Man*, n.s., 21, no. 4 (December 1986): 697–722.

Gray, John M. *A History of the Gambia*. London: Frank Cass, 1966.

Green, Toby. *Meeting the Invisible Man: Secrets and Magic in West Africa*. London: Faber and Faber, 2009.

———. *The Rise of the Trans-Atlantic Slave Trade in Western Africa, 1300–1589*. Cambridge: Cambridge University Press, 2012.

Grey-Johnson, Nana. *The Story of the Newspaper in the Gambia*. Banjul: Book Production and Material Resources Unit, 2004.

Gross, David. *The Past in Ruins: Tradition and the Critique of Modernity*. Amherst: University of Massachusetts Press, 1992.

Guyer, Jane. *Women and the State in Africa: Marriage Law, Inheritance, and Resettlement*. Boston: African Studies Center, Boston University, 1987.

Habermas, Jürgen. *The Structural Transformation of the Public Sphere: An Inquiry into a Category of Bourgeois Society*. Cambridge, MA: MIT Press, 1989.

Håkansson, Thomas. *Bridewealth, Women, and Land: Social Change among the Gusii of Kenya*.

Uppsala, Sweden: Almqvist and Wiksell, 1988.

Hanretta, Sean. *Islam and Social Change in French West Africa: History of an Emancipatory Community*. Cambridge: Cambridge University Press, 2009.

Harries, Patrick. *Work, Culture, and Identity: Migrant Laborers in Mozambique and South Africa, c. 1860–1910*. Portsmouth, NH: Heinemann, 1994.

Hashim, Abdulkadir. "Servants of Sharī'a: Qāḍīs and the Politics of Accommodation in East Africa." *Sudanic Africa* 16 (2005): 27–51.

Hawthorne, Walter. *Planting Rice and Harvesting Slaves: Transformations along the Guinea-Bissau Coast, 1400–1900*. Portsmouth, NH: Heinemann, 2003.

Hay, Margaret Jean, and Marcia Wright, eds. *African Women and the Law: Historical Perspectives*. Boston: Boston University, African Studies Center, 1982.

Hekmat, Anwar. *Women and the Koran: The Status of Women in Islam*. Amherst, MA: Prometheus Books, 1997.

Hirsch, Susan F. *Pronouncing and Persevering: Gender and the Discourses of Disputing in an African Court*. Chicago: University of Chicago Press, 1998.

Hodgson, Dorothy, and Sheryl McCurdy. *"Wicked" Women and the Reconfiguration of Gender in Africa*. Portsmouth, NH: Heinemann, 2001.

Horta, José da Silva. "Evidence for a Luso-African Identity in 'Portuguese' Accounts on 'Guinea of Cape Verde' (Sixteenth–Seventeenth Centuries)." *History in Africa* 27 (2000): 99–130.

Hughes, Arnold, ed. *The Gambia: Studies in Society and Politics*. African Studies Series no. 3. Birmingham: University of Birmingham, Centre of West African Studies, 1991.

Hughes, Arnold, and Harry A. Gailey. *Historical Dictionary of the Gambia*. 3rd ed. Lanham, MD: Scarecrow Press, 1999.

Hughes, Arnold, and David Perfect. *A Political History of the Gambia, 1816–1994*. Rochester, NY: University of Rochester Press, 2006.

Hunter, Thomas C. "The Development of an Islamic Tradition of Learning among the Jakhanke of West Africa." PhD diss., University of Chicago, 1977.

———. "The Jabi Tarikhs: Their Significance in West African Islam." *International Journal of African Historical Studies* 9, no. 3 (1976): 435–57.

Hunwick, John. "Sub-Saharan Africa and the Wider World of Islam: Historical and Contemporary Perspectives." *Journal of Religion in Africa* 26, no. 3 (1966): 230–57.

Hutson, Alaine S. "Women, Men, and Patriarchal Bargaining in an Islamic Sufi Order: The Tijaniyya in Kano, Nigeria, 1937 to the Present." *Gender and Society* 15, no. 5 (October 2001): 734–53.

Innes, Gordon, ed. and tr. *Kaabu and Fuladu: Historical Narratives of the Gambian Mandinka*. London: School of Oriental and African Studies, 1976.

Jeppie, Shamil, Ebrahim Moosa, and Richard Roberts, eds. *Muslim Family Law in Sub-Saharan Africa: Colonial Legacies and Post-Colonial Challenges.* Amsterdam: Amsterdam University Press, 2010.

Jobson, Richard. *A Discovery of the River Gambra and the Golden Trade of the Aethiopians.* London: Dawsons of Pall Mall, 1623.

Judicial Committee of the Privy Council (Great Britain). "Abdoulie Drammeh vs. Joyce Drammeh." *Journal of African Law* 14, no. 2 (Summer 1970): 115–20.

Kameri-Mbote, Patricia G. "Gender Dimensions of Law, Colonialism and Inheritance in East Africa: Kenyan Women's Experiences." *Law and Politics in Africa, Asia and Latin America* 35, no. 3 (2002): 373–98.

Kandiyoti, Deniz. "Bargaining with Patriarchy." *Gender and Society* 2 (1988): 274–90.

Karekwaivanane, George H. "'It Shall Be the Duty of Every African to Obey and Comply Promptly': Negotiating State Authority in the Legal Arena, Rhodesia 1965–1980." *Journal of Southern African Studies* 37, no. 2 (2011): 333–49.

———. "Legal Encounters: Law, State and Society in Zimbabwe, c.1950–2008." PhD diss., University of Oxford, 2012.

Keay, Elliot Alexander, and Sam Scruton Richardson. *The Native and Customary Courts of Nigeria.* London: African Universities Press, 1966.

Killingray, David. "The Maintenance of Law and Order in British Colonial Africa." *African Affairs* 85, no. 340 (1986): 411–37.

Klein, Martin A. *Islam and Imperialism in Senegal: Sine-Saloum, 1847–1914.* Stanford, CA: Stanford University Press, 1968.

———. "La notion d'honneur et la persistance de la servitude au Soudan occidental." *Cahiers d'Études Africaines* 45 (2005): 831–51.

———. "Servitude among the Wolof and Sereer of Senegambia." In *Slavery in Africa: Historical and Anthropological Perspectives*, edited by Suzanne Miers and Igor Kopytoff, 335–63. Madison: University of Wisconsin Press, 1977.

———. *Slavery and Colonial Rule in French West Africa.* Cambridge: Cambridge University Press, 1998.

———. "Social and Economic Factors in the Muslim Revolution in Senegambia." *Journal of African History* 13, no. 3 (1972): 419–41.

Kobo, Ousman. "'We Are Citizens Too': The Politics of Citizenship in Independent Ghana." *Journal of Modern African Studies* 48, no. 1 (2010): 67–94.

Langley, J. Ayo Dele. "The Gambia Section of the NCBWA." *Africa: Journal of the International African Institute* 39, no. 4 (1969): 382–95.

Last, Murray. "The Colonial Caliphate of Northern Nigeria." In *Le temps des marabouts:*

Itinéraires et stratégies islamiques en Afrique Occidentale Française, v.1880–1960, edited by David Robinson and Jean-Louis Triaud, 67–82. Paris: Karthala, 1997.

Launay, Robert, and Benjamin F. Soares. "The Formation of an 'Islamic Sphere' in French Colonial West Africa." *Economy and Society* 28 (1999): 497–519.

Law, Robin, ed. *From Slave Trade to "Legitimate" Commerce: The Commercial Transition in Nineteenth-Century West Africa*. Cambridge: Cambridge University Press, 1995.

Leach, E. R. "Polyandry, Inheritance and the Definition of Marriage." *Man* 55 (1955): 182–86.

Leary, Frances Anne. "Islam, Politics, and Colonialism: A Political History of Islam in the Casamance Region of Senegal (1850–1919)." PhD diss., Northwestern University, 1970.

Levtzion, Nehemia, ed. *Conversion to Islam.* New York: Holmes and Meier, 1979.

Levtzion, Nehemia, and Randall Pouwels, eds. *The History of Islam in Africa*. Athens: Ohio University Press, 2000.

Linares, Olga. "From Tidal Swamp to Inland Valley: On the Social Organization of Wet Rice Cultivation among the Diola of Senegal." *Africa: Journal of the International African Institute* 51, no. 2 (1981): 557–95.

———. *Power, Prayer, and Production: The Jola of Casamance, Senegal*. Cambridge: Cambridge University Press, 1992.

Lovejoy, Paul E., and Jan S. Hogendorn. "Revolutionary Mahdism and Resistance to Colonial Rule in the Sokoto Caliphate, 1905–1906." *Journal of African History* 31, no. 2 (1990): 217–44.

———. *Slow Death for Slavery: The Course of Abolition in Northern Nigeria, 1897–1936*. Cambridge: Cambridge University Press, 1993.

Lovejoy, Paul E., and David Richardson. "The Business of Slaving: Pawnship in West Africa, c.1600–1800." *Journal of African History* 42, no. 1 (2001): 67–89.

Lugard, Frederick. *The Political Memoranda: Revision of Instructions to Political Officers on Subjects Chiefly Political and Administrative*. London: Frank Cass, 1970.

Lydon, Ghislaine. "Droit islamique et droits de la femme d'après les registres du Tribunal Musulman de Ndar (Saint-Louis du Sénégal)." *Canadian Journal of African Studies* 41, no. 2 (2007): 289–307.

———. "Obtaining Freedom at the Muslims' Tribunal: Colonial Kadijustiz and Women's Divorce Litigation in Ndar (Senegal)." In *Muslim Family Law in Sub-Saharan Africa: Colonial Legacies and Post-Colonial Challenges*, edited by Shamil Jeppie, Ebrahim Moosa, and Richard Roberts, 135–64. Amsterdam: Amsterdam University Press, 2010.

Madhavan, Sangeetha, and Caroline H. Bledsoe. "The Compound as a Locus of Fertility Management: The Case of the Gambia." *Culture, Health, and Sexuality* 3, no. 4 (October–December 2001): 451–68.

Magubane, Peter. *Women of South Africa: Their Fight for Freedom.* Boston: Little, Brown, 1993.

Mahoney, Florence K. C. "Government and Opinion in the Gambia, 1816–1901." PhD diss., School of Oriental and African Studies, London, 1963.

Makinde, Abdul-Fatah 'Kola, and Philip Ostien. "Legal Pluralism in Colonial Lagos: The 1894 Petition of the Lagos Muslims to Their British Colonial Masters." *Die Welt des Islams* 52, no. 1 (2012): 51–68.

Mamdani, Mahmood. *Citizen and Subject: Contemporary Africa and the Legacy of Late Colonialism.* Princeton, NJ: Princeton University Press, 1996.

Mann, Kristin, and Richard Roberts, eds. *Law in Colonial Africa.* Portsmouth, NH: Heinemann, 1991.

Mark, Peter. "Economic and Religious Change among the Diola of Boulouf (Casamance), 1890–1940: Trade, Cash Cropping, and Islam in Southwestern Senegal." PhD diss., Yale University, 1976.

———. "The Evolution of 'Portuguese' Identity: Luso-Africans on the Upper Guinea Coast from the Sixteenth to the Early Nineteenth Century." *Journal of African History* 40, no. 2 (1999): 173–91.

———. "Fetishers, 'Marybuckes,' and the Christian Norm: European Images of Senegambians and Their Religions, 1550–1760." *African Studies Review* 23, no. 2 (1980): 91–99.

———. *"Portuguese" Style and Luso-African Identity: Precolonial Senegambia, Sixteenth–Nineteenth Centuries.* Bloomington: Indiana University Press, 2002.

Mason, Kathryn F. "Co-Wife Relationships Can Be Amicable as Well as Conflictual: The Case of the Moose of Burkina Faso." *Canadian Journal of African Studies* 22, no. 3 (1988): 615–24.

Masquelier, Adeline. *Prayer Has Spoiled Everything: Possession, Power, and Identity in an Islamic Town of Niger.* Durham, NC: Duke University Press, 2001.

———. *Women and Islamic Revival in a West African Town.* Bloomington: Indiana University Press, 2009.

Mbaye, Saliou. "Personnel Files and the Role of Qadis and Interpreters in the Colonial Administration of Saint-Louis, Senegal, 1857–1911." In *Intermediaries, Interpreters, and Clerks: African Employees in the Making of Colonial Africa*, edited by Benjamin N. Lawrence, 289–95. Madison: University of Wisconsin Press, 2006.

Mbow, Penda. "Les femmes, l'Islam et les associations religieuses au Sénégal: Le dynamisme des femmes en milieu urbain." In *Transforming Female Identities: Women's Organizational Forms in West Africa*, edited by Eva Evers Rosander, 48–159. Uppsala, Sweden: Nordic Africa Institute, 1997.

McClendon, Thomas V. *Genders and Generations Apart: Labour Tenants and Customary Law in Segregation-Era South Africa, 1920s–1940s.* Oxford: James Currey, 2002.

———. "Tradition and Domestic Struggle in the Courtroom: Customary Law and the Control of Women in Segregation-Era Natal." *International Journal of African Historical Studies* 28, no. 3 (1995): 527–61.

McMahon, Elisabeth Mary. "Becoming Pemban: Identity, Social Welfare and Community during the Protectorate Period." PhD diss., Indiana University, 2005.

Meer, Fatima. *Women in the Apartheid Society.* New York: United Nations Centre against Apartheid, 1985.

Mehdi, Rubya, ed. *Law and Religion in Multicultural Societies.* Copenhagen: Djøf Forlag, 2008.

Mernissi, Fatima. *Women and Islam: An Historical and Theological Enquiry.* Oxford: Blackwell Publishers, 1987.

Merry, Sally Engle. "Legal Pluralism." *Law and Society Review* 22 (1988): 869–96.

Mianda, Gertrude. "Colonialism, Education, and Gender Relations in the Belgian Congo: The Évolué Case." In *Women in African Colonial Histories*, edited by Jean Allman, Nakanyike Musisi, and Susan Geiger, 144–63. Bloomington: Indiana University Press, 2002.

Miller, Joseph C. "History and Africa/Africa and History." *American Historical Review* 104, no. 1 (February 1999): 1–32.

Mirza, Sarah, and Margaret Strobel, eds. *Three Swahili Women: Life Histories from Mombasa, Kenya.* Bloomington: Indiana University Press, 1989.

Moodie, T. Dunbar. *Going for Gold: Men, Mines, and Migration.* Berkeley: University of California Press, 1994.

Moore, Sally Falk. *Social Facts and Fabrications: "Customary" Law on Kilimanjaro, 1880–1980.* Cambridge: Cambridge University Press, 1986.

———. "Treating Law as Knowledge: Telling Colonial Officers What to Say to Africans about Running 'Their Own' Native Courts." *Law and Society Review* 26 (1992): 11–46.

Mwakimako, Hassan. "Kadhi Court and Appointment of Kadhi in Kenya Colony." *Religion Compass* 2, no. 4 (2008): 424–43.

Myers, Garth Andrew. *Verandahs of Power: Colonialism and Space in Urban Africa.* Syracuse, NY: Syracuse University Press, 2003.

Naniya, Tijani Muhammad. "History of the Shari'a in Some States of Northern Nigeria to circa 2000." *Journal of Islamic Studies* 13, no. 1 (2002): 14–31.

Ntephe, Peter. "Does Africa Need Another Kind of Law? Alterity and the Rule of Law in Subsaharan Africa." PhD diss., SOAS, University of London, 2012.

Nunn, Nathan. "Religious Conversion in Colonial Africa." *American Economic Review* 100, no. 2 (May 2010): 147–52.

Nyang, Sulayman Sheih. "The Role of the Gambian Political Parties in National Integration." PhD diss., University of Virginia, 1974.

Oba, A. A. "Islamic Law as Customary Law: The Changing Perspective in Nigeria." *International and Comparative Law Quarterly* 51, no. 4 (October 2002): 817–50.

O'Brien, D. B. Cruise. *The Mourides of Senegal: The Political and Economic Organization of an Islamic Brotherhood*. Oxford: Clarendon Press, 1971.

———. "Towards an 'Islamic Policy' in French West Africa, 1854–1914." *Journal of African History* 8, no. 2 (1967): 303–16.

Osborn, Emily Lynn. *Our New Husbands Are Here: Households, Gender, and Politics in a West African State from the Slave Trade to Colonial Rule*. Athens: Ohio University Press, 2011.

Ostien, Philip. *Sharia Implementation in Northern Nigeria, 1999–2006: A Sourcebook*. 5 vols. Ibadan, Nigeria: Spectrum Books, 2007.

Panzacchi, Cornelia. "The Livelihoods of Traditional Griots in Modern Senegal." *Africa: Journal of the International African Institute* 64, no. 2 (1994): 190–210.

Park, Mungo. *Travels in the Interior of Africa, in the Years 1795, 1796 & 1797*. Abridged ed. London: J. W. Myers, 1799.

Patai, Daphne. "US Academics and Third World Women: Is Ethical Research Possible?" In *Women's Words: The Feminist Practice of Doing Oral History*, edited by Sherna Berger Gluck and Daphne Patai, 137–53. New York: Routledge, 1991.

Peletz, Michael G. *Religious Courts and Cultural Politics in Malaysia*. Princeton, NJ: Princeton University Press, 2002.

Pélissier, Paul. *Les Diola: Étude sur l'habitat des riziculteurs de Basse-Casamance*. Dakar: University of Dakar, Department of Geography, 1958.

Pellow, Deborah. "Muslim Segmentation: Cohesion and Divisiveness in Accra." *Journal of Modern African Studies* 23, no. 3 (September 1985): 419–44.

Perry, Donna L. "Muslim Child Disciples, Global Civil Society, and Children's Rights in Senegal: The Discourses of Strategic Structuralism." *Anthropological Quarterly* 77, no. 1 (2004): 47–84.

Philips, John Edward. *Writing African History*. Rochester, NY: University of Rochester Press, 2005.

Pomeranz, Kenneth. *The Great Divergence: China, Europe and the Making of the Modern World Economy*. Princeton, NJ: Princeton University Press, 2000.

Quinn, Charlotte A. *Mandingo Kingdoms of the Senegambia: Traditionalism, Islam, and European Expansion*. Evanston, IL: Northwestern University Press, 1972.

———. "A Nineteenth Century Fulbe State." *Journal of African History* 12, no. 3 (1971): 427–40.

Ranger, Terence. "The Invention of Tradition in Colonial Africa." In *Perspectives on Africa: A Reader in Culture, History, and Representation*, edited by Roy Richard Grinker, Stephen C. Lubkemann, and Christopher B. Steiner. Malden, MA: Wiley-Blackwell, 2010.

Ranger, Terence, and Eric Hobsbawm, eds. *The Invention of Tradition.* Cambridge: Cambridge University Press, 1983.

Rashid, Ismail. "Class, Caste, and Social Inequality in West African History." In *Themes in West Africa's History,* edited by Emmanuel Kwaku Akyeampong, 118–40. Athens: Ohio University Press, 2006.

Rathbone, Richard. *Nkrumah and the Chiefs: The Politics of Chieftaincy in Ghana, 1951–1960.* Athens: Ohio University Press, 2000.

Renne, Elisha P. "Polyphony in the Courts: Child Custody Cases in Kabba District Court, 1925–1979." *Ethnology* 31, no. 3 (July 1992): 219–32.

Ritchie, Donald A. *Doing Oral History: A Practical Guide.* Oxford: Oxford University Press, 2003.

Roberts, Richard. "Conflicts over Property in the Middle Niger Valley at the Beginning of the Twentieth Century." *African Economic History* 25 (1997): 79–96.

———. "The End of Slavery, Colonial Courts, and Social Conflict in Gumbu, 1908–1911." *Canadian Journal of African Studies* 34, no. 3 (2000): 684–713.

———. *Litigants and Households: African Disputes and Colonial Courts in the French Soudan, 1895–1912.* Portsmouth, NH: Heinemann, 2005.

———. "Representation, Structure, and Agency: Divorce in the French Soudan during the Early Twentieth Century." *Journal of African History* 40 (1999): 389–410.

———. "Text and Testimony in the Tribunal de Première Instance, Dakar, during the Early Twentieth Century." *Journal of African History* 31, no. 3 (1990): 447–63.

Roberts, Richard, and Suzanne Miers, eds. *The End of Slavery in Africa.* Madison: University of Wisconsin Press, 1988.

Roberts, Richard, and William Worger. "Law, Colonialism, and Conflicts over Property in Sub-Saharan Africa." *African Economic History* 25 (1997): 1–7.

Robinson, David. "Ethnographie et droit coutumier au Sénégal." *Cahiers d'Études Africaines* 32, no. 126 (1992): 221–37.

———. "France as Muslim Power in West Africa." *Africa Today* 46, no. 3/4 (1999): 105–27.

———. "French 'Islamic' Policy and Practice in Late Nineteenth-Century Senegal." *Journal of African History* 29, no. 3 (1988): 415–35.

———. *The Holy War of Umar Tal: The Western Sudan in the Mid-Nineteenth Century.* Oxford: Clarendon Press, 1985.

———. *Muslim Societies in Africa: New Approaches in African History.* Cambridge: Cambridge University Press, 2004.

———. *Paths of Accommodation: Muslim Societies and French Colonial Authorities in Senegal and Mauritania, 1880–1920.* Athens: Ohio University Press, 2000.

Robinson, Ronald, and John Gallagher. *Africa and Victorians: The Climax of Imperialism in the*

Dark Continent. New York: St. Martin's Press, 1968.

Rodney, Walter. *A History of the Upper Guinea Coast, 1545–1800.* New York: Monthly Review Press, 1970.

———. "Slavery and Other Forms of Social Oppression on the Upper Guinea Coast in the Context of the Atlantic Slave Trade." *Journal of African History* 7, no. 3 (1966): 431–47.

Rosaldo, Michelle Zimbalist, and Louise Lamphere, eds. *Woman, Culture, and Society.* Stanford, CA: Stanford University Press, 1974.

Rosen, Lawrence. *Bargaining for Reality: The Construction of Social Relations in a Muslim Community.* Chicago: University of Chicago Press, 1984.

Ryan, Patrick J. "Ariadne auf Naxos: Islam and Politics in a Religiously Pluralistic African Society." *Journal of Religion in Africa* 26, no. 3 (1996): 308–29.

Saho, Bala. "Appropriation of Islam in a Gambian Village: Life and Times of Shaykh Mass Kah, 1827–1936." *African Studies Quarterly* 12, no. 4 (Fall 2011): 1–21.

———. "Challenges and Constraints: Forced Marriage as a Form of 'Traditional' Practice in the Gambia." In *Marriage by Force? Contestation over Consent and Coercion in Africa*, edited by Annie Buntung, Benjamin N. Lawrence, and Richard Roberts, 178–98. Athens: Ohio University Press, 2016.

Said, Edward. *Orientalism.* New York: Vintage Books, 1979.

Sanneh, Lamin. *The Crown and the Turban: Muslims and West African Pluralism.* Boulder, CO: Westview Press, 1997.

———. "Futa Jallon and the Jakhanke Clerical Tradition: Historical Setting." *Journal of Religion in Africa* 12, no. 1 (1981): 38–64.

———. *The Jakhanke: The History of an Islamic Clerical People of the Senegambia.* London: International African Institute, 1979.

———. *The Jakhanke Muslim Clerics: A Religious and Historical Study of Islam in Senegambia.* Lanham, MD: University Press of America, 1989.

———. "The Origins of Clericalism in West African Islam." *Journal of African History* 17, no. 1 (1976): 49–72.

———. *Translating the Message: The Missionary Impact on Culture.* Maryknoll, NY: Orbis Books, 1989.

Sarr, Assan. "Land and Historical Changes in a River Valley: Property, Power, and Dependency in the Lower Gambia Basin, Nineteenth and Early Twentieth Centuries." PhD diss., Michigan State University, 2010.

Sartori, Paolo, and Ido Shahar. "Legal Pluralism in Muslim-Majority Colonies: Mapping the Terrain." *Journal of the Economic and Social History of the Orient* 55, no. 4/5 (2012): 637–63.

Scanlon, Helen. *Representation and Reality: Portraits of Women's Lives in the Western Cape,*

1948–1976. Cape Town: Human Sciences Research Council Press, 2007.

Schipper, Mineke. *Source of All Evil: African Proverbs and Sayings on Women.* London: Allison and Busby, 1991.

Schmidt, Elizabeth. "Negotiated Spaces and Contested Terrain: Men, Women, and the Law in Colonial Zimbabwe, 1890–1939." *Journal of Southern African Studies* 16, no. 4 (1990): 622–48.

———. *Peasants, Traders, and Wives: Shona Women in the History of Zimbabwe, 1870–1939.* London: James Currey, 1992.

Schroeder, Richard A. "'Gone to Their Second Husbands': Marital Metaphors and Conjugal Contracts in the Gambia's Female Garden Sector." *Canadian Journal of African Studies* 30, no. 1 (1996): 69–87.

Schulz, Dorothea E. *Muslims and New Media in West Africa: Pathways to God.* Bloomington: Indiana University Press, 2012.

Scott, Rebecca J., and Jean M. Hébrard. *Freedom Papers: An Atlantic Odyssey in the Age of Emancipation.* Cambridge, MA: Harvard University Press, 2012.

Searing, James F. "Aristocrats, Slaves, and Peasants: Power and Dependency in the Wolof States, 1700–1850." *International Journal of African Historical Studies* 21, no. 3 (1988): 475–503.

———. "No Kings, No Lords, No Slaves: Ethnicity and Religion among the Sereer-Safèn of Western Bawol, 1700–1914." *Journal of African History* 43, no. 3 (2002): 407–29.

Shadle, Brett L. "Bridewealth and Female Consent: Marriage Disputes in African Courts, Gusiiland, Kenya." *Journal of African History* 44, no. 2 (2003): 241–62.

———. "Changing Traditions to Meet Current Altering Conditions: Customary Law, African Courts, and the Rejection of Codification in Kenya, 1930–1960." *Journal of African History* 40, no. 3 (1999): 411–31.

Shereikis, Rebecca. "From Law to Custom: The Shifting Legal Status of Muslim Originaires in Kayes and Medine, 1903–1913." *Journal of African History* 42 (2001): 261–83.

Simelane, Hamilton Sipho. "The State, Chiefs, and the Control of Female Migration in Colonial Swaziland, c. 1930s–1950s." *Journal of African History* 45, no. 1 (2004): 103–24.

Skinner, David E. "Islam and Education in the Colony and Hinterland of Sierra Leone (1750–1914)." *Canadian Journal of African Studies* 10, no. 3 (1976): 499–520.

———. "Mande Settlement and the Development of Islamic Institutions in Sierra Leone." *International Journal of African Historical Studies* 11, no. 1 (1978): 32–61.

Sloth-Nielsen, Julia, and Lea Mwambene. "Talking the Talk and Walking the Walk: How Can the Development of African Customary Law Be Understood?" *Law in Context* 28, no. 2 (2010): 27–46.

Soares, Benjamin F. *Islam and the Prayer Economy: History and Authority in a Malian Town.*

Ann Arbor: University of Michigan Press, 2005.

Solivetti, Luigi M. "Family, Marriage and Divorce in a Hausa Community: A Sociological Model." *Africa: Journal of the International African Institute* 64, no. 2 (1994): 252–71.

Sparks, Randy J. *The Two Princes of Calabar: An Eighteenth-Century Atlantic Odyssey.* Cambridge, MA: Harvard University Press, 2004.

Sossou, Marie-Antoinette. "Widowhood Practices in West Africa: The Silent Victims." *International Journal of Social Welfare* 11 (2002): 201–9.

Spear, Thomas. "Approaches to Documentary Sources." In *Sources and Methods in African History: Spoken, Written, Unearthed,* edited by Toyin Falola and Christian Jennings, 169–72. Rochester, NY: University of Rochester Press, 2003.

———. "Neo-Traditionalism and the Limits of Invention in British Colonial Africa." *Journal of African History* 44, no. 1 (2003): 3–27.

Stewart, Charles, ed. *Creolization: History, Ethnography, and Theory.* Walnut Creek, CA: Left Coast Press, 2007.

Stewart, Charles, with E. K. Stewart. *Islam and Social Order in Mauritania: A Case Study from the Nineteenth Century.* Oxford: Clarendon Press, 1973.

Stockreiter, Elke. *Islamic Law, Gender and Social Change in Colonial Zanzibar.* New York: Cambridge University Press, 2015.

Stuart, Andrea. *Sugar in the Blood: A Family's Story of Slavery and Empire.* New York: Alfred A. Knopf, 2013.

Sweet, James H. *Domingos Álvares, African Healing, and the Intellectual History of the Atlantic World.* Chapel Hill: University of North Carolina Press, 2011.

———. *Recreating Africa: Culture, Kinship, and Religion in the African-Portuguese World, 1441–1770.* Chapel Hill: University of North Carolina Press, 2003.

Stiles, Erin E., and Katrina Daly Thompson. *Gendered Lives in the Western Indian Ocean: Islam, Marriage, and Sexuality on the Swahili Coast.* Athens: Ohio University Press, 2015.

Swindell, Kenneth. *The Strange Farmers of the Gambia: A Study in the Redistribution of African Population.* Norwich, England: Geo Books, 1981.

Tal, Tamari. "The Development of Caste System in West Africa." *Journal of African History* 32, no. 2 (1991): 221–50.

Thompson, Steven K. "Revisiting 'Mandingization' in Coastal Gambia and Casamance (Senegal): Four Approaches to Ethnic Change." *African Studies Review* 54, no. 2 (2011): 95–121.

Tibenderana, Peter K. "The Irony of Indirect Rule in Sokoto Emirate, Nigeria, 1903–1944." *African Studies Review* 31, no. 1 (April 1988): 67–92.

———. *Sokoto Province under British Rule, 1903–1939: A Study in Institutional Adaptation*

and Culturalization of a Colonial Society in Northern Nigeria. Zaria, Nigeria: Ahmadu Bello University Press, 1988.

Tilly, Louise A. "People's History and Social Science History." *Social Science History* 7, no. 4 (1983): 457–74.

Todd, D. M. "Caste in Africa?" *Africa: Journal of the International African Institute* 47, no. 4 (1977): 435–40.

Triaud, Jean-Louis. "Islam in Africa under French Colonial Rule." In *The History of Islam in Africa,* edited by Nehemia Levtzion and Randall L. Pouwels, 169–88. Athens: Ohio University Press, 2000.

Trimingham, Spencer J. *A History of Islam in West Africa.* London: Oxford University Press, 1962.

———. *The Influence of Islam upon Africa.* New York: Frederick A. Praeger, 1968.

Turner, Rebecca. "Gambian Religious Leaders Teach about Islam and Family Planning." *International Family Planning Perspectives* 18, no. 4 (1992): 150–51.

Umar, Muhammad Sani. "The Tijaniyya and British Colonial Authorities in Northern Nigeria." In *La Tijâniyya: Une confrérie musulmane à la conquête de l'Afrique,* edited by Jean-Louis Triaud and David Robinson, 327–55. Paris: Karthala, 2000.

UNICEF. "Early Marriage: Child Spouses." *Innocenti Digest* (Florence) 7 (March 2001).

Vansina, Jan. *Oral Tradition as History.* Madison: University of Wisconsin Press, 1985.

———. *Paths in the Rainforest: Toward a History of Political Tradition in Equatorial Africa.* Madison: University of Wisconsin Press, 1990.

Waheeda, Amien. "Overcoming the Conflict between the Right to Freedom of Religion and Women's Rights to Equality: A South African Case Study of Muslim Marriages." *Human Rights Quarterly* 28, no. 3 (August 2006): 729–54.

Ware, Rudolph T., III. "'Njangaan': The Daily Regime of Quranic Students in Twentieth Century Senegal." *International Journal of African Historical Studies* 37, no. 3 (2004): 515–38.

Weil, Peter. "Mandinka Mansaya: The Role of the Mandinka in the Political System of the Gambia." PhD diss., University of Oregon, 1968.

Weller, Susan C. "Structured Interviewing and Questionnaire Construction." In *Handbook of Methods in Cultural Anthropology,* edited by Bernard H. Russell, 365–409. Walnut Creek, CA: AltaMira Press, 2000.

Wells, Julia C. *We Now Demand! The History of Women's Resistance to Pass Laws in South Africa.* Johannesburg: Wits University Press, 1993.

White, Luise, Stephan E. Miescher, and David William Cohen. *African Words, African Voices: Critical Practices in Oral History.* Bloomington: Indiana University Press, 2001.

Williamson, Thora. *Gold Coast Diaries: Chronicles of Political Officers in West Africa, 1900–1919.*

Edited by Anthony Kirk-Greene. London: Radcliffe Press, 2000.

Willis, John Ralph. *In the Path of Allah: The Passion of Al-Hajj-Umar; An Essay into the Nature of Charisma in Islam.* London: Frank Cass, 1989.

———. "Jihad fi Sabil Allah: Its Doctrinal Basis in Islam and Some Aspects of Its Evolution in Nineteenth-Century West Africa." *Journal of African History* 8, no. 3 (1967): 395–415.

Wright, Donald R. "Darbo Jula: The Role of a Mandinka Jula Clan in the Long-Distance Trade of the Gambia River and Its Hinterland." *African Economic History*, no. 3 (Spring 1977): 33–45.

———. "Niumi: The History of a Western Mandinka State through the Eighteenth Century." PhD diss., Indiana University, 1976.

———. *The World and a Small Place in Africa: A History of Globalization in Niumi, the Gambia.* New York: M. E. Sharpe, 2010.

Index